The Print

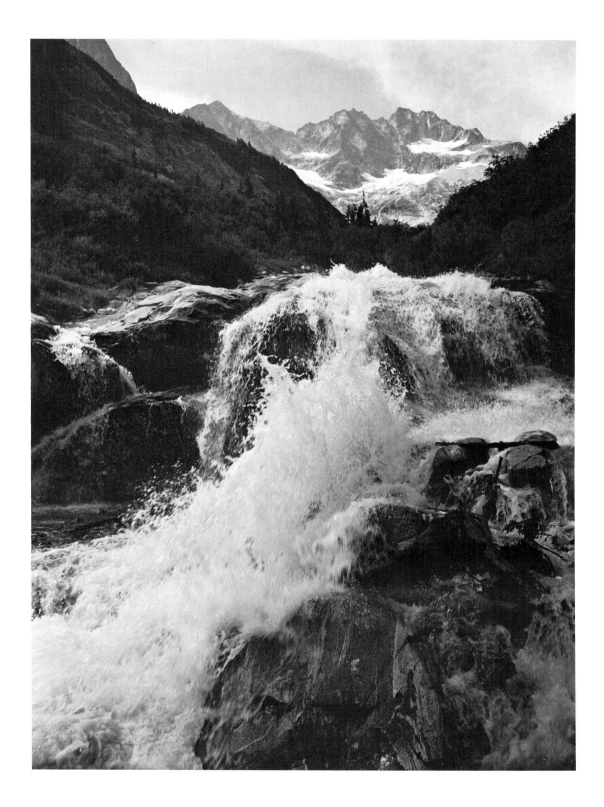

The Print

Ansel Adams

with the collaboration of Robert Baker

LITTLE, BROWN AND COMPANY

BOSTON NEW YORK TORONTO LONDON

Frontispiece: *Northern Cascades, Washington (hazy sunlight), 1960*

Copyright © 1983 by the Trustees of The Ansel Adams Publishing Rights Trust

This is the third volume of *The Ansel Adams Photography Series*.
Thirteenth printing, 1995
First paperback edition, 1995

Library of Congress Cataloging in Publication Data

Adams, Ansel Easton, 1902–1984
The print.
 (The Ansel Adams photography series ; book 3)
 1. Photography—Printing processes. 2. Photography—Enlarging. I. Baker, Robert. II. Title. III. Series: Adams, Ansel, 1902–1984. Ansel Adams photography series ; book 3.
TR145.A38bk.3 [TR330]770s [770'.28'4] 83–950 ISBN 0-8212-1526-4 HC
 ISBN 0-8212-2187-6 PB
Designed by David Ford
Technical illustrations by Omnigraphics
Printed and bound by Quebecor/Kingsport

Published simultaneously in Canada by Little, Brown & Company (Canada) Limited

PRINTED IN THE UNITED STATES OF AMERICA

Acknowledgments

The completion of a book of this type requires the advice and assistance of many colleagues and associates, all of which is most warmly appreciated. I am especially indebted to Robert Baker, my most competent collaborator and editor. In addition, John Sexton, as technical assistant, contributed greatly with the tests and in preparing the illustrations, as well as his careful reading and advice on the text. I also thank Jim Alinder for reading and commenting on the general content of the book, and Mary Alinder, Chris Rainier, and Phyllis Donohue, who were helpful in numerous ways.

My publishers, represented by Floyd Yearout, Janet Swan, Nan Jernigan, and Dale Cotton, were, as usual, most cooperative and helpful. Dave Ford, book designer for the Series, and Tom Briggs of Omnigraphics, who provided the drawings, deserve high recognition.

In addition I wish to express my appreciation to:

Jim Marron and Bob Shanebrook of Eastman Kodak Co.; John Branca and many others at Polaroid Corp.; Klaus Hendricks, Chief of Picture Conservation of the Public Archives of Canada; Dr. Paul Horowitz, Harvard University (designer of the light-stabilizer described in the text); Rod Dresser, for assistance in computer plotting of the paper curves; Henry Gilpin, photographer; Fred Picker, of Zone VI Studios; Ed Kostiner; Saul Chaiken; and our many friends, at Ilford, Inc., Oriental Paper Co., Beseler Photo Marketing, Calumet Photographic, Tri-Ess Sciences, Beckman Instruments, and Adolph Gasser, Inc. of San Francisco.

Contents

Introduction

Photography is more than a medium for communication of reality, it is a creative art. Therefore, emphasis on technique is justified only so far as it will simplify and clarify the statement of the photographer's concept. This series of books presents essential information and suggests applications of photographic methods to practical problems of artistic expression. My objective is to present a working approach to creative photography.

Certain controls that allow the photographer to achieve desired qualities in his negative are discussed in Books 1 and 2. In these volumes we considered *visualization* as fully as we could without actually making the final print. In this book I shall attempt to round out the basic procedures of the black-and-white photographic process — from original visualization to the completed print. I will present the technical aspects and controls that contribute to the final image in terms of both information and creative expression.

The reader must bear in mind that what these books are intended to accomplish is to present a concept (visualization) and a *modus operandi* (craft) to achieve desired results. This is obviously directed to serious participants in photography, but it should not be interpreted as *dogma*; each artist must follow his own beacons and chart his journey over the medium's seas and deserts. I wish to dispel here any thought that my approach is rigid and inflexible. I cannot repeat this too often! I have found that many students read descriptions of procedures in a rather strict way, and are then consumed with the effort to produce *exact* relationships between subject luminance values, negative densities, and print values. No matter what he does,

the photographer cannot violate the principles of sensitometry, but sensitometry is a tough discipline and will tolerate a good amount of bending without breaking!

As creative expression has no tangible boundaries and is limitless in content, space allows me only to suggest some typical concepts with examples. It is not possible (or desirable) to tell the photographer what to "see." I can only hint at the ways and means of accomplishing the desired visualized image. My intention is to suggest a fluent yet precise procedure that will provide assurance of the creative control of the image.

Ansel Adams
Carmel, California
September 1982

The Print

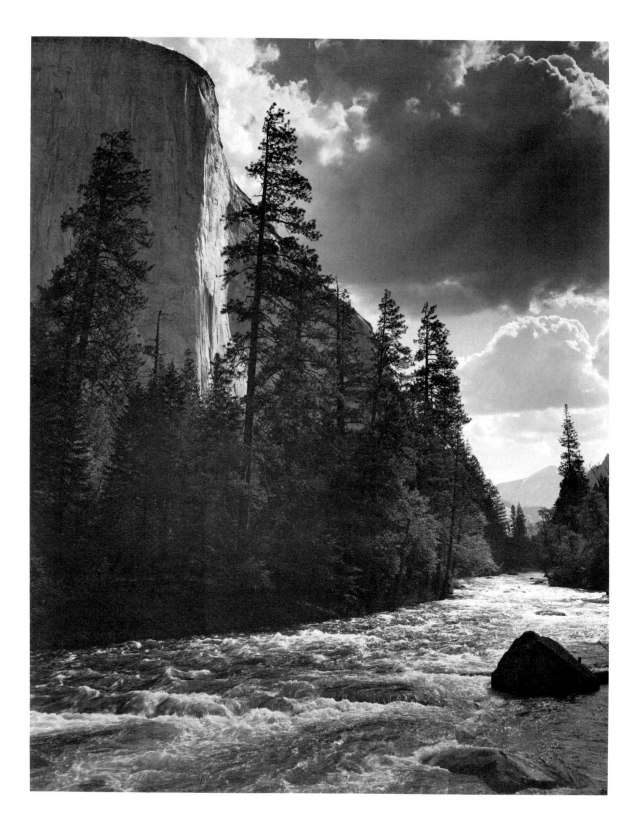

Visualization and the Expressive Image

Figure 1–1. *Merced River, El Capitan, Yosemite National Park.* The shaded forest could have had a little more exposure on the negative, but I was fearful of losing texture in the very bright distant clouds and the sun glint of the river. The forest was in sunlight a few seconds before the exposure was made, and I planned exposure accordingly; but cloud shadow reached the near trees just as I opened the shutter, and reduced the exposure by about one stop. Water-bath development helped, but it could not overcome the underexposure (water-bath processing enhances low values, provided there is adequate exposure to begin with — see Book 2, page 229). The horizon was quite hazy, and printing it darker would only gray the values without enhancing cloud-sky separation. The "soot and chalk" quality of so many landscapes of this kind can be explained by several common factors: underexposure, overdevelopment of the negative, excessive use of filters, enlarging with condenser illumination (see page 21) and papers of too-strong contrast.

I used an 8 × 10 view camera and 10-inch Kodak Wide-Field Ektar lens, no filter. The film was Kodak Super Panchro-Press rated at ASA 200, developed in the Ansco 47 formula using the water-bath method. I printed on Ilford Gallerie Grade 2 developed in Selectol-Soft.

The philosophy set forth in these books is directed to the final expression of the photographer's visualization — the print. The two previous volumes of this series have been devoted to achieving a completed negative, but despite this emphasis, a negative is only an intermediate step toward the finished print, and means little as an object in itself. Much effort and control usually go into the making of the negative, not for the negative's own sake, but in order to have the best possible "raw material" for the final printing.

The making of a print is a unique combination of mechanical execution and creative activity. It is mechanical in the sense that the basis of the final work is determined by the content of the negative. However, it would be a serious error to assume that the print is merely a reflection of negative densities in positive form. The print values are not absolutely dictated by the negative, any more than the content of the negative is absolutely determined by the circumstances of subject matter. The creativity of the printing process is distinctly similar to the creativity of exposing negatives: in both cases we start with conditions that are "given," and we strive to appreciate and interpret them. In printing we accept the negative as a starting point that determines much, but not all, of the character of the final image. Just as different photographers can interpret one subject in numerous ways, depending on personal vision, so might they each make varying prints from identical negatives.

The techniques of printing and enlarging are far more flexible than those involved in the processing of the negative. We generally have only one chance at exposing and developing a negative, and must

thus exert strict controls to ensure a good result. In printing, on the other hand, we reach our final version by progressing through stages of "work" prints. This procedure affords us great latitude for creative variation and subjective control, and we should take expressive advantage of this facility. A great amount of creativity lies in the making of a print, with its endless subtle variations which are yet all tied to the original concept represented by the negative. I have often said that the negative is similar to a musician's score, and the print to the performance of that score. The negative comes to life only when "performed" as a print.

To repeat: *visualization* is the most important factor in the making of a photograph. Visualization includes all steps from selecting the subject to making the final print. I emphasize the importance of practice in visualization — the constant observation of the world around us and awareness of relationships in terms of shape and potential form, value interpretation, and emotional and human significances. All these come together as we develop our ability to visualize, to see as our photographic equipment and materials "see." It is surprising how our vision intensifies with practice.

I have previously stressed the great value of critically examining images other than your own (of all types) and trying to "revisualize" them in your own way. In addition to the considerations of point of view and negative exposure controls, we are now ready to consider the actual image values. Of course, we cannot be certain of the physical limitations of camera location, or of the quality of the light, or even of what our emotional reaction might be in the presence of the actual subject. But we *can* make valuable assumptions and enhance our picture-viewing experience by attempting to revisualize the original subject.

In our own photographs, the negative can be thought of as containing the basic information for the print image. As we observed our subject, we applied *image management* concepts to control the optical image, and the Zone System afforded us a framework for mentally making the transition from subject luminances through negative density values to the desired print values. We paid particular attention to giving adequate exposure to low values in the subject, lest these be underexposed and lack the required detail; nothing can be done in printing to create texture and value where they do not appear in the negative.

Nevertheless, there is no doubt that we can take an inferior negative (inferior in the technical sense, but of expressive significance) and work wonders with it by imaginative printing procedures. We cannot create something from nothing — we cannot correct poor

focus, loss of detail, physical blemishes, or unfortunate composi-
tions — but we can overcome (to some extent) such accidents as
overexposure and over- or underdevelopment with reduction or in-
tensification of the negative and numerous controls in printing.
However, nothing is as satisfactory as a direct line of procedure from
visualization to finished print with everything falling well in place
along the way! The truth is that in a large body of work (even that
of a photographer of great experience) there will be many printing
problems and subtle variations of interpretation.

Thus the print is our opportunity to interpret and express the neg-
ative's information in reference to the original visualization as well
as our current concept of the desired final image. We start with the
negative as the point of departure in creating the print, and then
proceed through a series of "work" prints to our ultimate objective,
the "fine print."

The term "fine print" (or "expressive print" as I think of it) is
elusive in meaning. The fine print represents, to me, an expressive
object of beauty and excellence. The difference between a *very good*
print and a *fine* print is quite subtle and difficult, if not impossible,
to describe in words. There is a feeling of satisfaction in the presence
of a fine print — and uneasiness with a print that falls short of op-
timum quality. The degree of satisfaction or lack of it relates to the
sensitivity and experience of the photographer and the viewer. There
appear to be people who are "value blind," just as there are people
who are tone deaf. Practice and experience may overcome such de-
ficiencies, at least to a degree, and the viewing of original fine prints
is perhaps the best instruction.

A fine print has been generally assumed to have a full range of
values, clear delineation of form and texture, and a satisfactory print
"color." But what a catastrophe it would be if all photographs only
met these criteria! True, a note of pure white or solid black can serve
as a "key" to other values, and an image that needs these key values
will feel weak without them. But there is no reason why they must
be included in *all* images, any more than a composition for the piano
must include the full range of the eighty-eight notes of the keyboard.
Marvelous effects are possible within a close and subtle range of
values.

There are different schools of thought in photography that em-
phasize different palettes of print values, and it would not be appro-
priate to insist on a particular palette for all photographs. Some
photographers stress extreme black and white effects with very
strong print contrasts, perhaps disregarding what the basic mood of

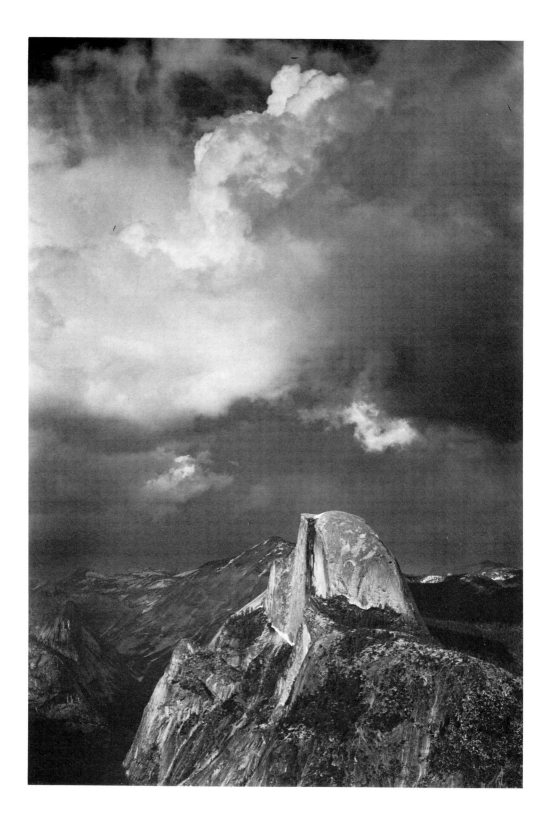

Figure 1–2. *Half Dome From Glacier Point, Yosemite National Park.* While the clouds were actually brighter than the dome, I wanted to emphasize the sunlit dome against the thunderstorm sky. I thus printed the clouds somewhat darker. The southwest shoulder of Half Dome is in advancing cloud shadow, and the Tenaya Canyon on the left is in heavy shadow. About 2 minutes after I made the exposure, the sunlight was off the dome, and this exciting moment was gone forever!

I used a 5 × 7 Zeiss Juwel and 7-inch Dagor lens with Wratten No. 8 (K2) filter. The film was Isopan, developed in D-23, and the print was made on Ilford Ilfobrom Grade 2 developed in Dektol.

the subject or the image itself may be. Others work for a softer effect; Edward Weston's prints are much "quieter" than many realize. Their power lies in the "seeing" and the balance of values Weston achieved. Such contemporary photographers as Lisette Model and Bill Brandt express themselves with great intensity, yet their image characteristics are completely different and not interchangeable. A print by Alfred Stieglitz from 1900 is different in many ways from a print by Brett Weston in 1980, although both are compelling expressions in their differing styles.

I wish to make it clear that the approach to the fine print I profess in this book is not directed to limitations of "straight" photography as defined by the use of glossy papers and emphasis on value and texture. Apart from the fact that I prefer the simplest and most direct revelation of the optical image, I stress these qualities because I believe they are basic to the medium. But it is also true that exploration in all directions of style and craft is not only valid, but often vital for individual creative growth.

One problem in discussing fine prints is the matter of verbally describing intangible qualities that are meaningful only in their *visual* effect. We thus rely on subjective terms like "flat," "tired," "harsh," "chalky," "brilliant," "luminous," and others. Such terms are vague. For example, I find it always necessary to stress the fact that we cannot equate *brilliance* with *contrast.* I recall about twelve years ago measuring the reflection densities of several of Frederick Evans's platinum prints from the late nineteenth century, which conveyed an astonishing sense of brilliance. Much to my surprise, I found that the actual range of reflection densities was only 1.20 (1:16) or less, far lower than I had expected. The apparent brilliance of the prints was explained by the subtle relationship of values, rather than by actual contrast.

For most fine prints the density scale of the negative should be approximately matched to the paper contrast, but the emotionally satisfying print values are almost never direct transcriptions of the negative values. If they are, the print may be informative, but often no more than that. The illusion of "reality" in a photograph relates primarily to the optical image; the actual values are usually far from reality. In some instances the physical or social meaning of a subject may demand only a "factual" representation. But once you admit your personal perception or emotional response the image becomes something more than factual, and you are on the doorstep of an enlarged experience. When you are making a fine print you are creating, as well as re-creating. The final image you achieve will, to quote Alfred Stieglitz, reveal *what you saw and felt.* If it were not

for this element of the "felt" (the emotional-aesthetic experience), the term creative photography would have no meaning.

I do not suggest that there is only one "right" print, or that all prints from one negative must be identical. Consistency may be required when making a number of prints at one time (when printing a portfolio, for example), but as months and years pass the photographer refines his sensibilities and may change the value relationships within an image according to his evolving awareness. I have compared this with the interpretive variations in the performances of music and drama. I think I make "better" prints as time goes on; I find them more intense and revealing. But there are people who prefer earlier printings of some of my negatives, which they apparently find "quieter" and more lyrical. All I, or any photographer, can do is to print an image as I feel it should be printed at a particular time.

I once prepared an exhibition for the University of California, consisting of a group of 5×7 contact prints of general subjects. The prints were very deep in value and richly toned. I had gone through a "high-key" period when I stressed buoyancy and lightness, and I wanted to return to more solid effects. My friends asked if the prints were not rather dark, and several reviewers wrote that the images were interesting but printed heavily. I stoutly defended the prints. They were returned after the show (none sold), and I put them away. When I looked at the prints about a year later, I was appalled at their heaviness — how could I have printed them so dark? In reviewing the situation I realized that I had "tuned" my judgment to an imposed idea: I was determined to get away from a high-key tendency, and I simply went too far, without having the judgment at the time to realize it.

I do not believe that anyone can (or should) attempt to influence the artist in his work, but the artist should always remain alert to comment and constructive observations — they just might have potential value in prompting serious thought about the work. Artists in all media find themselves in "grooves" at times, and some never escape. It is best to leave to critics and historians the dissecting of subtle differences in our work over time. The photographer should simply express himself, and avoid the critical attitude when working with his camera. Only when it is complete should we apply careful objective evaluation to our work.

Print quality, then, is basically a matter of sensitivity to values. What is important for all photographers is that the values of the image suit the image itself, and contribute to the intended visual

effect. Perhaps the best guideline I can give is for you to look carefully at your prints and heed the first impressions that enter your mind.

I have employed an interesting device in evaluating finished prints with students, and sometimes for my own work. The environment of the room in which this demonstration is made should be about 20 to 25 percent reflectance. Set up an easel illuminated by a flood-lamp in a deep, soft reflector; the lamp should be positioned so as not to shine in the observers' eyes. Include a rheostat or a Variac in the light circuit to provide control of the intensity (be sure the device can handle the wattage of the floodlamp used). Set the device at some middle position so the intensity can be either increased or decreased; with a Variac I usually set it at 80, using a lamp that provides illumination on the print of about 100 foot-candles (ft-c). With a typical fine print on the easel, move the lamp toward or away from it until it looks right to the eye.

Then place on the easel a print to be viewed critically. If it appears "heavy," ask the observer to keep his eyes steadily on the print while the rheostat is quickly set to a higher value. The effect on the print is that it suddenly presents the illusion of a "brighter" image. This is only temporary, however, as the observer's eyes rapidly adjust to the stronger light and the print returns to its inherent values. This experiment only hints at the optimum values for this print. With a too-flat, weak print, turning down the rheostat will give a transitory effect of greater richness — an effect that is also temporary. The observer receives a "message," and he may be induced to think more about the values of his prints. I do not know of any better way to suggest possible improvements in print quality.

In many ways, I find printing the most fascinating aspect of black-and-white photography. It is especially rewarding to me, when I am going through the thousands of negatives I have never printed (at least in fine-print form), to find that I can recall the original visualization as well as discovering new beauty and interest which I hope to express in the print.

The procedure I then typically apply is as follows: I examine the negative on a light box, to become aware again of the densities and the information they convey. I may measure the densities on a densitometer to note the range of values, as an aid in selecting a printing paper that matches the negative. This is as far as I would go in pursuing mechanical information for printing. I also visually assess the values in the negative and relate them in my mind to the values I desire in the print. Since my expressive print is never a direct

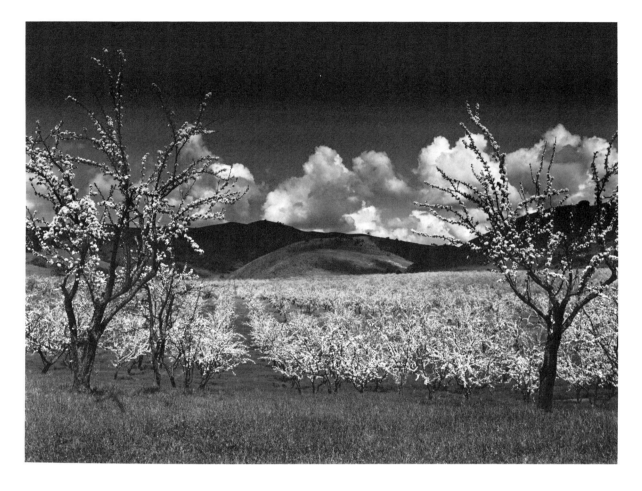

duplication-in-reverse of the negative, this stage is something of a voyage of discovery where I work not only to re-create the original visualized image, but to enhance it if possible.

I then prefer, as my first step in the darkroom, to make a very soft (low-contrast) work print, to reveal in positive values all the content of the negative. I find it preferable to work *up* to the desired contrast from a too-soft proof or first print, rather than trying to guess the final paper contrast and processing from the start. It is more difficult for me to "retreat" to softer printing during one darkroom session than to raise the contrast.

Ideally, if I have visualized the image and if I know my craft, I should always produce a negative that contains the required information and from which I should readily be able to make prints that fulfill the visualization, perhaps with moderate burning or dodging for local control. I can say that I achieve this in the majority of cases,

Figure 1–3. *Orchard South of San Jose, California, c. 1953.* I used an 8 × 10 view camera and a 7-inch Kodak Wide-Field Ektar lens, with a No. 58 (tri-color green) filter. The filter lowered the value of the blue sky as well as the shadows on the hills, and enhanced the foreground green values. The brightest areas of the cloud were placed on Zone VII, and the development was N + 1. The lighting was fairly flat, and no massive nearby shadows were in view.

The printing is rather difficult in that the high values of orchard and clouds must be delicately balanced. This print was made (several years ago) on Agfa Brovira Grade 3, developed in D-72. A more contrasty print would be quite unpleasant, as the impression of light would be lacking throughout.

but in honesty I must also admit that I can make doleful errors of judgment or calculation. The lens extension for close subjects can easily be overlooked, or we can expose for a different film than we are actually using; our shutters can fail inexplicably or our exposure meters go awry. A photographer is reminded that he is human, after all, and his equipment is not infallible. To assume otherwise is folly. It is fortunate that the printing process is as flexible as it is!

I should emphasize, however, that it is important to make the most consistent negatives possible, rather than relying on the flexibility of the printing process to correct for deficiencies in the negatives. With negatives of good general quality the subtleties of the printing process may be applied to correct the occasional fault, and for creative purposes.

Each photographer will inevitably develop his own variations of thought and procedure. The point I wish to emphasize is the dual nature of printing: it is both a carrying-to-completion of the visualized image and a fresh creative activity in itself. As with other creative processes, understanding craft and controlling the materials are vital to the quality of the final result.

You will find it a continuing delight to watch prints emerge in the developer and see that your original visualization has been realized, or in many cases enhanced by subtle variations of value. Naturally you will recall the subject, and it is not easy to divorce your judgment of the print before you from your sense of the subject. You should strive to remember the visualization — what you *saw* and *felt* — at the moment of making the exposure. Do not become trapped in rigid process; the essence of art is fluidity in relating to an ideal concept.

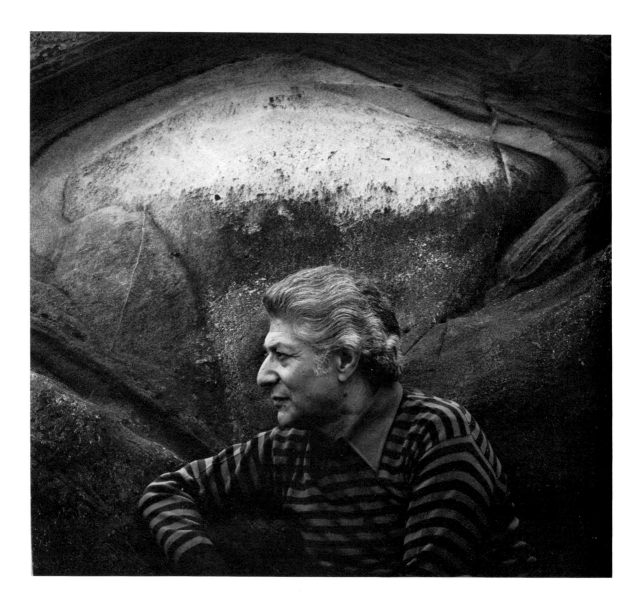

Chapter 2

Darkroom Design and Equipment

Figure 2–1. *Sandor Salgo, Conductor, Carmel, California.* I made this portrait on a very foggy day at Point Lobos. The subject was placed against an eroded rock in a rather narrow and shaded cleft of the seafront. The light was principally from above. The camera was a Hasselblad with 150mm Zeiss Sonnar lens and no filter. I used Kodak Tri-X film, developed in Kodak HC-110, and printed on Ilford Gallerie Grade 3.

Personal preferences should dominate in making decisions about the facilities of the darkroom and workroom. Of course, most photographers fit their darkroom within the existing layout of their homes, and thus it must often be tailored to available space — as well as budget. I was fortunate to be able to design my own darkroom as an integral part of my house. As a result, my darkroom is nearly ideal for me; but I am sure that I could not design the optimum darkroom for anyone else, since individual requirements must always be considered.

Many of the issues of darkroom design were discussed in Book 2 in relation to negative development. Printing uses more darkroom and workroom space than negative processing, however, and the design should thus be based on the largest printing projects you anticipate undertaking. I recommend visiting other darkrooms and constructing simple "mock-ups" of the planned space and equipment positioning.

Among the elements that must be considered is the expected level of use. The darkroom for a professional photographer will be much more complex and costly than one for the amateur photographer, especially if color processing is anticipated. Unless space is severely restricted, I would suggest planning facilities that will allow making 16×20 prints, even if you have no immediate intention to use this size. It is certainly better to build more capability than you now plan to use than to construct facilities that you will quickly outgrow. I also recommend making provision for more utility capacity than you currently need — particularly electricity, hot water, and ventilation — to allow for expanded use.

The darkroom plans described here are, of course, rather ideal and frankly impossible for many people, including those living in urban areas; an entire small apartment in New York may well be smaller than my darkroom and workroom, built in the early '60s as part of my home. Many years ago a friend moved from the West Coast to New York to make his fortune in photography. His first darkroom was a hall closet, with the work stages in vertical shelf sequence, functioning with the aid of a stepladder. His film and print washing area was his bathtub, his print dryer was a clean sheet under his bed. The ideas for work spaces presented here are basic in terms of work-flow and required facilities. How to combine the darkroom essentials into smaller and simpler form requires ingenuity and careful planning. Economy is often an important issue, and may place a limit on the size and furnishing of the darkroom.

THE DARKROOM

See Book 2, Chapter 9

The basic arrangement of the darkroom should, as discussed in Book 2, provide for all "wet-side" processes to occur in one area of the darkroom, with the "dry side" reserved for enlarging and contact printing, film loading, and other operations that must be protected from chemicals and moisture. It is a fundamental rule of darkroom operation *never* to allow anything wet — wet trays, film tanks, prints, or wet hands — to intrude on the dry side.

The simplest layout is a continuous worktable on the dry side, opposite an equally long sink assembly.◁* Making 16×20 enlargements requires 18×22 or 20×24 trays, and ideally the width of the sink should allow for *turning* the trays; thus the sink width should be at least 30 to 32 inches. The length of the sink should allow for the three processing trays (developer, stop bath, and fixer), plus a water tray and a print-storage and washing area. Using five 18×22 inch trays placed lengthwise, with about two inches between trays, and a separate 36-inch washing sink, we thus should ideally have about 14 feet in total sink length. It is certainly possible to reduce this length, but for a professional darkroom, it does become inefficient at some point to skimp on space.

The work space on the dry side could also be about 14 feet long. The vertical enlarger should, for efficiency, be placed opposite

*The ◁ pointer is used throughout to indicate a cross reference given in the margin.

Figure 2–2. *Darkroom floor plan.* The positioning of equipment on the "wet" and "dry" sides should relate to a logical flow of activity: after exposing paper in the vertical enlarger, the developing tray is directly across the center aisle, and processing proceeds in a straight line to the washing sink. A vertical enlarger is shown here in the position it occupies in my darkroom; the vertical easel can be used with either enlarger.

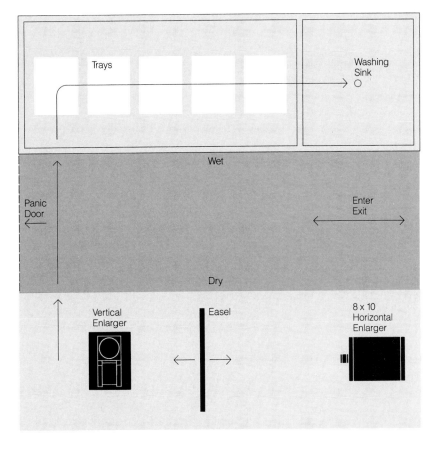

See page 26

the developer-tray end of the sink, with space on one side for fresh paper and on the other for storage of exposed paper. The remaining 6 or 7 feet of work space is then available for a table for negative viewing light, paper trimmer, and film loading, or for a horizontal enlarger. ◁

A fairly high ceiling — 8 feet or more — is helpful for ventilation. In addition, the clearance required for a vertical enlarger at maximum elevation must be considered. If the ceiling height is limited, a low enlarger table may be necessary, but it must not be so low as to make operation difficult or uncomfortable. If the ceiling is slightly too low, an opening might be cut between joists and lined to protect against dust, providing an additional 8 to 10 inches of clearance for the enlarger lamp housing.

The height of sinks and worktable is a personal choice. I am 6 feet tall, and the bottom level of my sinks is 36 inches above the floor, with an 8-inch depth. My worktable is also 36 inches high. Appro-

Figure 2–3. *The darkroom.* A general view from near the entrance of my darkroom shows the 8×10 enlarger and magnetic easel to the left, both on a track system in the floor. Not visible behind the easel are my two Beseler 4×5 enlargers (see Figure 2–6), which may be used in horizontal configuration to project on the far side of the easel. The emergency exit is at the far end of the darkroom, and not visible to its right is a film-loading area, with shelves for storing enlarger lenses and related equipment. This area is separated from the "wet side" sinks by a partition. The most distant sink is large enough to contain three 20×24-inch trays, and the second sink is used for water storage after fixing. The closest sink contains two 16×20 archival print washers and, with the washers removed, can be used to "store" prints up to 40×80 inches during processing. Note the drain holes connecting sinks; these protect against the possibility of overflow if one drain becomes blocked.

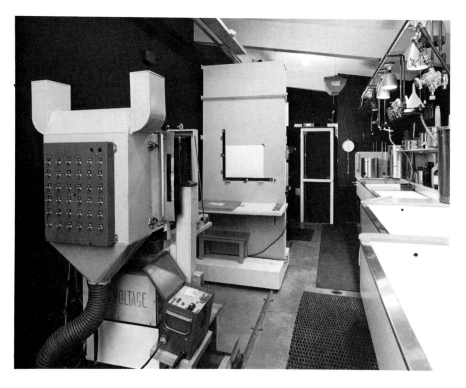

Figure 2–4. *The darkroom.* This view is from the position of the developer tray. The storage for mixed chemicals is visible, and racks overhead hold developer tanks, graduates, funnels. The shelf over the sink holds two digital timers and the Gra-Lab, as well as thermometers, etc. The overhead lights are on pull-chains, which are fully insulated. Note also the racks for trays beneath sink.

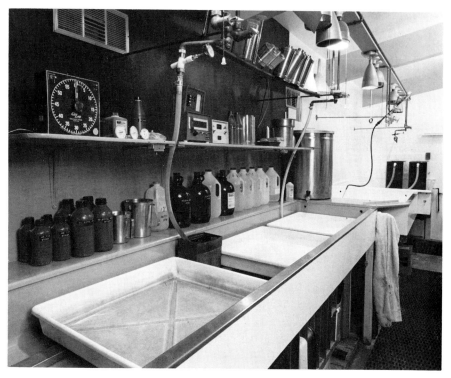

priate height of these surfaces is *very* important; if they are too low, annoying back discomfort can result.

Sinks can be purchased in either stainless steel or molded fiberglass. Or they can be constructed of wood — ¾-inch plywood for sides and bottom — and covered with a thin stainless-steel shell or several coats of chemical-resistant paint or varnish. Fiberglass, epoxy paint, or some marine varnishes work well. Be sure the support structure is strong; a wash sink holding a lot of water will be extremely heavy. The sink bottom must be tilted slightly toward the drain outlet, and trays should rest on movable racks that raise them an inch or two above the sink bottom. A sheet of stainless steel or plastic should also be supported at a steep angle near the washing end of the sink, on which prints can be placed for examination and drainage. Be sure to provide adequate water taps, one or more with temperature control, as discussed in Book 2 .◁

See Book 2, page 197

Your darkroom plans should also include space for storage: shelves above the sink can hold tanks and bottles of mixed chemicals; trays can be stored in vertical racks under the sink; chemicals should be provided shelf or cabinet space, perhaps beneath the "dry side" worktable; other compartments or shelves under the worktable are useful for printing frames and enlarging easels, towels, and miscellaneous equipment. However, film, negatives, paper, and equipment such as the densitometer and dry-mount press, should be stored *outside* the darkroom. Be sure that all shelves and cabinets are constructed above floor level, to allow cleaning underneath. If a floor sump is installed, the entire floor can then be hosed down, a great aid in controlling dust and cleaning up chemical spills; a sump is of great value should flooding occur.

THE WORKROOM

The workroom should include provision for print drying racks, paper cutter, dry-mount press, densitometers, and sufficient table area to accommodate trimming, mounting, mat-cutting, spotting, etc.

For drying prints, I prefer horizontal racks with screens made of plastic window-screen material. These will not rust or absorb chemical contaminants, and they can be hosed off at frequent intervals to remove dust and possible accumulation of chemicals from insufficiently washed proof prints, etc. For good air circulation the racks should be about 4 inches apart, and open on all sides; they should slide freely on the support frame for easy access to the prints. Be sure

Figure 2–5. *The workroom.* The facilities for dry-mounting and overmatting are shown. The counter space accommodates two large dry-mount presses, space for print tacking, paper cutters, and densitometers. Storage space visible beneath the counter holds small sizes of mount board and corrugated board, with larger sheets stored beneath the large worktable visible in the lower left corner. The shelves contain finished prints for mounting, plus supplies such as tape, envelopes, mounting tissue, etc.

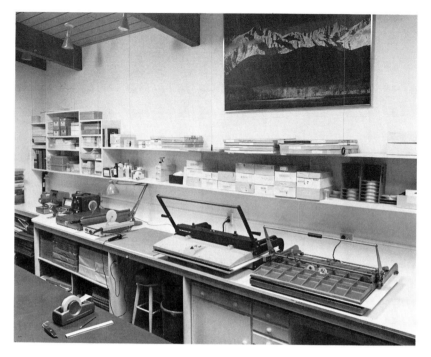

to design racks large enough for several prints of the largest size you anticipate handling, and sufficient for the volume of a major darkroom session with normal-size prints. It is usually best to reserve the bottom rack for proofs and work prints that may not have received full archival treatment; if any residual water drips off such prints, it should not be allowed to fall on other screens, or on fully treated prints.

The worktable should be about 30 to 36 inches wide and long enough to accommodate a dry-mount press, print trimmer, and densitometer, plus the print mounting and overmatting operations. Be as generous as space permits in determining length; extra length is helpful and gives greater freedom of movement. The surface of the table should be Formica or similar material, and should project at least 6 inches beyond the cabinets or supports underneath; a thin metal edge molding is advised, and a "cove" strip at the wall junction. Storage shelves for mounting supplies and so on can be built beneath the table. In addition, space for storing camera equipment and lights, paper and films, prints and negatives should all be accounted for in the plan. Fully archival storage of negatives and prints requires cabinets of metal, not wood, as well as acid-free envelopes and controlled temperature and humidity. ◁

See pages 165–167

The workroom must be provided with adequate electrical supply; a large dry-mount press alone can consume about 1700 watts, and may require a separate circuit. Extra outlets should be provided for possible future needs, in addition to those for the press, tacking iron, viewing lights, densitometer, and any other lamps or fixtures. Be sure to use grounded wiring and grounded connections for all equipment throughout the darkroom and workroom! In addition, the workroom should be furnished with good lighting and ventilation. I recommend consulting an electrician to plan for present and future needs. You should have plumbing and electrical circuits installed by licensed experts, and be sure everything meets building code standards; otherwise insurance coverage may be invalidated.

ENLARGERS

See page 26

The enlarger is a photographer's most important piece of equipment next to his camera and lenses. Many fine enlargers are available for 35mm, 120, and 4×5 negatives; an 8×10 enlarger can often be assembled rather than purchased, as discussed below. ◁ Several important considerations arise when choosing an enlarger, including:

Size. The enlarger should be chosen for the largest negative you expect to use in the foreseeable future. A 4×5 enlarger is probably a worthwhile investment, unless you are quite certain your work will always require only smaller formats. Even with roll-film sizes, however, a 4×5 enlarger has the advantage of ensuring uniform light distribution over the entire negative area; enlargers used with the largest negative they are designed for sometimes have a distinct and

See page 20

troublesome "fall-off" at the edges and corners. ◁

Capability. If you are printing color, or may wish to in the future, choose an enlarger that at least provides a drawer above the negative to hold color-printing filters. You may want to acquire one that permits addition of a "color head" with filtration controls included. If you expect to make very large prints, you may wish to consider an enlarger like the Durst Laborator which allows the baseboard to be adjusted from floor to table-height position, or the Beseler which can be tilted 90° for horizontal projection.

Construction. Any motion or vibration during enlarging will reduce image sharpness. Be certain the enlarger you buy is as strong and

Figure 2–6. *Vertical 4 × 5 enlargers.* The two enlargers are Beseler models. The one on the left has the Horowitz stabilizer for a special Ferrante double cold-light grid. The two-dial control unit for the original Codelite (see page 26) is located between the enlargers, with the stabilizer control on top of it. The enlarger on the right is a standard condenser unit, which also accepts the Beseler point-source lighting system visible on the shelf at rear. The walls around the enlargers are painted flat black, and the telephone button lights are covered with black tape when the darkroom is in use (this is especially important when loading or processing film). To the left of the point-source light is the electronic metronome, which has two "beepers" in the room.

The Beseler enlargers have an adjustment which allows positioning the lamp housing at varying distances above the negative. The closest distance from the negative is recommended for diffused light sources. With condenser illumination the light is moved closer or farther from the film plane according to the negative size, to concentrate the light on the image area.

See pages 24–26

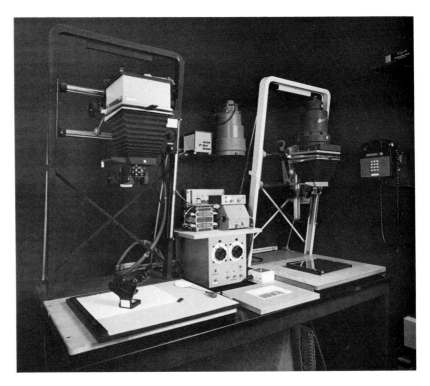

rigid as possible; as with tripods, the usual rule is the heavier the better. The problems of vibration and alignment are discussed below. ◁

The installation of the enlarger must be carefully considered. The bench or table it rests on should be quite strong and secure to minimize sway and vibration. The walls near the enlarger and easel should be painted *matte black* to minimize reflection onto the paper during exposure. In addition, the enlarger should be grounded so that electrostatic charges that attract dust are minimized, and, of course, for safety.

ENLARGER ILLUMINATION

In my early days in photography (around 1918–1920) my enlarger light source was a large white flat-enameled reflector set outside my darkroom wall. This reflected light from the sky to a ground-glass diffusing screen, through a shielded window. The enlarger was an old 8 × 10 camera mounted flush against the window frame, and the easel moved in guides on the table. The light quality was beautiful,

and fairly "fast." Shifting clouds caused grave troubles, of course, but thick fog or heavy overcast gave surprisingly consistent results over fairly long periods.

Today, tungsten bulbs are the most common light source. These may be adequate for small negatives, but other lighting systems are often preferable, especially for 4×5 or larger sizes. I use "cold light" mercury vapor lamps ◁ for enlarging all my negatives, from 35mm to 8×10; I find the print quality superior with such illumination (diffusion dichroic color heads available with some enlargers have qualities similar to cold-light sources).

See pages 22–23

The optical system also has a significant effect on the characteristics of the final enlargement. A *condenser* system focuses the light in a collimated beam above the negative, while a *diffusion* system, as its name implies, delivers diffused, uncollimated light on the negative. The condenser system provides high image acutance, but it also tends to emphasize grain, dust, or physical defects on the negative. Contrast is relatively high with a condenser enlarger, and there is often a loss of separation above Value VII caused by the *Callier effect*.

The Callier effect relates the amount of light "scattered" by the particulate silver emulsion with the density present. With the collimated beam from a condenser enlarger, the light will pass relatively undisturbed through a low-density negative area, but higher density causes a larger proportion of the light to be scattered (in addition to the light absorbed in a normal manner by the density). As a result, a negative often will show "blocked" high values when enlarged with a condenser system.

This effect is minimized with diffused-light enlargers (or with contact prints made by either collimated or diffused light). In a diffused-source enlarger, the light will be about equally diffuse whether it passes through a high- or a low-density area, and the scatter caused by high negative density produces no significant effect.

Thus with collimated light the high densities of the negative become, in effect, even higher, and the *contrast* of the projected image is increased compared with the image produced by diffuse illumination. This suggests that negatives which are to be enlarged with condenser light should be developed to a lower contrast (thereby having a lower density range) than negatives to be enlarged with diffuse light. However, the reduced development needed to improve the separation of high values with a condenser enlarger causes some loss of separation in lower values.

It is difficult to give specific rules on this effect because of the design differences from one enlarger to another, and because of the

See Book 2, page 220

characteristics of various negative emulsions. However, the following guidelines for negative density ranges, discussed in Book 2, ◁ should be approximately correct:

Table 1.

	Diffusion enlarger, negative density above filmbase-plus-fog	Condenser enlarger, negative density above filmbase-plus-fog
Value I	0.09 to 0.11	0.08 to 0.11
Value V	0.65 to 0.75	0.60 to 0.70
Value VIII	1.25 to 1.35	1.15 to 1.25
Approximate desired density range from Value I to Value VIII	1.20	1.10

It is unfortunate that many enlargers have light sources that are barely adequate in diameter to cover the largest negatives for which the enlargers have presumably been designed. For 4×5 negatives, a condenser or cold-light head that is somewhat *larger* than the negative is helpful to ensure uniform coverage. The uniformity of illumination may be improved in some cases by inserting diffusing sheets of plastic or glass in the lighting system; some enlargers have a filter tray above the negative stage where heat-resistant diffuser material can be placed. The diffuser must be positioned far enough from the negative plane that its texture or dust on its surfaces cannot come into focus, even with the lens stopped fully down. The overall intensity of illumination will be lowered by this method, but the

See page 110

improved light distribution should reduce the need for edge burning. ◁

You should check for even illumination by exposing a sheet of paper with the negative carrier empty. First focus the lens with a negative in place, and then remove the negative. Give sufficient exposure to obtain about a middle-gray value. If the developed sheet is lighter at the edges or corners than at the center, the illumination falls off. This problem can be reduced by using long-focal-length

See page 29

lenses, although this may create other problems. ◁

I consider the effect of diffuse enlarger illumination to be considerably more agreeable than that of condenser systems. Diffuse illumination does not distort the negative-density scale and holds more subtle distinctions in the high values of the print; it also minimizes the appearance of dust spots or emulsion defects. Diffuse-illumina-

Figure 2–7. *Enlarger light sources.*

(A) A diffusion enlarger has a translucent material between the lamp and the negative; a cold-light system uses a cathode tube or grid, and usually includes a sheet of diffusing material near the light. The diffuse light yields prints that have long scale and subtle high values.

(B) Condenser enlargers use a lens system to "focus" the light on the negative. Prints from condenser enlargers may appear somewhat sharper because of the higher acutance of the grain edges, but this system also raises the contrast of the print and emphasizes defects in the negative. High values in the print (relating to high densities in the negative) frequently appear "blocked" when condenser illumination is used.

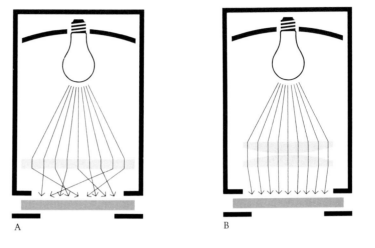

A B

tion enlarging yields a print scale that is almost identical to contact printing. It should be noted, however, that the Callier effect is less pronounced with modern thin emulsions than with earlier films; with dye color negatives, there is practically no light-scatter effect since the dye structure is not particulate (composed of relatively large particles). Some photographers who work with 35mm choose a condenser source because it helps retain the illusion of sharpness at the high magnifications usually required in enlarging small negatives, even though it also accentuates the grain.

Many enlargers incorporate elements of both systems. The types of enlargers can briefly be described as follows:

Condenser Enlargers

The most highly collimated light is from "point-source" lighting, which utilizes a very small but exceedingly brilliant lamp together with specially designed condenser lenses. The enlarged image has maximum sharpness and contrast, and also painfully reveals physical defects and grain of the negative.

More typical are condenser optical systems combined with a conventional tungsten bulb. A clear glass bulb provides light from a larger area than the point-source lamp, and thus gives less severe contrast. If the lamp is frosted, a further reduction in the contrast of the image occurs.

Some condenser optical systems require adjusting for different negative sizes to ensure that the light is focused on the film area and uniform. You should consult the manufacturer's instructions, and be sure to make the adjustment if necessary before using the en-

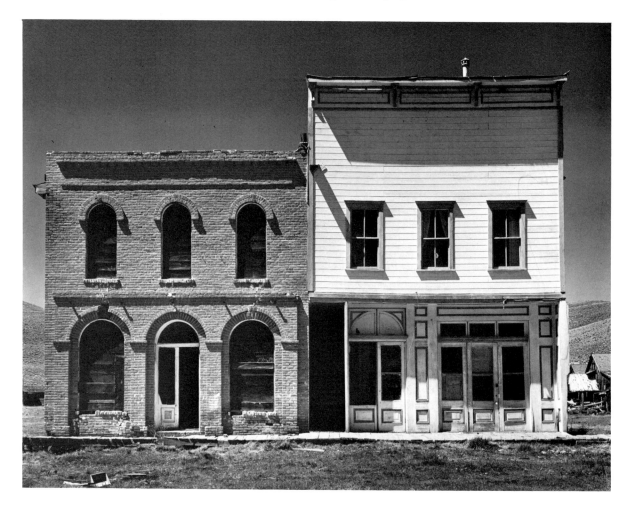

larger. It is also important that the enlarger light bulb be of the manufacturer's recommended size, and precisely centered above the condensers.

Diffused-Light Enlargers

The most common diffusing light source today is the "cold light," a tube or grid located behind a diffusing screen. The advantage of a cold-light source is that it gives a smooth diffused quality of illumination, transmitting the full density range of the negative with little or no interference from the Callier effect, and it produces little heat. Such lighting requires a high-voltage transformer, and the tube size and voltage determine the light output. I have been advised by

Figure 2–8. *Bodie, California.* This represents a typical enhancement of values. Bodie is a ghost town and a very hot place, with shimmering bleak sunlight. A realistic image of this subject would show a saturation of light, and the effect would be rather drab. I had several choices of visualization: a soft, high-key interpretation, a straightforward "literal" photograph, or a full-scale composition of values from black to white. The last appealed to me most.

I placed the stairwell (center) on Zone II, but the strong orange-red filter (No. 23A) lowered it to Zone I and below. A faint trace of the stairway is visible in the fine print. The glaring white wall is accentuated by the empty black "holes" of the windows, and the mid-afternoon light accentuated textures. The clapboard wall is actually a weather-beaten light gray and fell on Zone VII½, with normal development given the negative. A brilliant print is obtained on Kodabromide Grade 4 or Oriental Seagull Grade 3 papers.

The camera was a 4×5 view camera with 7-inch Dagor lens. I used Super-XX in the 5×4-inch Graflex roll-film format (no longer available), and developed it in DK-50 in a deep tank.

Dr. Paul Horowitz, a physicist at Harvard University who designed the cold-light stabilizer discussed below, that many solid state digital timers cannot be used safely with cold-light sources because the high voltages tend to produce surges of current that can damage the timer; I suggest contacting the timer manufacturer if you plan to use such a timer with a cold-light source.

Even the best cold-light tubes are sensitive to voltage changes and to temperature, and it is difficult to maintain constant output over a period of time. After turning on the light, its output usually reaches a maximum in about 5 minutes, and thereafter it will gradually diminish as the temperature rises. We therefore must follow a plan of allowing a cold lamp to warm up for several minutes, and then turning the light off and on every few minutes (at regular intervals) throughout the printing session to be sure of consistent output.

A device that greatly improves the stability of cold-light units was developed by Dr. Horowitz. It is a light-output stabilizer that monitors the lamp intensity and automatically adjusts it. Unlike voltage stabilizers, which monitor and adjust the incoming line voltage without regard for the actual light intensity, this unit achieves nearly perfect stability of the light output itself. I have found that it vastly improves the repeatability of exposures when making multiple prints or applying test exposure times. The stabilizer unit, which can be adapted to most cold-light heads, is sold through Zone VI Studios (Newfane, Vermont).

Excellent diffused illumination can also be obtained with tungsten lamps, by using appropriate diffusing material between lamp and negative. Or the lamp may be placed in an "integrating sphere" reflector above the negative; the lamp itself is shielded by a small diffusing disc, and a sheet of diffusing material is usually located above the negative to ensure an even field of illumination. Note, however, that tungsten lamps produce heat which, if excessive, can damage the negative or occasionally even crack condenser lenses and glass sheets. Any diffusing materials added to a tungsten lighting system must be capable of withstanding a certain amount of heat, and, of course, adequate ventilation for the lamp housing is *essential*. The heat produced by tungsten lamps frequently causes larger negatives to "buckle" and go out of focus; refocusing after the negative has buckled will be necessary.

A conventional voltage stabilizer can be a very useful addition to a tungsten lighting system — especially if it is to be used for color printing, where a change of voltage produces a marked change in the color temperature of the light output.

Negative Carriers

The negative carrier usually consists of two flat metal pieces with an opening the size of the image. For 8 × 10 negatives I use a negative carrier that sandwiches the negative between two sheets of glass to hold it flat. For 4 × 5 or smaller negatives I recommend a glassless negative carrier, which avoids several potential problems of the glass variety. For one thing, the two glasses provide four surfaces (in addition to the two sides of the negative) on which dust can collect. All surfaces must be carefully cleaned each time a negative is placed in the carrier.

Another annoying problem that may occur with a glass negative carrier is the appearance of Newton's rings when the film is pressed against the glass. These are concentric rings of irregular shape that resemble the iridescent patterns of an oil slick on wet pavement. They are caused by the interference effect of light reflecting within the extremely small space between the glass and the negative base. This does not occur between the glass and the emulsion side of the negative. Changing the pressure between glass and film may eliminate them, since with totally uniform contact between negative and glass, no rings occur. Newton's rings are aggravated by high humidity, and thus slightly heating the glass may help. I have found that the "anti-Newton-ring" glasses may give a slight textural effect that is disturbing.

STRUCTURE AND ALIGNMENT OF ENLARGERS

After installing any enlarger it is very important to be sure that it is precisely aligned. The negative plane must be parallel to the baseboard, and the lens axis must be perpendicular to both (meaning, in practical terms, that the lensboard must be parallel to them). It is too often assumed that enlargers arrive precisely aligned and remain that way, but such may not be the case; there are several possible reasons for misalignment, including sloppy assembly at the factory or the strains of shipping and use.

You can discover misalignments and estimate their severity using a good protractor level, which has the advantage of allowing the degree of error to be determined. Omega makes an adjustable level designed specifically for checking enlarger alignment. Correcting the alignment is another matter, and may require the attention of a good mechanic, although often simply adjusting and tightening all structural screws can solve the problem. The alignment should be

checked whenever you have difficulty securing sharp focus over the entire image area.

First bring the baseboard to precise level in both horizontal directions. If the bench on which the enlarger rests is not itself level, the enlarger can be "shimmed" with appropriate thicknesses of plain non-corrugated cardboard, or support screws can be added to permit leveling. Next, if the column is vertical, check that it is precisely 90° to the base in both front and side directions (although some enlargers have a column or frame that is tilted forward, not vertical). If the column is accurate, the next step is to check the level (in both directions) of the negative carrier. The design of the enlarger may make this difficult to measure, but we can usually insert in place of the carrier a stiff metal rod that projects far enough to be checked with the level. For the lens, we can check the level from either the lensboard (if it is accessible) or by placing the level across the lens bezel in both directions. Test the levels with the enlarger head at several positions on the column. If all these levelings are accurate, the enlarger is aligned.

Vibration

Engineers have told me that vibration is one of the difficult problems to overcome in design. It can appear with different "loading" (the weight of the supported components), or with sympathetic vibrations (resonance) that can occur in one or more elements of the design. In Book 1 I described a heavy and sturdy tripod I have that is capable of supporting an 8×10 camera with ease; in spite of its massiveness, if I attach my Hasselblad to it, the operation of the mirror sets up a sympathetic vibration that can affect the clarity of the image! The same camera, placed on a much lighter tripod, creates no vibration. For the same reason, an enlarger must be checked for vibration, even if it appears sturdy.

Vibrations can be caused by machinery operating nearby, weak flooring, impact (slamming doors or bumping the enlarger bench), etc. I recall a friend in New York who had his darkroom in the basement of an apartment near a subway; when trains passed, the vibrations were such that he could not expose an enlargement without getting unsharp images. Within the darkroom, ventilator fans may cause harmful vibration, and thus they should be located as far from the enlarger as possible. If a cooling fan is attached to the enlarger lamp housing, it should be mounted separately and connected via a *flexible* air hose. Vibrations can sometimes be traced by viewing a negative through a grain magnifier while turning on and off the fans, etc., that are suspected of causing the problem.

The enlarger itself may be prone to sway slightly, and the period of vibration can be rather long. When the negative is inserted or other operation performed, a vibration can be set up. We must be sure that once we have focused and clamped the adjustments in place, the vibration is allowed to die down before the exposure is made. My method with the horizontal enlarger is as follows: After focusing, I lean a dark card against the enlarger lens, blocking the light path. To begin the exposure I pick up the card but hold it in front of the lens a few moments to allow any vibration to die down. I then move the card quickly from the light path, and replace it when the exposure (including all burning and dodging) has been completed. I am very careful not to touch the enlarger, its support, or the easel at any time during the exposure.

See page 48

For years I have used a Beseler 4×5 enlarger, and I find it very satisfactory. Its frame and construction are quite strong, and the head assembly can be tilted for horizontal projection when making very large prints. I have the condenser head (which I use infrequently for small negatives), an Aristo cold-light head, a Beseler point source, and modified version of the Ferrante "Codelite." The Codelite consists of two grids, one of which gives a greenish light and the other a bluish light, with each grid controlled by a rheostat. Thus when printing with variable-contrast papers, ◁ the contrast of the print can be controlled by adjusting the output from the two lamp grids; the green light gives the softest result, and the blue light provides maximum contrast. Intermediate contrast is achieved by combining the two in various settings. Blue light alone is used with conventional graded papers. Since I now seldom use variable-contrast papers, I have had the Codelite adapted so that both tubes are blue, with only their intensities adjustable. I have also had a special oversize lamp unit made to ensure uniform coverage. Note that the Horowitz stabilizer is not usable with the variable-contrast Codelite system.

THE 8 × 10 ENLARGER

For negatives larger than 4 × 5 I have had built a horizontal enlarger from an old 11×14 studio portrait camera. It is often far more economical to build an 8 × 10 enlarger than to purchase one, since the basic structure can be an 8 × 10 or 11×14 camera (without impairing its use as a camera). The camera and lamp assembly can rest hori-

Figure 2–9. *The 8 × 10 enlarger.* My enlarger was adapted from an old 11 × 14-inch studio portrait camera in 1936, and has been improved and added to over the years. Simpler enlarging cameras can, of course, be adapted from flat-bed view cameras, or a good carpenter-mechanic can build one to specifications. Professional enlargers in 8 × 10 or larger formats are available, new or used, and are expensive.

My enlarger rests independently on tracks mounted in the concrete floor. The camera itself has limited bellows extension, so the lensboard shown is adapted for lenses of long focal length. A Color-Tran control box on the left allows the bank of tungsten lights to be set at varying intensities; each of the 36 lamps is on a separate circuit, cross-wired so they relate to the projected image (the upper-right switch controls the lower-left lamp, etc.). Cold-light tubes replace the tungsten light when required, controlled by an off-on switch and the Horowitz stabilizer (which maintains a remarkably constant intensity of light under voltage changes and tube heating).

While the camera is sturdy, I found it advisable to add an additional support; the adjustable rod on the right serves to minimize vibration. The wall behind the enlarger is flat black. The light-gray parts of the enlarger do not reflect perceptible amounts of light, but it has been my intention for many years to paint them black as a matter of principle!

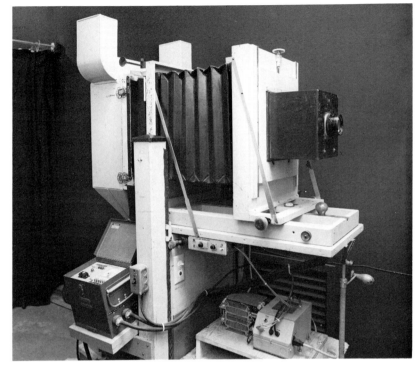

zontally on a secure shelf or table, facing a vertical easel (see Figure 2–3). The camera and lamp housing must, of course, be firmly supported; the supporting frame for my 8 × 10 enlarger rests on triangular tracks in the cement floor that also support the vertical easel. An alternative is to suspend the camera assembly and easel from strong overhead rails; this arrangement is somewhat simpler to operate and saves floor space for storage and other uses. Whether a floor- or ceiling-mounted enlarger track is best may depend on the nature of the building: if there is a wooden floor above with people walking on it, vibrations are likely to be troublesome with any ceiling-mounted system.

The lighting unit can be assembled by a good electrician, using a mercury-vapor grid, a bank of closely spaced fluorescent tubes, or even a simple bank of tungsten bulbs. Especially with tungsten bulbs, a forced-air ventilation system is needed, and the fan must be isolated from the enlarger to avoid vibration. I have the fan mounted on a separate small "truck" on rubber wheels, with a flexible air duct connected to the lamp housing. This unit follows the enlarger on its tracks.

For many years I used a bank of thirty-six 50-watt tungsten reflector lamps in my horizontal enlarger, with a diffusing screen of

Figure 2–10. *Light sources for the 8 × 10 enlarger.* The 36 tungsten reflector-floodlights are located in a hinged back with individual switches for each bulb at the rear (visible in Figure 2–3). The lamp housing is attached to a fan by a flexible hose at bottom, and the two prominent air outlets can be seen at top. Note that the outer rows of lights are about one inch closer to the negative plane; this slightly increases the light intensity near the edges of the negative and minimizes possible fall-off of illumination.

The two-grid cold-light system slips in place in front of the tungsten bulbs, with the latter, of course, switched off. It produces strong bluish light, which considerably reduces the printing exposure times.

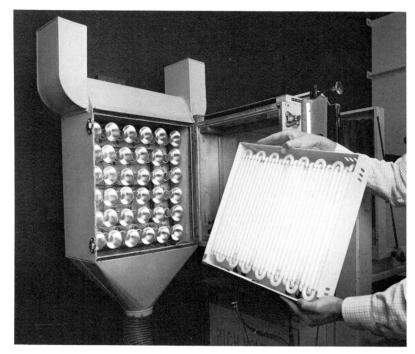

See page 102

See page 48

opal glass. Each of the bulbs was on a separate switch, so I was able to deliberately hold back exposure of broad areas of the negative to give them approximate "dodging." ◁ I have since replaced this unit with a powerful cold-light system that greatly reduces exposure times, thereby avoiding the reciprocity effect. ◁

The easel for horizontal projection can be a large panel that moves on the same tracks as the enlarger assembly. Adjustment of enlargement size is accomplished by moving either the easel or the enlarger. The dimensions of the easel should be larger than the greatest dimensions of enlargements to be made, to allow placement of the paper in various positions in the full image field. (The maximum projection size possible in the available space for a particular negative size and lens focal length can be calculated using the lens formulas in the Appendix to Book 1.) To ensure that the easel is aligned, it must be positioned so that the lens axis of the enlarger is centered on it and perpendicular to it.

I now use a vertical easel measuring 44 × 80 inches, with adjustable rods at the top to hold 20- or 40-inch-wide rolls of paper. The easel is precisely vertical and moves along the tracks powered by a small electric motor. It is positioned between my 8 × 10 enlarger and the smaller Beseler unit, and thus it can be used with either enlarger. The easel was constructed of particle board and covered with thin

rolled-steel sheets attached to both sides with epoxy adhesive. The metal was painted about 20-percent gray. Paper is held in place with magnetic strips. I have a magnetic corner piece that ensures accurate positioning of two edges of the paper, with ⅛-inch margins; the free edges are then held with additional magnets.

ENLARGING LENSES

See Book 1, pages 64–65

Enlarging lenses (or "process" lenses, which are similar) ◁ differ in quality and results to a greater degree than is sometimes realized. In earlier years, an often-heard bit of advice was to enlarge using the same lens with which you made the negative. The principle was that any corner fall-off in illumination that occurred in enlarging would be counteracted by the fact that the negative had been exposed with similar fall-off at the edges. However, using a camera lens for enlarging is not recommended: the qualities that make a good enlarging lens are not the same as those for a good camera lens.

See Book 1, page 55

In selecting a lens, you must first be sure that it is of appropriate focal length for the format. As with the "normal" camera lenses, ◁ the standard focal lengths are 50mm for 35mm negatives, 80mm for $2\frac{1}{4} \times 2\frac{1}{4}$, 150mm for 4×5.

See Book 1, page 76

A requirement for a good enlarging lens is that it have a flat field, ◁ that is, it must focus uniformly a flat subject (the negative) on a flat plane (the printing paper). Some curvature of field can be tolerated in most camera lenses, but not in enlarging lenses. This flat-field imaging must occur at focus distances normally encountered in enlarging; camera lenses are usually corrected for subject distances of about 30 feet, but for enlarging much closer focus distances are normal.

The lens must also "cover" the negative area with minimal fall-off at the corners. Using a lens of longer focal length than "normal" will help avoid this fall-off of illumination; it will also help ensure good definition at any aperture, since only the central portion of the lens's field of view, where resolution is highest, will be used. A longer-than-normal lens will require more distance from lens to easel for a given enlargement size, however, and this factor may place a practical limit on the useful focal length. Remember also that a long lens may require more extension than provided by the enlarger bellows.

See Book 1, pages 52–53

It is important that the lens be color-corrected, and free of significant lens aberrations. The lens must also not have focus shift ◁ (the

tendency of a lens to change focus when stopped down — some good camera lenses show this property when used for enlarging), or it will require a readjustment of the focus at the aperture used for exposure.

Coating is very important, since this greatly enhances contrast and acutance in the image. An uncoated or dirty lens may demand as much as one full paper-grade more contrast for the expected results. Flare ◁ and loss of contrast are also caused by reflections within the enlarger, reflections from the walls near the enlarger, and light leaks from the enlarger itself. All these must be carefully checked to avoid degraded print quality. ◁

See Book 1, pages 36, 69

See page 75

The enlarging lens, like camera lenses, will usually give its optimum image sharpness if stopped down two to three stops from the widest aperture. A quite small aperture may be necessary to maintain overall sharpness if either the negative or paper has a tendency to buckle.

SAFELIGHTS

See Book 2, page 21

General purpose (graded) photographic papers are intentionally made to be sensitive to blue light only (comparable to the earliest photographic plates ◁) so they can be used with relatively bright "yellow" safelight filters. Variable-contrast papers, such as Kodak Polycontrast or Ilford Multigrade, are sensitive to a broader range of colors, and may require other safelight filters. There are also orthochromatic and panchromatic printing materials, and these must *not* be used with yellow safelights. The most common orthochromatic darkroom materials are high-contrast "litho" films (such as Kodalith) which require use of a *red* safelight. Panchromatic papers (e.g., Kodak Panalure) are made for black-and-white printing from color negatives; such papers must be handled in total darkness, or under the weak dark amber safelight specified (Kodak No. 10).

There are a wide variety of safelight types, from inexpensive plastic units that screw into an ordinary light fixture to the powerful sodium-vapor lamps. I do not consider the "ruby lamps" or some molded plastic units which purportedly contain the "filter" in the glass or plastic itself, to be truly safe. I recommend instead safelights that are designed to accept the Kodak filters, as these filters are made to high standards and are given recognized designations that can be used to match the filter with the paper or film.

The standard Kodak filter for black-and-white contact and enlarging papers, including Kodak's variable contrast papers, is the light amber filter designated OC. Most papers from other manufacturers are compatible with this filter, but you should check the manufacturer's specifications, particularly with variable-contrast paper. The filter is designed to be used with a 15-watt bulb, and located at least four feet from the paper. If the safelight is used indirectly, by bouncing off walls or ceiling, a 25-watt bulb may be used. Using a bulb stronger than recommended is likely to cause fogging, and the heat may also damage the safelight unit.

For large darkrooms, several safelights may be installed at convenient locations. One should be in the vicinity of the enlarger, positioned so that the shadow of the enlarger (or your own shadow) is not cast upon the easel, and another one or more over the sinks. It can be convenient to have a safelight directly over the developer tray, but in that case I recommend that it be on a separate switch of the "pull cord" type, so it can be turned off to avoid possible safelight fog when developing times are long; such pull-cords *must* contain electrical insulators for safety.

A high general level of illumination can also be obtained with a sodium-vapor lamp, such as the one manufactured by Thomas Instruments. These lamps make use of a bulb that emits almost exclusively wavelengths that do not affect a blue-sensitive emulsion. They can consequently be quite strong, and a single Thomas unit is often sufficient for an entire darkroom. The lamp is suspended from the ceiling and directs light upward, so it is reflected and distributed throughout the room (the ceiling must be white or very light gray). I must advise caution, however; I have found that this light does cause fogging with some papers if the illumination level is too high or with prolonged exposure of the paper. You may need to be especially careful with variable-contrast papers. Be sure to test before printing.

Safelight Fog

One of the most common causes of "depressed" high values, first noticeable in very high values or highlights (the pure white areas of the image), is safelights that are too strong, or otherwise not "safe." Safelight filters can deteriorate over time without visible change and begin passing some actinic light. The disintegration is hastened by over-strong or too-hot lamps. You should discard any safelight that shows signs of uneven density or other deterioration. In addition, safelights near enlarger and sinks should not be too close

Figure 2–11. *Safelight test.* Two sheets of photographic paper were given sufficient exposure to achieve a print of about Value VII, with an opaque rectangular card placed on each. One print was developed for 3 minutes in total darkness (the left section) and the other was developed for the same time under a strong safelight. The prints were cut in half and mounted together for comparison purposes.

In the left-hand section, which received no safelight exposure, the central area is pure white against the Value VII surround. In the right-hand section the area that was covered is slightly grayed. The surrounding value is considerably deepened in tone.

This demonstrates what can occur under unsafe or too-strong safelights. Once the enlarging exposure has been made the paper is, in effect, slightly "pre-exposed" (see Book 2, p. 87), and therefore highly sensitive to safelight illumination. Safelight fogging of the highest values of the image, such as pure white specular reflections from water, metal, etc., will give a depressed quality to the image. Our eye is very acute in evaluating subtle high values. A good number of the prints I see have this "safelight" effect.

to the paper; follow the manufacturer's recommendations as a guideline to determine the appropriate positioning and bulb used. The safelight should be so chosen and located that a print can withstand 5 minutes of continuous exposure without fogging. For further protection the print should be kept face-down for the greater part of the developing time, while agitating constantly; examine it at intervals only as needed.

Whatever safelights are installed, I strongly urge you to make a test of their "safety." One useful and sensitive test is to make a test print on the fastest paper you ordinarily use. Pre-expose the paper under the enlarger sufficiently to produce a very light gray — about a Value VII. Then place an opaque object (a coin will do) over part of the paper and leave it at a normal distance from the safelight for two minutes. When developed, the outline of the coin should not be detectable. Repeat the test, adding one or two minutes to the safelight exposure each time, until you first see the outline of the coin. The longest exposure that yields no sign of the coin's outline is the *maximum* safe exposure to the safelighting.

The reason for using the pre-exposure is to make the test more sensitive; without it, the safelight alone must provide sufficient exposure to reach the threshold of the paper emulsion before any effect will be visible, and a longer exposure will appear to be safe than is actually the case. Once you have exposed an enlargement, the safelights will cause fog in the high values sooner than with a totally unexposed sheet.

Another test that will indicate if something is wrong with the safelights is to expose a print and then cut it in half. Store one half

in a light-tight paper box and leave the other half under the normal safelight for several minutes. Then develop both halves in total darkness. Direct comparison will show if the high values are "depressed" in the sheet exposed to the safelights. Reflection-density readings will indicate the degree of fogging. Delicate variations of values are difficult to determine when the prints are wet, so examine them after drying. ◁

See pages 82–84

If a problem is evident, the tests can be repeated, turning off a different safelight each time, to determine which one causes the fogging. We have recently tested the safelights in my darkroom using a step tablet for the exposure, and found reason for additional precautions; in particular, I have partly closed the baffles of a sodium-tube safelight located near the sinks to reduce its output.

OTHER PRINTING EQUIPMENT

Easels

The best adjustable easels for use with vertical enlargers consist of a metal base and a hinged top assembly designed to hold all four edges of the paper in place with the desired margins. These easels, like the Saunders, have independently adjustable blades, so the position and width of each border can be controlled. If you want only the standard narrow borders, the less expensive easels with two fixed edges and two adjustable blades may be adequate. I have found that many easels do not give accurate rectangular margins, however, and you should check alignment carefully before purchasing; try various settings of the easel borders and check them with a square. Check also the nature of the edges of the easel blades. If these are beveled toward the paper, they may reflect light and produce a thin black or gray line parallel to the borders in the image area of the developed print.

A white surface on the easel makes it easy to see the projected image. However, with single-weight papers, enough light may pass through the paper and reflect back from the white surface to produce an appreciable value change in the print. It may thus be preferable to paint the easel yellow or black, or use a thin sheet of dark cardboard behind single-weight papers. Double-weight papers do not transmit enough light to worry about.

Focusing Magnifiers

Optimum focus is assured for an enlargement when the *grain* of the negative is focused sharply over the entire image area. Focusing on the grain requires the use of a focusing magnifier such as the Omega. This device rests on the easel, and a mirror diverts a small part of the projected image to an eyepiece for viewing. The dimensions of the magnifier are carefully controlled so that when the grain is sharply imaged in the eyepiece it is also sharply imaged on the easel.

Some magnifiers do not allow inspecting the corner sharpness effectively. Because of the optical path, the image at the corners strikes the mirror at a more severe angle than at the center of the image area; as a result the light may not be directed to the eyepiece. Magnifiers like the Omega Micromega have an extra-large mirror and a tilting objective that help eliminate this problem.

Since you wish to determine focus accurately on the enlarging *paper*, it is best to rest the magnifier on a scrap sheet of enlarging paper in the easel. Focusing is most easily accomplished at maximum aperture, but should be checked at the working aperture as well if the lens has any tendency to shift focus when stopped down. Do not use *acetate* Polycontrast filters below the negative, since they will affect the optical quality. I recommend thin gel filters, like Kodak's Polycontrast filters, as they have minimum effect on the optical path. Filters located between the negative and the light source do not affect the focus or optical quality.

Timers

Accurate timing of printing exposures and development is important. I do not use the timers that directly control the length of exposure, as I prefer freedom in this respect. Instead, I time my exposures using an audible metronome that is set to one beat per second. I then count beats during the exposure, and have both hands free for burning and dodging procedures, ◁ See page 102 with no need to watch a clock dial. Timers are available which have both a visible display and an audible signal. As mentioned earlier, some electronic timers may not be appropriate for use with cold-light enlargers. ◁ See pages 22–23

For timing print development I use a digital electronic timer that resets to zero and counts up in whole seconds when I press a switch. As the paper is immersed in developer, I reset the timer, and then can easily apply the factor method. ◁ See page 95

Enlarging Meters

The use of an enlarging meter does not, in my opinion, contribute to expressive controls in black-and-white printing. A meter can be of some use in the mechanical process of evaluating the scale of a negative and suggesting the appropriate paper contrast grade. But the important qualities of a print or enlargement are *subjective;* only by trial and sensitive appraisal of values can an expressive print be made, and the process does not invite numerical analysis. In color printing, however, an enlarging meter may be important for the controls required in this exacting work.

Trays

The best trays are heavy plastic or stainless steel. Plastic trays are sometimes available in a "nest" of three or four of different colors, which can be helpful in identifying the different solutions. Stainless-steel trays are more expensive, but they are practically indestructible. You can have a metalworking shop make up stainless steel trays if you need special sizes, but be sure they use an appropriate alloy that will resist acids and salts (18-8 Type 302 or 316 stainless).

I generally prefer trays that have ribs or ridges on the bottom, as these make it far easier to pick up a negative or print. Having one or two flat-bottomed trays available is also helpful, as they can be inverted for use as drainboards or as surfaces for squeegeeing. Stainless-steel trays should be used in all applications that require water jacketing, since they conduct the heat of the jacket water much more efficiently than does plastic. ◁

See Book 2, pages 202–204

At the end of a printing session I discard the developer and fixer solutions, and then pour the stop bath into the developer tray to neutralize the residual alkaline developer solution. Then all trays should be thoroughly rinsed out with *hot* water. I no longer consider it necessary to use the same tray each time for developer, fixer, etc., since commercially available trays today are impervious to chemical contamination. However, this practice depends on *careful* rinsing of trays after each use.

See page 175

I have standard tray sets on hand in sizes up to 20×24, and, as stated elsewhere, ◁ I use trough-type trays for very large prints. The latter can be fabricated of stainless steel or fiberglass, and should be appreciably longer than the paper width to facilitate handling — 50 inches long for roll papers of 40- to 42-inch width.

Print Washers

See page 134

There are numerous designs available. Since the washing of prints is critical to their permanence, ◁ I recommend acquiring one of the "archival" washers. These washers are designed to hold each print in a separate slot to keep the prints from sticking together, thereby ensuring fresh water circulation to all prints. The water flow should be regulated to the recommended speed. The design of the washer should usually have the water inlet at the opposite end from the drain, to ensure a continuous flow of water across the prints.

Washers of the rotating-drum variety are also available, though they may cause damage to print corners and folding of the prints. The horizontal drum type washer may not separate prints efficiently while washing; such washers demand constant attention to be certain the prints move about *separately* in the water. Prints that stick together in the device will not be properly washed.

Other types of washers include various tray designs or attachments. These may be effective for washing a very few prints (the Kodak tray siphon is considered to be one of the best washing systems when only one print is being washed). However, they do not generally provide adequate washing for larger volumes without considerable help — continuous agitation to separate the prints, plus draining and refilling at regular intervals.

Dry-Mount Press

See page 155

I recommend acquiring one, if budget permits, although it is possible to dry-mount with a household iron. ◁ The press should probably be large enough for 16 × 20 prints (the 11 × 14 size may be usable for 16 × 20 prints with multiple pressings), and should include an automatic thermostat. Dry mounting of resin-coated prints or Polaroid prints requires careful heat control, so a press that includes a dial thermometer is ideal. The press should also include provision for adjustment to ensure uniform pressure over the entire print surface. I suggest that the dry-mount press be on a separate circuit.

Paper Trimmer

A poor trimmer is a very bad investment! The rotating-wheel type has some advantages for papers, and thus is adequate in the darkroom, but it cannot be used for mount board. The heavy-duty blade trimmers are excellent. I favor those like the Kutrimmer or Dahle

that include a pressure bar that firmly clamps the print down along the entire cutting edge; this helps prevent the "creeping" of the print that is a major cause of non-straight edges. The pressure bar should be relatively wide and padded to prevent indentations on print or mount board. Check freqently to clear this pad of any particles; there is no way to repair a dent on a print! I recommend buying a trimmer with a safety bar to prevent accidents.

Reflection Densitometer

See Book 2, page 85

See page 142

In Book 2 I described the transmission densitometer used in density measurement of negatives. ◁ For precise evaluation of prints the reflection densitometer can be a valuable piece of equipment, and in color printing it may be essential. As discussed later, ◁ the reflection densitometer is a device that projects a controlled beam of light at an angle on a small area of the print, and measures the amount reflected. The reflected light is interpreted in the logarithmic values of density.

Stabilization Processors

A stabilization processor is a small mechanical unit that permits very rapid processing of prints. Special stabilization papers, usually available in variable contrast, incorporate developing agents that work rapidly as the exposed paper passes through the machine. The print emerges slightly damp and "stabilized," meaning it can be viewed under normal light for a moderate length of time. Being stabilized rather than fixed, the print may last only a matter of months without signs of deterioration; for permanence the stabilized print *must* be given conventional fixing and washing. The stabilization process is thus potentially useful for making quick proofs or prints that are to be used immediately (such as for newspaper engraving or proofs for a client). I have found, however, that the savings in time are minimal unless the photographer is producing a very considerable number of prints for short-term use. I would seldom consider it advisable to produce impermanent prints!

PH Meter

I have used a good pH meter (Beckman Model 3560 Digital) in tests and experiments relating to the preparation of this text. It has con-

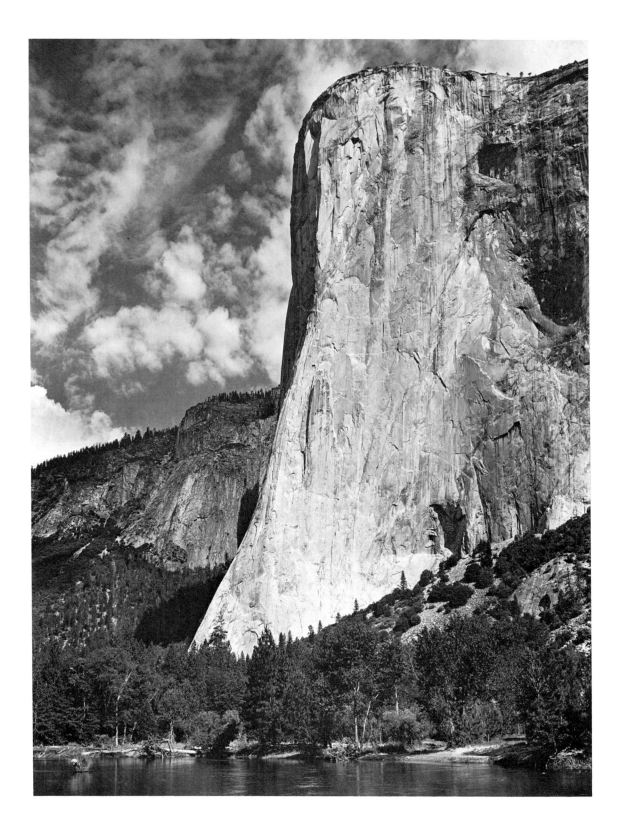

Figure 2–12. *El Capitan, Yosemite National Park, California, c. 1937.* I made this photograph with a 5×7 Deardorff and a 7-inch Dagor lens, using Agfa film and a pyro-metol developer. I used a Wratten No. 23A (light red) filter to lower the values of the forest and accentuate the separation of sky and clouds. The scale of the subject is enhanced by its dominance of the picture format. The print was made on Grade 3 Kodabromide developed in D-72.

firmed acid-alkaline values of solutions in various stages of use, as well as the pH of the water supply, etc. A pH meter is not a necessity for photographers, especially for black-and-white work, as most formulas are designed with chemical buffers to overcome normal pH variations in the water in different regions, and to ensure stability over the useful life of the solutions. But the instrument has certainly proved useful and informative in many ways for me.

Miscellaneous

Anti-static brushes are always helpful in removing surface electrical charges from glass and film, and are essential in areas of low humidity. Small hand brushes with a polonium cell (like the Staticmaster) work very well, but be sure to observe the precautions regarding their use and disposal. I have the electric Kodak Static Eliminator unit, and find it an invaluable darkroom aid. There is no doubt that the use of these devices reduces dust on the negative and saves hours of subsequent print spotting, provided the enlarger interior and negative carriers are thoroughly clean. Grounding of the enlarger will also be very helpful in reducing dust spots, and the area around the printing or enlarging equipment should be vacuumed frequently. Compressed-air blowers usually just scatter the dust from one place to another!

It is also helpful to have a small flashlight with the lens covered with safelight filter material. With it you can set the enlarger lens, find things in the dark, and so on, without fogging the paper. Such units are commercially available, or may be adapted from a conventional flashlight.

See Book 2, pages 197, 204

See page 102

Much of the additional darkroom equipment needed will be chosen according to personal preference. Water temperature control units are extremely helpful, as discussed in Book 2. ◁ Other necessary equipment includes an accurate thermometer, graduates and storage bottles, dodging and burning devices, ◁ and gloves or print tongs if desired (some photographers develop a skin allergy to the developer or other photographic solutions, and thus must avoid direct contact with them). I advise acquiring a notebook to record the details of each printing session, to save time in future repetitive work.

Chapter 3

Printing Materials

There has been much debate and discussion in recent years on the quality of photographic printing papers. At this writing, I find a number of papers that are as good as or better than any I have used in the past. Of course, this is a personal judgment. But the current high level of interest and activity in photography seems to have encouraged manufacturers to provide printing papers that are capable of maintaining an exceptional range of values, with clean whites and deep, rich blacks. Given materials of high quality, it is up to the photographer to learn to choose and handle them in ways that contribute to achieving the optimum final print.

Figure 3–1. *White Branches, Mono Lake, California.* This is one of the few images I have where high values, in this case the white branches, are printed pure white. They are alkali encrusted and show little or no texture to the eye, and none in the negative. Hence, any attempt to print them down would result in flat gray values. The intention is that they stand in glaring contrast with the relatively dark background of the thundercloud reflections. The print is not realistic, but a faithful equivalent of the visualization.

I used an 8 × 10 view camera with 10-inch Kodak Wide-Field Ektar lens and a Wratten No. 15 (G) filter. The film was Isopan, rated as ASA 64 and developed N + 2 in Edwal FG-7. I printed on Ilford Gallerie Grade 3 paper developed in Dektol.

Printing-Out and Developing-out Papers

Nearly all papers today require development of the image, and are thus called developing-out papers (DOP). There are a few printing-out papers (POP) still available, usually intended for use in making portrait proofs. With these, no development is needed; instead the paper is exposed using sunlight or other very strong light. The image is formed directly during this process, and then "fixed" by a toning procedure (See Appendix 1, page 195). The characteristics of such printing-out papers differ greatly from standard enlarging papers.

I once attempted to print on modern paper from old wet-collodion negative plates made by the Matthew Brady group during the Civil War. These negatives are in the National Archives, and I was asked

to make contact prints of several for the exhibition *Matthew Brady and the American Frontier* at the Museum of Modern Art, New York. I found the negatives to be extremely high in contrast, and I had difficulty making adequate prints even using the softest contact-printing paper (Kodak Azo Grade 0) and a very dilute amidol developer. The qualities of the negatives were still not fully revealed, as their density ranges greatly exceeded the exposure range of the paper/developer combination I used.

Such negatives are suited to the use of printing-out papers, which have an extremely long exposure scale. The reason for this long scale is not the inherent range of the emulsion itself, but rather is due to a progressive self-masking process. Light striking the emulsion transforms the silver halides directly to metallic silver, and as this silver forms it acts as a screen to the light: the denser the image, the less light can penetrate the depths of the emulsion. Consequently prolonged exposure has diminishing effect on already darkened areas. Extending the exposure beyond that required to give a good value in the dark portions of the print has relatively little additional effect on these areas, but may reveal subtleties in the very light areas and high middle tones.

Of course such prints have no greater range of reflection densities than other prints; rather, they have a longer effective *exposure* scale. Hence they will interpret a negative of a very great range of densities, and the tones in a well-processed image on printing-out paper are usually very rich and enhance the impression of long tonal scale and brilliance. These papers also have a considerable potential range of print "colors," depending chiefly on the toning bath used. Since they are very slow, printing-out papers are not usable for enlarging.

Modern developing-out papers have a far shorter exposure scale than printing-out papers, and are better suited to the density ranges of typical contemporary negatives. Since they are universally used today, we will consider only developing-out papers in this volume.

CHARACTERISITICS OF PHOTOGRAPHIC PAPERS

Photographic papers contain a silver-halide emulsion on a white paper support. If we were to strip a print emulsion from its paper base and examine the image by transmitted light, we might be surprised at its low density and contrast. This effect can be partly demonstrated by viewing a print strongly lighted from *behind*; "black"

areas of the print become merely dark gray, and may reveal subtle density differences that are not visible by reflected light. A transparency or lantern slide intended for projection requires considerably greater range of silver deposits than the most brilliant print. It is easy to understand why if we think about the structure of a print.

The print image is composed of varying amounts of silver particles in an emulsion affixed to a paper base. The base itself reflects about 90 percent of the light falling on it through the clear gelatin of the emulsion layer. But the light reflected to our eyes from parts of the image that are not pure white must pass through the silver densities *twice.* If one area of the emulsion transmits 50 percent of the incident light, this amount reaches the paper base; from there about 90 percent is reflected back (or 45 percent of the initial incident light), but this light must again pass through the silver deposit, which removes another 50 percent. The result is that only about 22½ percent of the incident light reaches the eye from this area of the print. Since it thus acts twice in screening the light, a relatively low actual deposit of silver in the print becomes quite efficient in absorbing light. (This is a figurative, not a scientific, description.)

Base Material

The emulsion is coated on a paper base that contributes its own characteristics. So-called fiber-based papers are the conventional printing materials, and are still recommended for maximum quality and permanence. Resin-coated (RC) papers have a polyethylene coating that prevents chemicals from soaking into the paper fibers. They can be washed clean very rapidly, since the residual processing chemicals are easily removed. However, at this time there is serious question about their archival qualities, as the polyethylene layer tends to deteriorate and develop cracks in time. In addition, I do not personally favor the image quality of the RC papers, although improvements may certainly take place.

Most papers are coated with a baryta layer on the paper base, below the emulsion. Baryta is a clay substance, and this coating smooths out the inherent texture of the paper and provides a clean white background. Since it is often the baryta layer, rather than the paper itself, that is seen as the print "whites," any warm or cool coloring desired may be added by the manufacturer in this layer. "Optical brighteners" are also frequently added to provide maximum reflectance in the high print values (some brighteners may eventually lose their effect).

Figure 3–2. *Cross sections of photographic papers.* With conventional paper the processing solutions penetrate the paper base. RC paper has a polyethylene layer on either side of the paper so the solutions only reach the emulsion; therefore much less time is required to wash them out. (Not drawn to scale.)

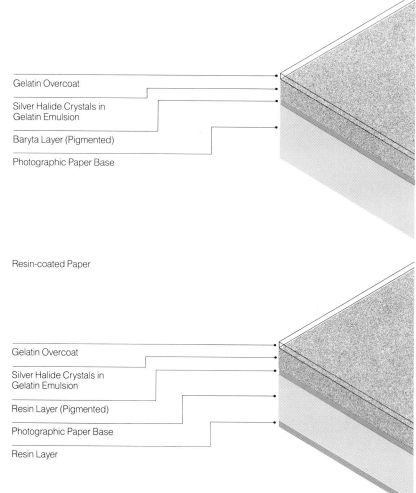

Gelatin Overcoat

Silver Halide Crystals in Gelatin Emulsion

Baryta Layer (Pigmented)

Photographic Paper Base

Resin-coated Paper

Gelatin Overcoat

Silver Halide Crystals in Gelatin Emulsion

Resin Layer (Pigmented)

Photographic Paper Base

Resin Layer

Weight

This term refers to the thickness and bulk of the paper base. The standard choices are single-weight and double-weight, although there are sometimes others such as medium-weight for RC papers, or light-weight. I use double-weight paper for all purposes. These thicker papers withstand the rigors of processing much better than lighter varieties, being more resistant to pinches and breaking. They also lie much flatter after drying on print racks, and they can be mounted with greater ease and smoother results. Although single-weight papers are more delicate and must be handled with great care, they may be appropriate to some high-volume operations and for prints that are to be dried in blotters or on belt driers; they are also more quickly washed free of residual chemicals than double-weight papers. I·have found that in the handling required to process very

large prints, a single-weight paper is almost certain to suffer physical damage.

Surface

Maximum image brilliance is obtained on a smooth, glossy-surfaced paper, which can have a reflectance range of up to 1:100 and higher (with some current papers the range approaches 1:200 in testing, although it is unlikely that this entire range would be visible in a photograph under normal lighting). The matte papers have much lower brilliance, with a reflection-density range of about 1:25. Between these extremes lie the many other paper surfaces with varying degrees of gloss and texture. Surfaces like the one called "silk," for example, are mechanically impressed on the paper. The various manufacturers all have their own names for different surfaces, and there is little systematic designation.

Ferrotyping is a method of drying a print on a special metal sheet which imparts a very high gloss to the surface. The high gloss was once considered beneficial for reproducing photographs. I find the glare from such prints objectionable, unless the print is mounted flat and viewed under glass or Plexiglass (in which case there is little reason for ferrotyping!).

I use glossy papers comparable to Kodak's "F" surface. Unferrotyped, these papers give a smooth semi-gloss finish with long tonal range. I prefer such smooth finish to keep the paper texture from interfering with the fine detailed revelation of the lens. I have occasionally used Kodak's "G" surface enlarging paper; it has a slight "tooth" and a natural white (not "buff"!) base, which can make it a See pages 173–182 good choice for very large prints (20 × 30 inches and larger). ◁

It was once common practice to apply wax or varnish to the print for added brilliancy, particularly with prints made on matte or semi-matte paper, and to provide a protective layer. I hesitate to recommend such treatment, because it may reduce print permanence. Varnishes and lacquers may turn yellow in time, as can be seen in many older photographic books where the reproductions have yellowed because of a varnish layer. If varnish is used, a thin layer will show less yellowing than a heavier one.

Image Color

Image color is a property of both emulsion and paper base combined (the term "color" as used here bears no relation to color photographs, but refers to subtle hues of greater warmth or coldness in reference

to neutral black and white). The color of the base can range from a cold (bluish) white through neutral to slightly warm and very warm (ivory or buff) colors. Since there is no standard system of designating the base color, it is often most useful to compare paper samples from several manufacturers.

The image color is modified by the development, and still further modified by toning. In general, an emulsion of warm color is composed of finer silver grains than a cold-toned emulsion; being smaller, these grains are more susceptible to atmospheric attack than larger grains, and it is believed that warm-tone papers have slightly lower archival permanence than the cold-tone varieties.

Developer formulas also tend to favor warm or cold tones in the image; the warmest tones are naturally obtained by using a warm-tone developer on a warm-tone paper. In my opinion the olive-greenish values of many papers detract from the image, but they can See page 130 often be neutralized by selenium toning. ◁

To sum up my personal preferences in the physical qualities of papers: I use double-weight papers of neutral or cool emulsion color on a cold white stock, in the glossy (but unferrotyped) finish. I work for a cool purple-black image by using a cold-toned developer and a slight toning in selenium. With this combination I feel that I can achieve an image of maximum strength and beauty of print color — an image that is logically related to the clean crisp sharpness of the image formed by the lens.

EMULSION CHARACTERISTICS

In earlier years it was possible to categorize papers according to the silver halides present in the emulsion: silver *chloride* papers were slow, and mainly used for contact printing; the fast enlarging papers were either *bromide* emulsions (cold toned), or mixtures (*chloro-bromide* or *bromochloride* — both usually warm in coloring). Most emulsions today are much more complex, and manufacturers do not usually reveal the halide content.

Papers designed for contact printing still appear to have an emulsion composed chiefly of silver chloride. These papers are relatively slow, but have very good scale and tonal values. Their low sensitivity to light makes them unsuitable for most enlarging purposes unless the illumination is quite high, or if very long exposures can be tolerated. Since these papers are often marketed as "commercial" materials, some photographers automatically scorn them even though many fine modern images have been made on them. At the other

extreme are the devotees who think the tonal scale of contact-printing papers is superior to the enlarging papers; I do not. I have used enlarging papers for both contact printing and enlarging for many years with success. Chloride papers have always toned more readily than most enlarging papers, but otherwise I have found the enlarging papers to give superior quality.

Numerous enlarging papers are available today. They are designed to work at manageable exposure times under typical enlarging illumination levels. Various systems for rating a paper's sensitivity to light (its "speed") have been advanced over the years. The "ASAP" code specified by the American National Standards Institute (ANSI) uses a numerical system comparable to ASA speeds for films. ◁ Paper speed ratings are of limited value without a darkroom photometer, however, and it is difficult to specify a print value to use for comparing speeds. I do not use any such system in my work.

See Book 2, page 18

Both Kodak and Ilford are currently making papers that include a developing agent in the emulsion layer. These papers, including most current Kodak RC papers, are designed to develop very rapidly — typically in 30 seconds to one minute, rather than the two to three minutes otherwise often required. Unfortunately, though, almost no development control is possible, since these papers develop fully so rapidly. This becomes a problem if factorial development or other controls are to be applied. ◁

See page 95

If you are using one of these papers and wish to have some control of development, Kodak recommends using their Ektonol developer. Apparently the lower pH of this developer does not trigger the developing agents within the emulsion, so development proceeds in a more normal manner. Most developers using borax as the accelerator should be appropriate for developing these papers conventionally, while the developers containing carbonate, being more alkaline, will provide rapid development (this includes Dektol and most other conventional developers). Of the fiber-based papers, few, if any, have developing agents incorporated at the present time. Consult the manufacturer's "tip sheet" or catalogue if in doubt.

We are naturally less concerned with data and the chemistry of a paper's emulsion than with its practical printing characteristics. I, for one, consider it impossible to be certain of the various properties of speed, contrast, developer response, and susceptibility to toning until I have tested a paper for its visual qualities.

Paper Grades

In principle, the exposure range of a paper must match the density range of the negative in order that all negative values may be fully

revealed in the print. Hence papers are given numbers indicating their contrast in terms of *paper grades.* The softest papers are Grade 0 or 1, and the hardest are Grade 5 or 6, depending on the manufacturer's system. A contrasty negative will require a paper of long exposure scale for printing, Grade 0 or 1; a flat, low-contrast negative requires a shorter-scale paper, perhaps Grade 4, 5, or even 6. Do not confuse this *exposure* scale of the paper with its potential scale of *reflection densities;* ◁ a contrasty negative printed on a Grade 0 or 1 paper should yield about the same full range of print densities (values) as a flat negative printed on a high-contrast paper.

See pages 141–142

Although the grades differ widely from one manufacturer to another (and even from one batch to another of the same paper!), I standardize my printing on a Grade 2, using a diffused-light enlarger. ◁ I resort to other grades only when required to compensate for different negative scales or for particular image requirements. Some small-format workers prefer to standardize on a Grade 3, and thus they plan a somewhat "softer" negative. ◁ It should also be understood that two papers that have the same overall exposure scale may produce prints of quite different quality; the progression of values *within* the scale is determined by the properties of the paper expressed in its characteristic curve. ◁

See page 22–23

See page 20

See page 142

The alternative to graded papers is variable-contrast material, such as Kodak's Polycontrast and Ilford Multigrade. Such papers yield a different exposure scale depending on the color of the enlarging light. Filters or a variable-color light source ◁ can thus be used in printing to control image contrast, giving the benefit of different grades from a single paper. This capability is achieved by combining two different emulsions, one low in contrast and one higher, each sensitized to a different color of light; usually the high-contrast emulsion is sensitive to blue light and the lower-contrast emulsion is green-sensitive. Because these papers respond to a broader spectrum band than graded papers, be sure to follow the manufacturer's instructions regarding choice of safelight filters. ◁

See page 26

See pages 30–31

There are a few papers that are available only in a single contrast grade. These papers are produced for use by studio portrait photographers, who can control the negative contrast through adjustments of lighting and development.

The Reciprocity Effect

Exposures with paper emulsions are subject to the reciprocity effect. ◁ Our most recent testing indicates that exposures of 5 minutes may cause a loss of paper speed by 2 or 3 times, compared with

See Book 2, pages 41–42

an exposure of around 20 seconds. Modern papers do not appear to undergo the contrast change that was typical of many earlier papers; the contrast of the papers I now use is remarkably consistent for exposures of up to several minutes. ◁ However, reciprocity characteristics may change, affecting both speed and contrast.

See Appendix 2, page 200

CONTEMPORARY PAPERS

Over the years I have used practically all brands of printing paper manufactured by Eastman Kodak, Agfa, Ilford, Oriental, DuPont, Zone VI Studios, and many others. Every photographer must contend with the issue of selecting papers, so it seems appropriate to comment on some of those currently available. These are personal preferences and are not intended to imply inherent superiority. I must also caution you that the manufacturers may alter the characteristics of their papers over time.

Ilford Gallerie. This is a paper of very high quality which I use extensively. It is available in four grades. To begin with, Gallerie has a rather warm and slightly greenish color, but it tones differently

Figure 3–3. *Road Sign, Arizona.* This photograph was made with intentionally high contrast to convey the feeling of brightness and "color" of the sign. The dark shadows were placed on Zones I and II, and further deepened by the orange-red Wratten No. 23 filter. The light gray sign was on Zone VI½, and the blue sky fell on Zone V, lowered to about Zone III by the filter (note the brightness of the sky near the horizon). The painted frames of the windows were dark blue and the doors red, rendered respectively darker and lighter by the red filter.

I used an 8 × 10 view camera with 12¼-inch Cooke Series XV lens and Isopan film. I gave N + 2 development in Ansco 47, and printed on Agfa Brovira Grade 4 developed in Dektol.

from any other paper I have used. A few minutes in selenium toner changes the color to neutral. Thereafter it does not change in color, but actually intensifies in contrast and depth of value — revealed visually and as a measurable increase of reflection density of the low values. Most papers intensify somewhat, but Gallerie does so to a greater extent, and without the marked color change that occurs with other papers. This ability to acquire some intensification during toning is a rewarding refinement of value control. The Gallerie papers are designed to have the same exposure speed for Grades 1 through 3, and one-half this speed for Grade 4; the matching of speeds is not essential, but it helps reduce the time required to secure a good work print.

Ilford Ilfobrom. Ilfobrom is of good quality and has been relatively consistent over the years. It is available in four contrast grades: I find Grade 2 developed in Dektol or Grade 3 developed in Selectol-Soft ◁ to be about "normal," and I can then depart from the norm as required. This paper tones well in selenium, although it does not take on the strong coloring of some other papers.

See pages 55–57

Oriental Seagull. This paper has had exceptional quality and consistency. It tones very well in selenium, but the toning process must be watched carefully as it is very easy to over-tone. Each of its grades appear to be higher in contrast than similarly numbered papers of other manufacturers. For example, I have found that Seagull Grade 4 gives me a better print of my *Frozen Lake and Cliffs* ◁ than I was ever able to get on Agfa Brovira Grade 6, and the tone is magnificent. This is one of those significant early negatives (c.1932) that must be considered quite poor in quality and *very* difficult to print. The negative contains enough information to yield an acceptable print with great effort, and I continue to improve the "salvage" printing as best I can.

See Figure 7–2

Kodak papers. I have used Kodak papers for decades with very good results. I have found that Kodabromide Grade 4 tones very well in selenium, but the other grades do not. Other Kodak papers, especially Azo, tone very well. I have had excellent results with Polycontrast in prints for reproduction. However, it does not tone in selenium as I would like; the two emulsions required for variable contrast tone differently, giving a good tone to the middle and low values and little, if any, tone in the high values. The result is a "split-tone" effect that I find unpleasant.

Zone VI Studios Brilliant. The tests we have made on this new paper show it to be truly "brilliant," in that it has fine clean whites and an excellent value scale throughout. Its image coloring is slightly warm, but it tones very well in selenium.

Agfa Portriga. Portriga has a warm tone and rich value scale. I do not generally respond to warm print values, but Portriga does give excellent results for many photographers. Especially in portrait work, it can have a rewarding luminosity.

Paper Defects

With even the best papers we will occasionally find defective sheets. Unfortunately the defects may not appear until after the print is dry (and sometimes mounted!). My preference in papers depends partly on consistent performance, including freedom from defects. Among the manufacturing defects I have encountered are the following:

1. Physical dents, breaks, and scratches.
2. Broken corners, often due to rough handling.
3. Wavy appearance of sheet, apparently due to changes in humidity before or after packaging.
4. Pits or "bumps," usually particles of fiber, etc., embedded in the emulsion, and small "blisters."
5. Rough feeling of print surface, sometimes visible before development. It can be felt while processing by running the fingers lightly over the sheet. This problem may disappear in processing.
6. Emulsion defects, such as evidence of poor coating, deposits from cutting and packaging, uneven gloss, and evidence of moisture present in handling.
7. Abrasion lines, appearing as very thin dark lines across the print. Such lines are usually too fine to be visible in the unprocessed sheet.
8. Emulsion fog.

Some of these defects can be seen on the sheets before exposing and processing, and early detection can reduce wasted time. Each sheet can be examined under the safelight, holding it at a glare angle to the light, while inspecting for surface defects. However, the last two defects listed do not appear until after processing. The abrasion lines apparently occur during the coating or packaging of the sheet, when the emulsion is scraped by some foreign object and thereby sensitized. (Abrasion cannot be considered a defect in the paper if it is caused by the photographer, as it frequently is; paper surfaces must be treated most gently!)

DEVELOPERS

See pages 55–57

See page 117

See Book 2, page 187

Photographers often have a kind of "holy water" complex about developers. There are many varieties, in proprietary compounds or published formulas, and many people have strong preferences (or prejudices). I have done nearly all my printing in recent years using Dektol and Selectol-Soft developers, ◁ both from Eastman Kodak.

There is no doubt that the quality and consistency of packaged developers leave little to be desired. Some published formulas can be useful, however, such as the Beers formulas ◁ for variable contrast development (although combining Dektol in varying proportions with Selectol-Soft is almost equally effective). Some of the agents in typical print developer solutions are similar to those in negative developers, ◁ but certain factors like image color become important in relation to prints. In general, developers of high alkalinity tend to produce warm print colors, as does underdevelopment.

The chemistry of photography is as complex as you wish to make it for yourself. The important issue is knowing as much as you need to know in order to achieve desired print qualities with assurance and consistency. We need not know the organic chemical structure of a developing agent, but we should know how to use it and modify its effects in useful ways. The following material on darkroom chemicals is relatively basic and should be of good practical value.

Water quality. Water "hardness" is an important issue to consider. At present my incoming water measures about 180 parts per million (ppm) of calcium carbonate (or equivalent), and I have been advised by chemists from Ilford that this is close to the ideal. I formerly used a commercial water-softening system, which reduced the content to around 18 ppm, but the surface of some prints was abraded by even gentle contact during processing. Eliminating the water softening has corrected this problem. I do recommend that incoming water be *filtered* to remove impurities such as rust and organic matter. I use a self-cleaning filter that has replaced the water softener.

Developing Agents

Metol and hydroquinone. Metol (which Kodak sells under the trade name Elon) tends, if used alone, to produce a soft and delicate image of good color. With prolonged development, metol yields strong values and excellent color. In most formulas it is combined with *hydroquinone,* one of the first developing agents used. Adding

hydroquinone to a metol solution enhances contrast in the image by building up heavier deposits in the middle and low values than is obtained from metol alone. Hydroquinone is seldom, if ever, used alone; it requires a small proportion of another agent like metol to "activate" it. Metol/hydroquinone developers comprise the most popular and widely used formulas. They give consistent results, with the advantages of long life and economy.

Phenidone. This is Ilford's proprietary name for a developing agent that is similar in many respects to metol. Like metol, it has the property of "activating" hydroquinone, and thus it is often used in combination with hydroquinone. Phenidone developers have a very long tray life and can process a large number of prints. Phenidone is recommended for photographers who are allergic to metol.

Amidol. This is a long-used developing agent popular with some photographers; it produces rich and slightly cold black tones. It can be highly diluted to give very soft images if desired, while maintaining reasonably consistent print color. In the past I have used an amidol formula diluted with up to 20 or more parts of water, and achieved prints of beautiful tone from extremely contrasty negatives. The developing time, however, was very long — 10 minutes and more. Another variation on amidol processing is its use at high concentrations and at fairly high temperature (75°F) to give an extremely rich and brilliant print. Because of the high temperature, however, the solution is very short-lived, and it has a tendency to stain the print.

The chief disadvantage of amidol is that it must be mixed just before use (it deteriorates rapidly even at normal temperature), and it stains fingers and fabrics severely. The addition of citric acid as a buffer prolongs tray life and minimizes stain. In my own use amidol appeared to "block" the shadow values; texture and subtle value differences did not seem as clearly revealed as with Dektol, although current papers may not have this problem. In addition, amidol is very expensive (currently about $75 per pound). But Edward Weston used amidol, and Brett Weston still does; it works splendidly for images by both photographers.◁

See Appendix 1, page 192

Glycin is sometimes used in conjunction with metol or hydroquinone, or both, in paper developers. It gives rich, brilliant images, and — in suitable combination with other ingredients — produces subtle print colors which can be modified by selenium toning. With some papers glycin gives a light "stain" to the very high values and

highlights; this appears as a "glow" which I have found rewarding at times. Usually a slow-working developer, glycin is sometimes preferred when a considerable number of prints are to be developed together. ◁

See pages 169–170

For the prints in my *Portfolio One,* I used a metol/glycin developer. This was actually a modified Ansco 130 solution — a metol/hydroquinone/glycin formula in which I omitted the hydroquinone to achieve a fairly soft-working developer. The relatively large amount of potassium bromide in this formula favored clear high values, and also added quite a warm color, which was neutralized by selenium toning.

Other Developer Components

Alkali. Both the stability and energy of developing solutions depend upon their alkalinity (*pH;* on the pH scale, 7 is neutral, numbers lower than 7 represent acids, and numbers above 7 represent alkalis). Thus an alkali may be added to function as an *accelerator* in the solution. In general, the more alkaline a developer solution is, the more active, but the shorter its life. Many developers, such as Dektol and D-72, contain an alkali (usually sodium carbonate) that has a buffering action — that is, it has the ability to maintain a fairly stable pH throughout the useful life of the developer. When the developing agent is overused, there is a relatively sudden weakening of developer power, and the developer is said to be exhausted. Borax is occasionally used as the alkali, as in the Kodak Ektanol developer. Sodium hydroxide (caustic soda) is of very high pH, and seldom used in print developers; one exception is Edwal G, a very active formula. ◁ Use great caution if you handle sodium hydroxide.

See pages 117–118

Developing agents such as amidol require no addition of alkali to the solution; the reaction of sodium sulfite with the water creates appropriate pH for their activity. Amidol, in fact, is exceedingly sensitive to the presence of alkali and will quickly oxidize and become useless if the pH is too high. In order to extend its life in solution, citric acid (a buffer) is usually added. This lowers the active energy of the developer, thus requiring longer development time, but prolongs the life of the developer.

Preservative. Sodium sulfite is added to retard oxidation, and is an essential ingredient to preserve the life of stock solutions. With such high reduction-potential* developers as amidol, it also produces a

Reduction potential indicates a developer's activity. Hydroquinone has been given the arbitrary reduction potential of 1, metol is 20, and amidol 35 plus.

slight alkalinity (pH of about 8), which is more than sufficient to activate amidol.

Restrainer. This substance retards reduction of silver halides, and is useful in preventing fog caused by high-energy developers, prolonged developing times, or the age of the paper. Out-dated papers or papers exposed to heat or humidity are especially likely to exhibit fog, and added restrainer may be needed. Without restrainer, the developing agent may reduce some *unexposed* halide to metallic silver, thus causing an overall fog. With negatives, *slight* fog can be ignored, since it is "printed through" and thus does not affect image values. With prints, however, even minor fogging can cause high values that are visibly degraded and "depressed." (Most cases of degraded high values I see, it should be noted, are caused by safelight fogging, ◁ See page 31 which must be cured by reducing the safelight intensity or by more careful handling of the paper.)

Potassium bromide is the most common restrainer added to prevent fogging. However, adding excessive bromide tends to cause the print color to become greenish with some papers (although this can usually be neutralized by selenium toning). Benzotriazole (available as Kodak Anti-Fog No. 1) is another widely used restrainer. It is sometimes claimed that benzotriazole lessens the image contrast. It may slow the development somewhat, but I have not been aware of a loss of contrast using normal quantities; if anything, it appears to increase contrast by "clearing" the high values. Benzotriazole tends to give cold tones, shifting the image color toward the blue.

Kodak Dektol and Kodak Selectol-Soft

My basic print developer for a number of years has been Dektol, a metol/hydroquinone developer which is similar in action to the published D-72 formula. ◁ See Appendix 1, page 190 At standard dilution (1:2 or 1:3) it gives what I consider to be normal contrast with moderate developing times (2–3 minutes). Using the development-factor method ◁ See pages 95–101 I can dilute Dektol stock solution with as much as 6 to 8 parts water, and still achieve rich print quality. With *under*development, however, Dektol tends to give muddy values and an unpleasantly warm print color.

Selectol-Soft (note that this is different from Selectol) is a low-contrast "surface" developer, similar in action to the old Ansco 120 formula which used only metol as the developing agent. With normal processing time, Selectol-Soft will favor the high values of the print

first, gradually building up the dark values as it penetrates into the emulsion. Given long development time (up to 8 or 10 minutes) it will approach the effect of Dektol in deep black areas, with a rich and neutral print color. I use it alone, or combine it with Dektol for more subtle contrast control. ◁

See pages 93–95

Temperature Effects

The action of a developer solution responds (like most chemical reactions) to temperature change. Raising the temperature makes the action more rapid, so that less time is required for development; lowering the temperature retards the action, so that more time is needed. As with film development, ◁ 68°F (20°C) has been selected as the standard print-processing temperature for a variety of reasons, including practical developing time and efficiency of solutions. For optimum processing, all solutions including the wash water should be as close to this temperature as feasible.

See Book 2, page 201

The change of activity caused by a temperature change can be represented by the *temperature coefficient* for the developing agent. In a formula containing only one developing agent, a single temperature coefficient applies, and the relationship between temperature and developing time is easily determined. But in a developer that contains two or more agents, each may have a different coefficient, and it becomes more practical to experiment than to compute.

However, a change of temperature may affect not only the development time, but also the character of the developer, so that the print quality changes. For example, with metol the required development time varies uniformly with temperature change over a wide range, while the activity of hydroquinone is somewhat irregularly affected by temperature variations. Hydroquinone loses much of its activity at about 55°F, but has a very high activity at or above 75°F. Consequently, a metol/hydroquinone developer, producing normal effects at 68°F, gives somewhat softer effects as the temperature is lowered and the activity of the hydroquinone is thereby diminished; more vigorous effects occur as the temperature is raised and the hydroquinone becomes more active. Roughly speaking, a cold metol/hydroquinone developer (about 50°–55°F; 10°–12°C) acts as though it were mostly metol. A certain amount of control is possible through variations in the temperature of a metol/hydroquinone developer, but the results should be judged on the basis of color as well as contrast. I became well aware of this effect while trying to get good prints in a chilly darkroom during cold winters in Yosemite!

Figure 3–4. *Lava, Mauna Loa, Hawaii, Hawaii (c. 1948)*. Lava rock is of quite low reflectance, although some, like this, gives bright specular reflections. To emphasize the shapes and textures in sunlight I chose to place the shadows very low on the exposure scale and give very full development. Here the deep shadows were placed on Zone I, and N + 2 development was given. I used the camera back tilt to gain maximum depth of field (see Book 1, Chapter 10).

The print is on Brovira Grade 3, although today I would probably use Seagull Grade 2.

OTHER PROCESSING CHEMICALS

Stop Bath

See Appendix 1, page 193

The stop bath, a weak solution of acetic acid, ◁ neutralizes the alkalinity of the developer solution, thus stopping the developer action and preventing stain. The fixer bath, being acidic, would itself arrest development, but the use of stop bath prevents contamination of the fixer with alkaline developer solution. With no stop bath, the fixer loses acidity and becomes exhausted rather quickly, and stains are increasingly liable to occur. I have always prepared a generous quantity of stop bath, and I discard it frequently; as long as the stop bath quickly removes the "slimy" alkaline feeling on the fingers and surface of the print, the solution is still effective. If gloves or tongs are used, we cannot rely on this sensation, and the stop bath's activity is estimated by monitoring the quantity of paper put through it.

Fixer

The fixing agent is usually sodium thiosulfate ("hypo"), which has been in use since the earliest days of photography. The fixer removes all residual silver halide not reduced to metallic silver in development, and thus "fixes" the image so it will not discolor in light. Most standard fixers also include a hardener (usually potassium alum) which makes the print surface tougher and more resistant to scratches and abrasion; acetic acid, to produce the acidity required for efficient fixing and hardening, and to counteract the alkalinity of any developer not neutralized in the stop bath; and boric acid or Kodalk, to act as a buffer providing stable pH and to prevent sludging. Sodium sulfite is used as a preservative.

Pre-packaged hardening fixers like Kodak Fixer are usually adequate for general use. The Kodak F-5 acid-hardening fixer (using boric acid) and its odorless counterpart F-6 (using Kodalk Balanced Alkali)

See Appendix 1, page 193

are in common use and are quite satisfactory. ◁ Edward Weston favored a non-hardening hypo-metabisulfite (or sodium bisulfite) formula comparable to Kodak F-24, asserting that it produced a better print color. I have not personally observed any significant difference, although this formula does work well and reliably in temperatures below 70°F (22°C).

Rapid fixers are made with ammonium thiosulfate. I do not use these for any purpose, since too-long immersion quickly begins to

bleach out the image silver along with the unreduced silver halides. The same effect can occur with conventional hypo fixers, but not nearly as soon as with the rapid fixers. Recently Ilford has described a method of archival fixing that uses ammonium thiosulfate fixer. The print is fixed with constant agitation for only 30 seconds, and then given an abbreviated wash and hypo-clearing treatment. The advantage is supposed to lie in the short fixing time, which does not allow the fixer to penetrate the paper fibers. Thus the fixer is more quickly washed out. This method has merit, but it is not one I have used; I am quite confident that my procedures for fixing and washing provide excellent archival stability.

Sodium sulfite (not sodium sulfate) is included in most fixer formulas to prevent the disintegration of the thiosulfate in the presence of acid. Thus the order of mixing is *very* important with fixing baths, and each component must be thoroughly dissolved before adding the next: first the hypo, next the sodium sulfite, then the acid. (This is the order the chemicals are listed in the formula, and it is standard required practice to mix all formulas in the order the components are given.) Failing to follow this sequence will cause sulfur to precipitate in the hypo solution, ruining the fixer. After the acid, the hardener is added; in the case of the F-6 formula the buffer (Kodalk) is added before the alum hardener.

In my own use, I have found that I can reduce the amount of hardener in the F-6 formula to about one-half the stated amount, since my working conditions are cool; the more hardener used with prints, the more washing time they may require. Excessive hardening may also make spotting more difficult and reduce archival stability. If the prints frill along the edges, however, or when working in a warm environment, more hardener will be needed.

Agitating the print in the fixer is of great importance, to ensure that the emulsion is always exposed to fresh and active solution. Thorough rinsing and then washing are also extremely important if the prints are to be permanent. The procedures for fixing and washing prints are described in Chapter 6.

Hypo Clearing Agent

If residual hypo or the byproducts of fixing are allowed to remain in the paper base, they will eventually cause print discoloration. Since paper is fibrous, it absorbs more chemicals than film products or RC paper base, and it requires longer wash times and very careful treatment. Several manufacturers produce hypo-removing products (such as Kodak Hypo Clearing Agent or Heico Perma-Wash) which neu-

Figure 3–5. *Eucalyptus Stump, Olema, California, c. 1932.* This was made in the Group f/64 period. I used an 8 × 10 view camera and a 10-inch Goerz Dagor lens on Kodak Super-Sensitive Pan film. I recall using a No. 8 (K2) filter. The negative was developed in pyro, and shows the usual pyro stain; hence it prints with higher contrast than appears to the eye. The shadows were underexposed, and only a trace of texture can be seen in the dark areas. I made this print on Agfa Brovira Grade 3 paper, which held the extremes of values and textures very well indeed. The problem in printing is to achieve richness of value in the shaded area while holding all textures and, at the same time, keep the desired brilliance and texture in the white barn.

See page 132

tralize the fixer residuals and significantly reduce the required wash time. Note that Kodak's Hypo Eliminator (HE-1) is a totally different formula, and I do not use or recommend it.

Toners

There are numerous formulas for solutions that impart a tone to the print, causing some "warming" or "cooling" of values or even yielding a pronounced color. The old standard sulfide toners (bleach-and-redevelop processes) have given way to single-solution toners. Selenium toning is, in my opinion, the most satisfactory in terms of color, simplicity, and permanence. Selenium toning causes a subtle change to a cool color, and enhances the archival permanence of the print. The selenium toner protects the emulsion from attack by certain atmospheric contaminants, and also causes some deepening of the black and very dark gray values. Be sure to follow the toning procedures given later ◁ to avoid print discoloration.

Archival protection is also provided by the use of the Kodak Gold Protective Solution, GP-1. This solution causes a shift in print color to blue, and thus I consider selenium toning preferable. Selenium toning followed by the use of GP-1 is not advised, as it will produce red tones on some papers.

Proofs and Work Prints: Basic Printing and Enlarging

While the general procedures are similar for all photographs, the nuances of print exposure and processing become personalized over time, as they depend partly on individual preferences and the equipment and facilities available. It is worthwhile here to give a fairly complete description of procedures I have found dependable, to introduce these methods for new photographers and to help more experienced workers refine their printing technique.

EVALUATING THE NEGATIVE

Figure 4–1. *Windmill and Thunder Cloud, Cimarron, N.M.* The key textured high value is the white tip of the cloud, rendered just below pure white. The sun glare on the windmill blades is pure white. Increasing the contrast of the print in search of brilliancy merely coarsens it, and with reduced contrast the image loses its essential vitality.

The camera was a Hasselblad with 150mm Zeiss Sonnar lens. I used a deep yellow Hasselblad filter and Kodak Plus-X film developed in Edwal FG-7. The print was made on Ilford Ilfobrom Grade 2 developed in Dektol.

Before we begin to print we should consider the negative for what it is — the source of the *information* required for the creation of the print. Although the negative is an intermediate step between the subject and the print, it also represents a starting point itself. We have visualized the final image as best we can, and we can learn to judge the potential of the negative for fulfilling our visualization. But we are also free in printing to enhance our original visualization for expressive reasons. Our ability to do so will be limited by the information on the negative and by our printing craft.

Inspection of the negative should begin with evaluation of the low-value (shadow) areas. Observe the nature of the shadow edges as signs of the kind of lighting on the subject: sharp shadow edges indicate sunlight or acute artificial light, and diffuse or vague shadow edges suggest light from open sky or diffused artificial lighting. In

these low-density areas, note where full detail begins, and where there is only slight texture or none at all. It is extremely helpful to recall the visualization, perhaps making reference to the Exposure Record or notes made at the time of exposure; misreading of the meter, faults in exposure placement or development, wrong filter or lens extension factors can often be diagnosed by reference to accurate notes. In this way we can begin to relate the appearance of the negative with the remembered and recorded values of the subject, and with the anticipated print values. Look also at the borders of the negative to check the minimum density level (filmbase-plus-fog density); if you encounter a negative that has a high minimum density compared with other negatives (either visually or measured with a densitometer), you should look for possible causes of negative fog.

Then visually evaluate the middle and high densities of the negative. The high densities should show separation and detail through all important image areas. The character of the lighting can be further evaluated by examining the appearance of the highlights: if small and crisp, the source may be sunlight or distant artificial light; if broad and diffused, the source may be open sky or diffused artificial light. You should also attempt at this point to estimate the overall contrast of the negative. By considering the negative in this way, you will better understand what you may expect to have in the print.

See Book 2, pages 233–234

It should be noted that the *color* of the negative can have an effect on its printing contrast. Some developing agents, like pyro or pyrocatechin, ◁ produce a "stain" on the negative image that is *proportional* to the density. The stain is usually yellow in color, so it acts as a blue-absorbing "filter." Since papers are sensitized to blue light, the yellow stain functions like a higher density in printing than is evident to the eye. Thus a negative produced by a staining developer can be expected to print with higher contrast than visual evaluation suggests, provided the staining effect is proportional to the silver density (a uniform all-over stain would simply increase the required printing exposure time). The difference in contrast caused by staining developers can be quite surprising — sometimes more than one paper grade.

The recently introduced chromogenic films, such as Ilford XP-1 and Agfa Vario-XL, are color-dye materials that yield a black-and-white negative. The XP-1 negative has a reddish cast, so it prints with higher contrast than we might expect — especially with vapor-tube light sources — a similar effect to that of a staining developer.

As the final step in evaluating the negative, I repeat that it is best to use a soft grade of paper to make a proof or first print. The print may be visually flat, but the purpose is to reveal all the information

available in the negative, especially the texture and detail in the extreme values. This stage is important not because we may perceive something unexpected, but because we will be able to judge the expressive potential of different areas in relation to our original visualization. From this point we can increase the contrast as necessary in progressive trials, and use local controls like burning and

See page 102

dodging, ◁ and others. I find it far better to work from softer papers *up* to the appropriate contrast grade than to make the first print too harsh; it seems to be difficult to "work down" in contrast, just as it might be difficult to adjust to a string quartet after listening to a brass choir!

PREPARING EQUIPMENT AND CHEMICALS

Assuming the darkroom and equipment are clean and in good working order, we must first assemble the necessary equipment and prepare the solutions for printing. Be sure the safelight filters are

See page 32

appropriate for the papers to be used (and previously tested ◁), and that the required timers, viewing light, and other general equipment are ready. This includes a camel's hair brush or anti-static brush for removing dust from negatives, focusing magnifier, dodging and burn-

See pages 33–39

ing devices, towels, etc. ◁ Before preparing the trays of chemicals, I usually turn on the sodium-tube safelight and the enlarger cold light, as both require warm-up time.

The chemical solutions should be mixed to working strength and brought to the correct temperature in their trays (water jacketing,

See Book 2, pages 202–204

used for temperature control in developing negatives, ◁ is seldom required for black-and-white printing as we can monitor visually the activity of the developer). Be sure to arrange the trays in the order listed, with a few inches between each to avoid contamination:

Developer. Mix stock Dektol solution (assuming that is your normal developer) to a working strength of 1:2 or 1:3, in sufficient quantity to cover the print in the tray generously. I always check to be sure that both Dektol and Selectol-Soft stock solutions are mixed and available before starting to print. The solutions should not be used beyond their capacity.

My experience indicates that each ounce (30cc) of Dektol *stock solution* can develop about two 8 × 10 prints or the equivalent, after dilution. Thus one quart of stock mixed with three quarts water to make a gallon of 1:3 working solution can be expected to develop

about sixty-four 8×10 prints, or sixteen 16×20 prints (comparable figures in metric units would be one liter of stock, three liters of water to make four liters of working solution, which would have a capacity of about seventy 8×10 prints). This is quite conservative; Kodak estimates about 50 percent more capacity for Dektol, but I personally would seldom use a developer to that extent. With Selectol-Soft, I estimate one print per ounce (30cc) of *stock* solution, at 1:1 or 1:2 dilution.

Stop bath. In the next tray, prepare an acetic acid stop bath. The stop bath is mixed from 28 percent acetic acid (the "stock solution") by mixing 1½ ounces of stock per quart of water, or 48cc per liter. If you purchase glacial acetic acid, you should first dilute it to a 28 percent solution by adding 3 parts glacial acetic acid to 8 parts water.

Figure 4–2. *Wood Sculpture, Masonic Temple, Mendocino, California.* The deepest shadow areas were placed on Zone III, and were lowered about one-half zone by the use of a Wratten No. 12 (minus-blue) filter. The central sunlit area of the wooden structure fell on Zone VII, and the area to the right fell about on Zone VIII. The brightest areas of the painted statue fell on Zone VIII½. The sky was deep blue, reduced considerably in value by the filter.

I felt it was important to show the brightness difference between the slightly gray-white of the tower and the brilliant white of the freshly painted sculpture (reportedly carved from a single large block of redwood). D-23 developer contains a relatively large amount of sodium sulfite which tends to block subtle high values, and no amount of printing will show texture. I printed down the whitest areas as far as I dared, and a trace of texture shows in the original print, but I do not expect it to hold in reproduction.

I used a Hasselblad with 250mm Zeiss Sonnar lens, and Kodak Panatomic-X film.

Be sure to handle glacial acetic acid with care, as it is strong and can be irritating to the skin and respiratory system.

The stop bath should be mixed to correct proportions. A too-strong solution can cause blistering of the emulsion from the rapid formation of carbon dioxide gas as the acid interacts with the alkali in the developed print. It is also not advisable to leave the prints in stop bath for more than the recommended 30 seconds, or a mottle can form that is visible on the back of the print. Occasionally this mottling shows through the face of a wet print as light gray patches, although these are seldom visible after the print dries.

Fixer. Prepare a single tray of fresh hardening fixer (F-5 or F-6, or the packaged Kodak Fixer). All prints should receive a 3-minute fixing, with regular agitation, and then can be "stored" in water (be sure to agitate the prints and change the water from time to time). Additional fixing in a fresh second bath should be given at the end of the printing session, but the procedure differs depending on whether the prints are to be toned or not. (See pages 130-132.)

Print storage. Fill a deep tray with water for rinsing prints and place it next to the fixer tray. I also keep a separate container of hot water in the sink for rinsing hands. It is important never to wipe hypo-contaminated hands on towels; rinse the hands carefully and dry them thoroughly after handling prints in any solution.

Before starting the printing session, be sure that all doors and other light seals are tightly closed, that the ventilation is working, and that notes on the negatives are at hand.

PROOFS AND CONTACT PRINTS

Contact printing is useful today for proofs of all negatives, and some photographers still prefer it for printing 4×5 or larger negatives, although enlarging has become standard procedure for most workers. An entire roll of 35mm (36 exposures) or 120 roll film can be proofed by contact printing on a single 8×10 sheet of paper.

Until the end of the last century, nearly all printing was done with the negative in contact with the paper, often using sunlight for the exposure. The albumen printing-out papers of the late nineteenth century were far too slow for practical enlarging; when an enlarged image was needed the usual process was to make an enlarged glass

positive and then make a glass negative therefrom which could be contact-printed.

Among later practitioners, Edward Weston contact-printed his negatives using the most basic equipment — a simple printing frame and a bulb suspended from the ceiling. During the time of exposure he would dodge the image where necessary. Then after the basic exposure time had elapsed, he would continue with burning-in as required. With a dense negative, however, it is difficult to see the image from above, and dodging and burning are not as certain as when the image is projected on the enlarging paper.

In my early days I contact-printed using a frosted lamp on the end of a wooden rod; the lamp was raised or lowered by inserting the rod in any of several holes in a piece of wood on the wall, thus providing some control of the intensity of light on the paper. I now make contact prints using the enlarger as light source. This method of contact printing is efficient and consistent, and well suited to working with the fast enlarging papers. The intensity of the light can be readily controlled by adjusting the lens aperture and the height of the enlarger above the paper. The light is confined by the enlarger and does not illuminate the room, thus making it easier to see the negative during printing. For those who may not have an enlarger, however, it is still perfectly feasible to contact print using an ordinary lamp.

Little equipment is needed for contact printing. Some older printing frames have a hinged back; these were intended for use with printing-out papers, which require that the user be able to check periodically on the effect of the exposure. For contact-printing with developing-out paper, however, I discarded these years ago in favor of a simple "sandwich" of negative, paper, and heavy cover glass, supported on a sheet of sponge rubber. It is best to use a fairly heavy cover glass to ensure good contact between the negative and the paper. For safety the glass should have beveled or polished edges, or the edges can be covered with thin strong tape. Both the glass and the negative must be carefully dusted before printing. I am presently using the HP Film Proofer, which consists of a hinged sheet of heavy glass, foam pad, and base.

You must be sure that the enlarger gives uniform illumination over the area of the printing paper. With an empty negative carrier in place, raise the enlarger until the projected rectangle of light generously covers the area where the paper will be, with several inches to spare on all sides. At full aperture, set the lens focus *forward* from the position that produces sharp edges of the negative carrier; this is important because it ensures that the "image" of the enlarger's

diffusing screen, or dust on the condenser, will not be projected on the paper causing uneven lighting or mottle, especially when the lens is stopped down.

Contact-printing light boxes have few advantages and one major disadvantage in that the negative cannot be seen while printing. However, for printing large quantities I have used an early "Air Force" printer, which contained twelve frosted lamps, each with its own off-on switch. It is thus possible to control the distribution of light during the printing exposure, to broadly compensate for uneven negative densities; turning off the central lights, for example, will increase the *relative* exposure of the borders and edges of the image. Actual dodging and burning, however, are quite difficult to accomplish with such a printer, since they require the use of translucent masks, cut to the appropriate shape, inserted below the negative. The printing-frame principle remains, for me, simpler and more efficient.

Exposing the Test Print

I suggest that you use Grade 1 for first trials. The first print is a test of exposure times, and can be accomplished using a sheet of paper or a strip about 2 inches wide. My preference is to use at least one-half or one-third of a full sheet for tests instead of the narrower strips; some photographers may consider this an extravagance, but I find it very useful to see several values of the print, and I consider larger test strips a time-saver. If you decide to use only a narrow strip of paper, try to position it so that each exposure segment includes both important high values and shadow areas.

The test print will be made by covering successive portions of the paper while the light is on. Decide first on the exposure intervals that seem appropriate. If you have an estimate of the correct exposure, "bracket" it with your test exposure times. As stated previously, I use a metronome to time all printing exposures. If you use an enlarging timer you should not find it difficult to adapt the following procedure.

Position the support pad on the baseboard, and then place a sheet or strip of enlarging paper on it with the emulsion side up. Remove the negative from its envelope, dust it carefully, and place it emulsion-down on the enlarging paper so the emulsion sides of the negative and paper are in contact. Put the glass sheet on top and then cover the entire sandwich with a piece of opaque cardboard, or oth-

erwise arrange to shield the print when you turn on the enlarger.

Assume that you have decided to go from 10 to 30 seconds in 5-second intervals. You will use the covering card to control the area of the paper that is exposed for these times; note that the edges of each exposure area will be most easily seen if the card is held close to the negative — it can rest on the cover glass. With a metronome (usually set at 60 beats per minute) you would first turn on the enlarger light and, *starting to count from 0*, uncover the entire sheet while counting to 10. Then quickly cover about one-fifth of the negative area (being careful not to shift the negative-paper sandwich) while continuing the count for five more beats, etc. The entire sequences of exposures would be as follows:

1. Turn on the light and, when ready, quickly remove the covering card (*on beat "0"*).
2. At beat 10 quickly move the card to cover one-fifth of the paper.
3. At beat 15 cover an additional one-fifth of the negative.
4. At beat 20 cover another one-fifth.
5. At beat 25 cover another one-fifth.
6. At beat 30 cover the entire print and turn off the enlarger.

Once the test print has been exposed, note the exposure sequence in soft pencil on the back of the print (10/15/20/25/30 seconds), and develop it according to the procedures given below. ◁

See page 75

Figure 4–3. *Exposing a test strip.* The contact-printing "sandwich" is exposed strip by strip under the enlarger light. The same procedure is followed with enlargements, except that the negative is in the enlarger and the paper is held flat in an easel. Be sure to record the series of exposures in soft pencil on the back of the test print.

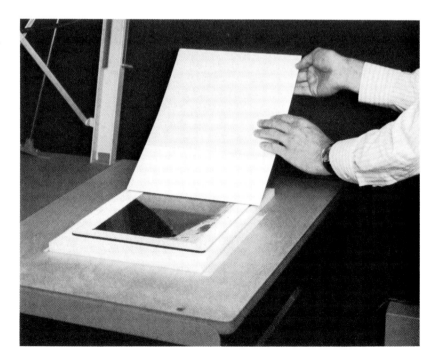

ENLARGEMENTS

Enlarging raises several issues not present with contact printing. One important factor to be considered is the size of the enlargement. Enlarging a small negative to 8×10 will give certain effects not observed in the contact print; enlarging it to 16×20 introduces other effects, and so on. These effects are both technical and aesthetic.

See Book 1, pages 97–98

The true perspective of the image on the negative depends on the distance from the lens to the subject photographed, regardless of focal length of lens, subject field, or size of negative. ◁ In a contact print, a "literal" impression of the perspective is seen when the image is viewed from a distance equal to the focal length of the lens used in making the negative. (To be more precise, the actual distance from the camera lens to the negative is the appropriate viewing distance, for when working with close subjects the lens is extended well beyond its focal length. ◁) Now if the negative is enlarged 2 times, the print viewing distance should be doubled to retain the same perspective effect. This issue should be considered when making a print to be seen under known conditions; a mural-size print may be appropriate for a large room where it will be viewed from a considerable distance, but for a hallway where the viewer must stand

See Book 1, pages 179–181

Figure 4–4. *Inserting negative carrier.* Most 8×10 enlargers, and many smaller ones, use glass negative carriers. Great care must be taken to remove dust from all glass surfaces, as well as from the negative. The white tape on the upper left corner of the negative carrier, when flush with the enlarger frame, indicates that the negative is centered. The knob above can be set to place the carrier at any desired location behind the lens.

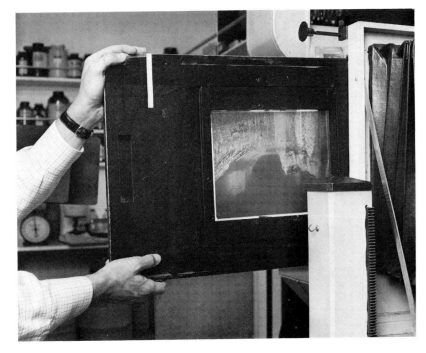

fairly close, a smaller print will usually have a more "natural" effect. However, close viewing of a large print may reveal exciting aesthetic qualities of detail and depth otherwise not seen.

A related visual factor is the eye's characteristic of viewing the image by "scanning." The eye images sharply only a small section of the field at any one moment; the complete impression of the scene is reconstructed in the brain from the lingering of myriad impressions on the retina and in the cortex over a short span of time. If the act of scanning a print matches the scanning of the original subject, the impression will be quite "realistic." This effect contributes to the subjective differences between an 8×10 image and a 16×20 image, if both are viewed at the same distance. Thus the size of the enlargement bears a direct relationship to the subjective effect produced in the viewer, and we may say that the intensity of the visual expression relates, not to the sheer size of the print, but to the relationship of size to the image itself and the viewing conditions. The intuitive-aesthetic effects are critical.

See Book 2, page 19

The other primary technical issue in enlarging is the problem of definition and grain. ◁ There is usually a limit to enlargement of a negative where the size of the grain and the loss of definition detract from the desired qualities of the image (unless, of course, grain is being emphasized intentionally). Small defects or areas of pure black or white that may not be objectionable in a contact print may also become disturbing when enlarged. Textured papers help to minimize grain visually, but they also reduce the acutance and brilliance of the print image.

Enlarging Procedure

See page 65

The general darkroom preparations are the same as already described, ◁ but an enlarger and easel are necessary. Check that the enlarging lens is clean on *both* inner and outer surfaces (in vertical enlargers, dust often settles on the upper surface). The interior of the enlarger should be frequently and thoroughly cleaned, preferably with a mild vacuum cleaner, followed by wiping with a slightly damp cloth (be sure to unplug the enlarger during cleaning); leave the lens off and the enlarger "open" until any trace of moisture has had time to dry. In addition, be sure that the condenser adjustment, if any, is appropriate for the negative size, and that the field of illumination is uniform. See that the easel is clean, and that the margins and paper guides are properly set.

Select the negative. Carefully dust it with an anti-static brush and place it in the negative carrier so that its emulsion side is down,

Figure 4–5. *Primitive Cart, Kit Carson Museum, Cimarron, N.M.* There was fairly weak tungsten floodlight on nearby parts of the cart. The wood was placed on Zone VI and N + 1 development given, in addition to printing on Agfa Brovira Grade 4 paper developed in Dektol. I carelessly overlooked the reciprocity effect at the required long exposure time (8 seconds), and the shadows suffered greatly. Since there is practically no detail in the far background, it must be printed nearly solid black or the effect will be depressingly drab and "empty." The result is a strong emphasis on the "design" of the subject. I should have exposed at about 30 seconds and given Normal development. A paper of normal contrast grade could then be used.

I used a 4 × 5 view camera with 90mm Schneider Super Angulon lens, and Kodak Plus-X filmpack film at ASA 64, given (erroneously) N + 1 development in Edwal FG-7. I could probably achieve about the same contrast effect with Ilford Gallerie Grade 3 or Oriental Seagull Grade 2.

See page 157

See page 34

See Book 1, page 76

See page 24

facing the lens. If a glass negative carrier is used, it must be perfectly clean; remember that a glass negative carrier adds four glass surfaces where dust can collect, and dust means laborious spotting later on!◁

Place a piece of white paper in the easel for focusing; the back of a discarded print of the same weight as you are now using will serve. With only the safelights on, turn on the enlarger light and compose the image on the easel. When the desired size and composition are achieved, focus critically at maximum aperture. Optimum focus for the negative is achieved when its *grain* is sharply defined; I consider a high-quality focusing magnifier such as the Omega to be essential. ◁ Check that the image is sharp at the center and at all corners.

Inability to focus the center and edges simultaneously can be caused by misalignment of enlarger head, lens, and baseboard; by a lens defect (curvature of field ◁); or by buckling of the negative in a glassless negative carrier. These problems will be somewhat reduced by stopping down the enlarging lens, and thus it may be necessary to expose at quite a small aperture. Severe problems in focusing may indicate the need for realigning the enlarger. ◁

I recommend stopping down the lens at least two stops from the maximum aperture before making the print. With some lenses, a slight refocusing may be necessary after stopping down due to focus shift. Unless you are certain your lens is free from focus shift, ex-

amine the image again with the grain magnifier at the working aperture, and adjust the focus as necessary.

The procedure for making a test print is the same as in contact printing. ◁ A half sheet or a 2- or 3-inch-wide strip of paper may suffice for the initial test print, provided that you position it carefully to include important high and low values. We then expose successive portions of the paper at specific time intervals to "bracket" the anticipated correct exposure. Be sure to note the exposure sequence and other details in soft pencil on the back of the test print: my notations include enlarger height, lens focal length and aperture, paper brand and grade, developer and dilution, developing factor, ◁ and exposure sequence.

The test print should be developed immediately using the processes described below. If processing must be delayed, the print can be stored in a light-tight container (such as an empty paper box) to protect it from excessive exposure to the safelights. Do not store exposed prints for more than a day before processing.

Possible Problems in Enlarging

Intensity of enlarging light. Unless a stabilizer or other monitoring system is used, there is always the possibility of changes in the light intensity. Sometimes a change in electrical use within the building (such as turning on a heavy appliance) can lower the voltage, and thus the intensity of the enlarging light. Some enlargers are equipped with a meter that allows the voltage to be checked for variation, although it does not correct voltage. The "cold-light" illuminants require a certain warm-up time to reach full output, ◁ and thus they should be left on, or "cycled" on and off regularly, throughout the printing session. I now use the Horowitz cold-light stabilizer unit,◁ which provides remarkably stable light output regardless of changes in voltage or tube temperature.

Vibration. The enlarger must be entirely steady during the exposure. Impact of the body against the worktable, or vibrations due to other causes (such as a darkroom exhaust fan) may reduce the definition, especially with enlargements of high magnification. Such vibrations can often be detected by viewing the grain through a high-power focusing magnifier; the grain should be steady and sharp in the viewer.

See page 69

See page 95

See page 23

See page 23

Reflections. Reflections of light leaking from the enlarger can cause fogging of the paper, and they sometimes are hard to locate. Reflections can be caused by bright metal enlarger supports, poor light seal at the lensboard, white walls reflecting light that leaks out around vents in the enlarger head or at the negative stage, bright objects nearby on the worktable, or even the beveled edges of the enlarging easel.

In some cases a source of reflection can be identified visually as you stand by the enlarger, but often the best means of detection is to examine the enlarger and its environment from the position of the paper, by looking into a mirror placed on the baseboard. Another method is to place a white focusing sheet in the easel and put a snug lens cap on the lens. Then turn off all lights and safelights in the darkroom and wait a few minutes for the eyes to adjust. Turn on the enlarger and try to see the paper in the easel. Light leaks in the enlarger should be quite apparent; often they can be repaired using black photographic tape, securely attached, but be certain not to obstruct ventilation holes in the enlarger head.

PROCESSING THE TEST PRINT

See Book 2, page 204

The test print should be processed in exactly the same manner you will use for subsequent prints; all aspects of processing, including development time and agitation, must be kept constant throughout the test-print and work-print stages, unless deliberately altered to modify image values. Agitation of prints during development is important for the same reason as with negatives: ◁ the developer at the interface with the emulsion becomes exhausted and must be replaced constantly with fresh solution. With prints the agitation should be continuous since the developing time is usually quite short compared with typical negative developing times. Symptoms of inadequate agitation include mottle and weak low values.

I prefer to agitate by carefully lifting the print out of the solution and turning it over. When several prints are developed together, the bottom print is lifted out and turned over on top of the stack; this agitation keeps all in motion constantly, and ensures that they are separated from each other at frequent intervals. (With amidol, however, exposing the print to air can cause oxidation of the print, producing stain.) Single prints should be turned over periodically, but rocking the tray will suffice for part of the agitation. Keep the print

Figure 4–6. *Inserting paper into the developer.* The paper must be slipped quickly but gently into the developer so all areas are wetted at almost the same moment. The print can then be *gently* pressed down with the balls of the fingers; undue pressure, however, may "dimple" the paper.

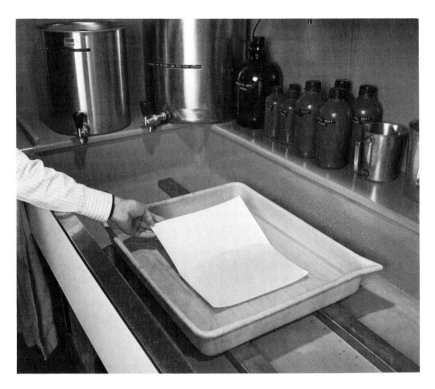

Figure 4–7. *Agitating several prints in solution.* When developing several prints together, they are agitated by leafing through the stack, raising the bottom print to the top and pressing it gently down with the fingers.

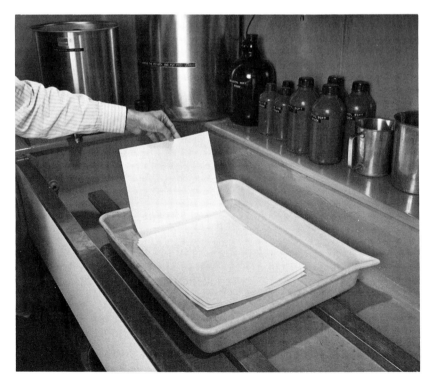

Figure 4–8. *Improper handling of wet prints.* Once the print is wet, the emulsion becomes very delicate, and it can easily be pinched or broken by careless handling. This illustration intentionally exaggerates the appearance of a pinch; actually, the effects of pinching are often not visible until the print is dry. A *very light* pinch can sometimes be smoothed out in the dry-mounting press, but nothing can be done to repair a cracked emulsion.

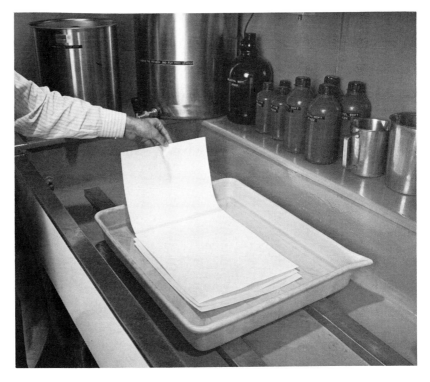

See page 31

face-down for as much of the time as possible to minimize exposure to safelights; ◁ avoid rubbing the print against the tray bottom, however, as any rough spots in the tray will damage the delicate emulsion.

I have always preferred to handle the prints with my fingers. Some people, however, find the solutions irritating, and in such cases it is better to wear surgical gloves or use tongs (the kind with soft rubber tips are least likely to cause emulsion damage). In any case, it is important that the hands or tongs not become a source of contamination of the solutions or the darkroom environment. Rinse the fingers thoroughly after they have been in any solution, and dry them on a clean towel. With tongs, one set should be used in developer only and another in stop bath and fixer.

When you are ready to begin processing, slide the print quickly and evenly into the developer. Agitate the print throughout the normal 2- to 3-minute development time. About 10 seconds before the time is up, lift the print and hold it by one corner over the developer tray to allow the excess solution to drain. Then immerse the print in the stop bath. Give it 30 seconds in the stop bath with continuous agitation. Then drain it and place it in the fixing bath. After a minute or so in the fixer it can be inspected under white light.

A

Figure 4–9. *Mountains, from Conway Summit.*

(A) The test print covers a range from obviously too light to obviously too dark (7, 14, 21, 28, 35, 42, 49, 56 seconds), thus assuring that the appropriate time can be estimated.

(B) The 28-second exposure gave good rendering of the high values — the snow. The foreground was dodged somewhat (see page 102), and thus received a bit less exposure.

When processing several prints together, I prefer to lift them as a group out of each solution and drain them for several seconds; I then place them in the next tray face-down and, as swiftly as is safe, rotate them one by one from the bottom of the stack to the top, turning them face-up. I continue through several cycles, in a manner similar to the procedure for developing film (See Book 2, page 210).

Throughout the processing steps, remember that the wet print is delicate and must be handled with the greatest care. The print becomes quite heavy when wet, and it is easy to pinch or break the emulsion; such damage cannot be repaired. Emulsion breaks may be of no importance with test prints, but careful handling should become a matter of routine for all processing.

B

EVALUATING THE TEST PRINT

See Book 2, page 72

The next step is to evaluate the test print for exposure time and contrast (be sure also to inspect it for sharp focus, dust spots, etc.). The principle is actually the same as for negatives: ◁ the low-density areas (*high* values in the print) are determined primarily by exposure, and higher densities (*low* print values) are then controlled by changes in contrast. Thus we inspect the textured high values, about Value VII–VIII, to determine the appropriate *exposure time*. Never make judgments based on *pure* whites; they will be pure white at any

exposure reasonably close to the optimum, and thus will not help much in determining the appropriate time. Once we find the optimum printing exposure, we look at the low-value densities (at the same exposure) to see if the *contrast* is appropriate.

The most useful test strip or print will show the optimum high-value rendering near the middle step, surrounded by steps that are "too light" and "too dark." Without such a range, it is difficult or impossible to be certain that the exposure is optimum. For example, if the longest exposure on the test sequence looks best, we cannot be sure that an even longer exposure will not be an improvement!

It is likely that a second test print will be required before we can make an accurate judgment about exposure time and contrast. If the high values are too light even at the longest exposure, it is obvious that the exposures have not been sufficient. The exposure can be increased by simply using a new range of exposure times or by using a larger lens stop. If you find the high values are all too dark in the test print, a new print must be made with reduced exposure. In general the most practical print exposure will be in the range of 10 to 30 seconds — to afford good accuracy and control for dodging.

I strongly recommend that you make a habit of estimating all exposure changes as a *percentage* of the initial exposure. We can become quite accurate at estimating the effect of a 20 percent exposure change, for example, but a change of "about 5 seconds" can have very different effect depending on how it relates to the total exposure time. Note also that a percentage change will have different effect depending on the paper grade: a 10 percent change may be scarcely visible with a Grade 1 paper, and quite pronounced with Grade 4.

The test print may indicate that a moderate increase or decrease in the exposure will suffice. If so, it is usually convenient to change the exposure *time*. For example, if the longest exposure on the test print was almost adequate, make a new series beginning at this exposure and continuing with longer times; if it was 18 seconds, try 18, 20, 22, and 24 seconds. However, if the time is becoming inconveniently long or short, it may be helpful to change the aperture.

If you stop down the enlarging lens one stop, exposures comparable to those of the test print will require twice the time. Similarly, opening the lens one stop will result in a comparable test print at half the exposure times previously given. Knowing this, you can adjust the aperture as needed and then estimate an appropriate range of exposures for a new test print.

In contact printing, the light intensity can also be changed by moving the light source (the lamp or the enlarger head) closer to or

farther from the paper. If a photometer is available, it can be used to measure the change caused by moving the lamp; by making adjustments that cause a doubling or halving of the light intensity, the effect on exposure times can be anticipated just as if whole-stop changes in aperture were used.

See page 47

Gross adjustments in contrast are made by a change of paper grade:◁ if the dark areas are dense black and lacking in detail at an exposure time that gives good high values, use a *lower* grade (softer paper); if they are grayish and washed-out in appearance, use a *higher* grade (harder paper). If a different paper grade is indicated at this point, make a new test strip with it.

WORK PRINTS

Arriving at a "fine print" involves proceeding through various stages of "work prints" until you arrive at a rendering that looks and feels right in all ways. This process involves considerable skill and judgment, and is continually refined with practice. Your next step after making the first exposure test series (assuming the right paper grade) is to make a second test print with exposures more closely spaced around the one that appears to give the best high-value rendering. A third test print may also be necessary to pinpoint exposure and estimate burning and dodging requirements. ◁

See page 102

Once you find what appears to be the optimum exposure time and paper grade, use a full sheet of paper to make the first work print. No matter how experienced you may be in printing, this should be a *straight* print, without burning or dodging, to allow you to make a full and objective judgment about the additional steps needed. Record exposure data lightly in soft pencil on the back of the print. After normal development and about a minute in the fixer, examine it in bright light to see the entire image and the relationship of other values to the textural rendering in the light areas, which should be about right if your exposure determination was carefully made.

Study this print: perhaps your first impression is that the blacks are not sufficiently rich, that what should be a full black is only a dark gray. If so, an increase in contrast will be necessary. Or the blacks may be too deep and lacking substance and texture that are present in the negative, indicating the need to reduce contrast. Contrast changes of less than a full paper grade are accomplished by variations in processing; numerous means of controlling and refining

A

the image values will be discussed separately in the next chapter. There are also several additional factors that affect our decisions in judging work prints:

"Dry-Down"

As you are working you must keep in mind the visual effect of the print when dry: the glistening, beautiful print in the fixing bath or rinse tray often dries to a "dull thud." I recall, when printing the "White Church, Hornitos, California" for my *Portfolio One*, that my

Figure 4–10. *Cross, Grave Railing, Los Trampas Church, N.M.* The photograph was made with a Hasselblad with 60mm lens and yellow filter, using Kodak Plus-X film developed in Edwal FG-7.

(A) The rough proof shows there was no detail in the deep shadows, but considerable texture in the high values. Hence I was aware that I should print the shadows as solid black to avoid having their values appear weak.

(B) Maintaining texture in the high values is obviously important, although some small specular reflections must remain pure white in the print. Such a rich printing is a considerable departure from reality, but carries — for me — the desired effect.

B

first prints in the fixing bath showed a subtle and pleasing value for the white clapboards on the sunlit side of the structure. They looked so good I decided to make all 120 prints required. But the next morning my fond hopes were shattered; what had been a beautiful shining white clapboard wall dried down to a depressing gray! It was not a major change in terms of actual measured values, but it was aesthetically unacceptable and all of the prints had to be redone. I found by experimenting that the print that properly rendered the subtle white tones showed *no* value or texture in these areas while wet, but dried down to perfect value.

Thus the final judgments about subtle high values cannot be made with a wet print. Some of the brilliance of the wet print is inevitably lost as the high values dry down. The reason for the change in high values appears to relate to the swelling of the emulsion when it is wet; the silver "galaxies" are physically spread apart, and light reflects relatively freely from the paper base. When the print is dry, these "galaxies" gather together more closely, and thus appear of greater density. In addition, black areas that are rich and glistening in the wet print may seem rather flat after drying (this is mostly a print-surface effect).

The best way to learn to judge this effect is to make two identical prints, dry one, and compare it directly with the wet print. You can also see *some* of the effect of drying by holding the wet print at a sharp angle to the light, so it almost goes into shadow.

I have taken advantage of the electronic age by drying my work prints in the microwave oven! About 1½ minutes will dry an 11×14–inch proof, and smaller prints require proportionally less time. To dry a test 16×20–inch print, I tear the sheet in half. An unwashed (but rinsed and squeegeed) test print dried in the microwave oven will have a slightly warm tone, but the normal paper color is restored if the print is returned to the fixer. I do *not* use the microwave for fine prints, as I do not know what physical change it might cause in the emulsion. It is a remarkable time-saver for drying test prints, however, and greatly facilitates judging the dry-down effect. Unfortunately, all papers do not undergo the same degree of change in drying, so each must be tested separately as it is used.

Quick drying may also be accomplished using a dry-mount press. I suggest that you squeegee the print and place it between two smooth boards used *only* for this purpose. Place this sandwich in the hot press for about 20 seconds, then remove it and "air" the print. Repeat this process several times until the print is dry. It is not necessary to put full mounting pressure on the print. A conventional heated oven will also work, but seems to cause more paper curl and can scorch the print. Again, I do not recommend these procedures for fine prints. I consider a microwave oven best of all test-print drying methods.

Toning Effects

For prints that are to be toned, we may have to make allowances as we print for the effect of the toner on image contrast. Selenium
See page 130
toner ◁ produces a cooling of the image color that I like, as well as having archival benefit. Its other principal effect is to deepen the

Table 2.

SUMMARY OF PROCEDURES

Process	Chemicals	Time	Comment
Develop	Dektol (1:2 or 1:3)	2–3 min.	Immerse print quickly and smoothly, give constant agitation. Keep print face-down or covered by other prints to protect from excessive exposure to safelight. Drain for the last 10 seconds of development time.
Stop Bath	dilute acetic acid	30 sec.	Mix as indicated on page 66; immerse print and agitate constantly to arrest development; then drain.
1st Fixer	F-5, F-6, or Kodak Fixer	3 min.	Agitate constantly, and keep prints separated. Prints may be inspected after one minute.
Rinse			Under running water or in a tray with agitation. Prints may then be stored in cold water until ready for final processing.

PROCEDURE FOR UNTONED PRINTS*

Process	Chemicals	Time	Comment
2nd Fixer	F-5, F-6, or Kodak Fixer	3 min.	Use fresh solution, agitate continuously.
Rinse			In a tray for several minutes under running water, with agitation.
Hypo Clearing	Kodak Hypo Clearing Agent	3 min.	Mix as instructed; give constant agitation.
Rinse			Under running water or in a tray with agitation for several minutes.
Wash		at least 1 hr.	Keep prints separated; lift and drop prints to remove bubbles.

PROCEDURE WITH TONING*

Process	Chemicals	Time	Comment
2nd Fixer	nonhardening fixer or plain hypo bath	3 min.	Use fixer formula given on page 194, with constant agitation.
Selenium Toning	Kodak Rapid Selenium Toner, mixed 1:10 to 1:20 with Hypo Clearing Agent	1-10 min.	Prints go into toner *directly* from the second fixer. Watch carefully and remove prints before full toning is achieved. Use higher dilution with papers that tone rapidly.
Hypo Clearing	Kodak Hypo Clearing Agent	3 min.	Agitate continuously to ensure that toning is arrested.
Rinse			Under running water or in a tray with agitation for several minutes.
Wash		at least 1 hr.	Keep prints separated; lift and drop prints to remove bubbles.

*These processes are discussed in Chapter 6.

Figure 4–11. *Burned Trees, Owens Valley, California, c. 1936.* I used a 5 × 7-inch camera and a 29cm Zeiss Protar lens, with a Wratten No. 15 (G) filter to lower the value of the sky. The print was made on Brovira Grade 3 paper developed in Dektol. The trees were burned black in a fire, and the exposure of the negative placed them close to Zone I. What detail was held in the negative was intentionally printed down to deep black; my visualization demanded intense blacks against a somewhat glittering background of winter branches.

The sky was very slightly burned in. The light was coming from the left and produced more shadow in the branches near the left edge of the image. They could have been dodged a little to balance them with the other small branches to the right. However, this would have lightened the sky value behind them, and the effect might suggest a "thin" value area.

black and dark tones, causing a *slight* increase in density and contrast, and thereby producing greater richness in the print. Toning also sometimes brightens the highlights and very high values. The precise effect differs from one paper to another, and thus we must take into account the paper brand and contrast grade in trying to anticipate the final appearance of the toned print.

Completion of Processing

The test prints and work prints are often discarded at the end of the session, but for prints that are to be saved, full fixing and washing are important (toning is not necessary except for fine prints). The prints can be stored in a water tray (with frequent agitation and changes of water) after the first 3-minute fixing, and processing completed at the end of the printing session. If prints are to be stored in water for more than an hour or so, use cold water (60°F — 15°C — or lower) to prevent excessive swelling and softening of the gelatin. Note that the procedures given in the chart differ depending on whether or not the prints are to be toned. The final fixing and subsequent procedures are described fully in Chapter 6.

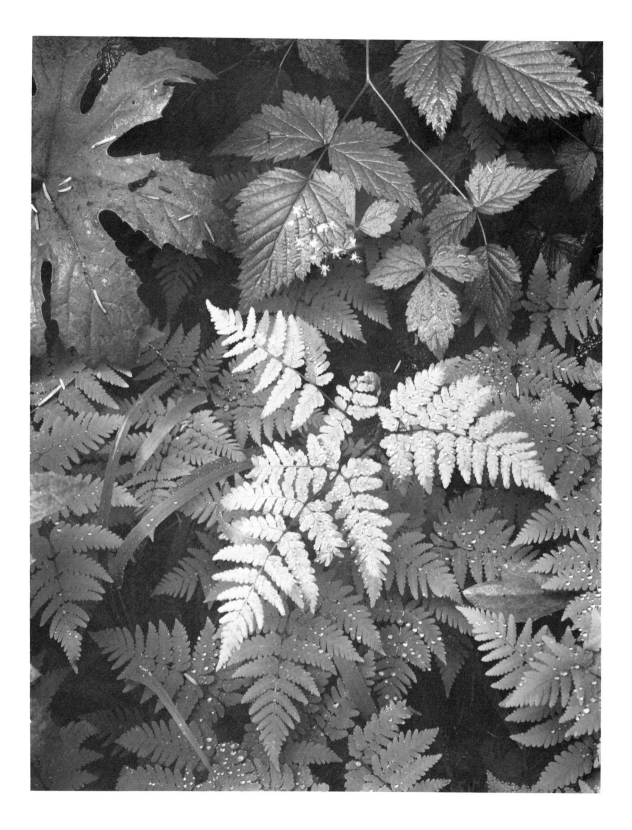

Chapter 5 **The Fine Print: Control of Values**

Figure 5–1. *Leaves, Mount Rainier National Park, Washington.* The central bright leaves (holding a trace of frost and dew) were reflecting a bright cloud. Because of this and the contrast effect of the Normal-plus development I gave, it is necessary to burn them down a little. To do so I used a card with a small hole (¼ inch), and "traveled" all over these leaves after the basic exposure was given. I also gave some edge burning all around, plus burning of the leaf in the lower right area.

I used my 8 × 10 camera with 12¼-inch Cooke Series XV lens, no filter. The film was Isopan at ASA 64, given N + 1 development in D-23. I made the print on Agfa Brovira Grade 3 developed in Dektol.

The differences between the various stages of work prints leading to the fine print are often subtle, and require meticulous craftsmanship. Even with the best equipment and competent procedure, the control of print quality is sometimes very difficult. I know from experience that there are no shortcuts to excellence. Inadequate attention to procedure or to archival considerations will yield less-than-optimum results. However, the technical issues of printing must not be allowed to overwhelm the aesthetic purposes: the final photographic statement should be logical and complete, and transcend the mechanics employed.

The procedures discussed in this chapter range from basic methods used when a substantial change in values is needed, to more subtle controls. They are presented in roughly the order they might be employed. Further refinements of values can be applied later, in the bleaching and toning processes discussed in the next chapter. Frequently you will find that several means are available to achieve a desired effect. Judgment and experience are required to make such choices efficiently, and I urge you to approach the learning process with patience. Before delving into the specifics of controlling print values, however, there is a basic issue that should be considered:

PRINT CROPPING AND TRIMMING

Ideally the original visualization should include awareness of the final proportions and desired borders of the image. However, a nat-

ural subject can be quite complex and unruly, and small details may intrude upon the edges and create visual distractions no matter what care we may take to avoid them. It is relatively easy to manage these details when using a view camera, but it can be quite difficult to be aware of them with a roll-film camera, especially if it is hand-held. In addition, the visualized final image may not fit precisely in the format of the camera; the world was not designed in 4×5–inch rectangles or $2\frac{1}{4}$-inch squares!

I usually visualize image proportions that relate to the subject. Of course these must fit within the negative format, but with that limitation, I am entirely at liberty to select any proportion I desire. I anticipate the principle "trim" when I see the subject in the viewfinder or ground-glass screen of the camera.

In printing, I crop to fit the basic trim visualized, being careful not to crop too much. The edges of the print demand careful scrutiny. A small light or dark area that intrudes near the edges may prove unduly distracting; the eye wanders to these areas continually as we "scan" the print. The composition of a rather large print can be disturbed by a small intrusion at the borders. Sometimes it helps to rotate the easel slightly to better manage subtle print edge requirements. For a small light area, we may find it necessary to spot it out. \lhd

See page 157

It may also be possible to trim off small distracting elements without harming the essential composition, and I make this final decision when mounting the prints. I suggest making several proof prints simply for experimenting with the trim. You will frequently find that trimming a small distraction from the border of a print serves to strengthen the overall composition.

EXPOSURE SCALES AND PAPER GRADES

The densities of a negative yield a certain exposure range in printing, and we can expect a paper of similar exposure scale to be reasonably well matched to this negative. If we have carefully exposed and processed the negative, it should usually have a density range that is appropriate to the exposure scale of "normal" paper. A negative of longer density range (more contrast) will require a paper with correspondingly longer exposure scale, that is, a "softer" paper. And similarly a negative of short density range (lower contrast) requires a paper with a short exposure scale — a "harder" paper. Remember that this *exposure* scale of the paper is not the same as its potential range of *reflection densities.* A paper with an exposure scale of only

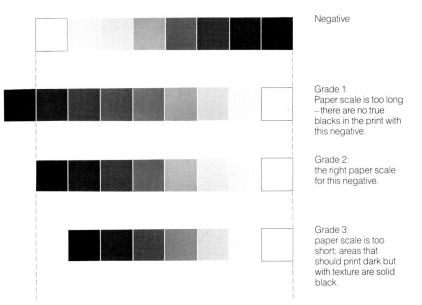

Figure 5–2. *Negative scale and paper grades.* The appropriate paper grade must be found for each negative, with its particular scale of density values. For the negative scale represented here, Grade 1 paper is too soft: when the high values are printed appropriately, the low values are only dark gray. Grade 3 is too hard: when the high values are right the low and lower-middle values print too dark. The negative scale represented here matches the Grade 2 paper scale: when the highest values print white, the lowest values are black, and intermediate values fall into place. In expressive photography we may intentionally select papers of different grades, or apply different development methods to depart from a "literal" rendering of subject contrast.

Negative

Grade 1:
Paper scale is too long —there are no true blacks in the print with this negative.

Grade 2:
the right paper scale for this negative.

Grade 3:
paper scale is too short; areas that should print dark but with texture are solid black.

1:25 may, after developing, have a reflection-density range of 1:100 or more. Once we match the paper to the negative, we can expect a full range of print densities regardless of the paper grade used.

As stated earlier, the situation in printing is analogous to the relationship between subject contrast (luminance range) and the negative exposure scale. When exposing negatives, we measure a low value of the subject and place it on one of the lower exposure zones; then we measure the higher values and see where they fall on the exposure scale. In printing, we usually consider first the exposure required to control the high values, and then use contrast controls as necessary for the low values.

By making test prints, we establish the appropriate exposure for the high values. Then, if the paper has too short an exposure scale for the negative, the low values will be too heavy, and less contrast is needed; if the paper has too long a scale, the low values will be weak and more contrast is required.

However, determination of the appropriate contrast is too subtle to permit a totally mechanical approach. Seldom can we simply measure the density range of the negative and choose a paper that appears to "match." What we will find is that one image requires more deep blacks and pure whites than another, and thus calls for different printing contrast for aesthetic reasons, even though the negatives may have similar measured density ranges. It is of great assistance

to have carefully controlled the exposure and processing of the negative, but in printing we are trying to breathe expressive life into the image, and this raises intangible issues that do not yield to formulas or measurement.

Thus the procedure is to find a paper that gives a reasonably good trial print from our negative, and then apply additional measures to work toward the fine print. In searching for a paper with appropriate scale, we must remember that a Grade 2 paper of one brand may differ significantly from the same grade in a different brand, and one batch of a particular paper and grade may not even be the same as another batch. I have three or four standard paper brands that I use regularly. In seeking a paper that "works" with a particular negative, I often find a change of brand more useful than changing grades within the same brand; frequently I can achieve the effect of a "half-grade" change by using a different brand of paper.

For example, if you are using Ilford Gallerie Grade 2, you can achieve about a half grade more contrast by changing to Oriental Seagull Grade 2. However, the Seagull tones differently from the Gallerie, so if you wish to preserve the tone values obtained with Gallerie, you will have to use Gallerie Grade 3, probably with Selectol-Soft. In general I consider it better to explore the exposure-development controls with one paper before changing to another.

Determining the exposure and contrast characteristics of different papers depends upon establishing some standard procedure. If we expose and develop two papers identically, we are almost certain to have different effects due to differences in paper speeds and exposure scales. We can depart from standard processing, however: we can adjust the exposures to compensate for the differences in paper speeds, and vary the development to control their density and contrast. By so doing, we might well achieve two prints of nearly identical quality from the two papers.

It is common for experienced photographers to make snap judgments about the paper and contrast grade they expect to use for a particular negative. As you gain experience judging negatives, you will indeed find you can estimate their printing qualities quite successfully. I would like to repeat, however, that it is usually helpful to start by making a soft proof or work print, which will allow consideration of the textures and values revealed in all parts of the negative.

It is also worth repeating that some penalty is paid for relying too heavily on changing paper grades to control image contrast instead of originally working for the optimum negative scale. A low-contrast negative combined with a high-contrast paper will yield a print in

See page 143

which some compression of light values occurs, and the shadow values may be darker than anticipated because of the effect of the paper-curve "shoulder." ◁ Less difficulty occurs when printing a contrasty negative on a soft paper, but standardizing on a Grade 0 or 1 paper leaves us no softer choice for "emergency" requirements. It is therefore best to control the contrast scale of the negative as much as possible, and standardize on a Grade 2 or 3 enlarging paper.

Once you have found a paper that gives a reasonably good print from your negative, you must determine what additional steps are needed to achieve the optimum print. Control of contrast and values can normally be achieved using:

Changes of exposure
Changes of developer
Changes of development time (development factor)
Dodging and burning
Toning (a secondary effect)

Procedures available for special situations or emergencies include:

Water-bath or two-solution development
Locally applied developer, alkali, or hot water
Variable-contrast papers (used for local contrast effect)
Pre-exposure ("flashing") of the paper
Overall bleaching (uncertain!)
Local bleaching

DEKTOL AND SELECTOL-SOFT

I recommend working with these developers — especially at first — until their potential is fully grasped. A number of others are available, but in my opinion these two developers can be adjusted to match almost any other formula by using one or the other alone, or by using them together in varying quantities.

Dektol is a metol/hydroquinone formula (comparable to D-72) that gives full, rich prints with fairly neutral color; it is an excellent general-purpose print developer. I consider development in Dektol diluted 1:3 for 2 to 3 minutes to be a good starting point for "normal" contrast (this time is often modified by factorial development◁). Some photographers standardize on a 1:2 dilution with 2-minute developing time.

See page 95

Kodak Selectol-Soft contains only metol or similar agent (the actual formula is proprietary and has not been published), which is

primarily a "surface" developer — that is, it penetrates the emulsion slowly in comparison with metol/hydroquinone formulas. The higher values of the print image develop first, and the middle and lower values are strengthened later in the development time. Consequently a "normal" development time tends to give quite a soft image, but prolonged development yields a nearly normal scale with excellent print color. Thus varying the time of development can be used to control print contrast.

If Dektol is used as the standard developer, Selectol-Soft may be tried when it is necessary to reduce contrast by *less* than a full paper grade. Similarly, if more contrast is needed but the next higher paper grade gives too much contrast when normally developed, it can be developed in Selectol-Soft to achieve the effect of about a "half grade" increase in contrast.

See page 117

Further refinement is possible by combining the two developers. The ability to combine developers this way (or with the Beers variable-contrast formulas ◁) depends on the different activity of metol and hydroquinone. Metol alone gives soft contrast, and higher contrast is obtained with hydroquinone alone (although a small amount of an agent like metol must be present to initiate the action of hydroquinone). Thus by combining a low-contrast developer with a high-contrast developer in varying proportions, intermediate degrees of contrast become possible.

A typical episode might be as follows: You have made a soft print that shows the full range of the negative, and now wish to improve the contrast. To gain contrast, you change to the next higher paper grade, but you find that Dektol is a bit "hard" for this paper. Try Selectol-Soft (1:1), using at least 3 minutes as the "normal" developing time. If this is too soft and does not provide the "brightness" you require, you can then add Dektol in varying amounts.

My usual method is to start by adding about 50cc of Dektol stock solution per liter (or 1½ ounce per quart) of Selectol-Soft *stock solution,* regardless of the dilution of the working solution. If the contrast increase that occurs with the addition of the first increment of Dektol is not sufficient, you can increase the Dektol in units of 50cc until the desired effect is obtained. It appears that about 350cc of Dektol per liter of Selectol-Soft stock (or about 10 ounces per quart) gives maximum effective contrast; that is, by the time the amount of Dektol stock solution equals about one-third the Selectol-Soft stock solution, the effect is similar to using Dektol alone.

It is important that the quantity of Dektol added be sufficient for the volume of prints to be made, or the Dektol will become exhausted before the Selectol-Soft weakens. For example, if only a few

ounces of Dektol stock solution have been added to Selectol-Soft, the solution may be able to develop only a few prints before developer fatigue sets in. My general rule of thumb when using Dektol alone is that one-half ounce (15cc) of Dektol *stock solution* is required per 8×10 print (80 square inches). Because different prints contain different amounts of silver to be reduced, the exact capacity of the developer will vary; one-half ounce per 8×10 print is quite conservative, but it is always best not to overwork the developer. In combination with Selectol-Soft, each ounce of Dektol can be expected to last longer, and the capacity must be estimated. You may need to increase the total volume of solution, maintaining the desired proportions of Dektol and Selectol-Soft, if consistency for a number of prints is important. The factorial method can help compensate for a certain amount of developer fatigue.

An alternative procedure is to develop the print in Selectol-Soft until good separation in the high values is observed, and then transfer it to a Dektol bath for completion of development. Dividing the development time in half (1½ minutes each in Dektol and Selectol-Soft) seems to have an effect about halfway between that of either developer used alone. Variation in the time the print is in each solution will permit further refinement of contrast. In this case, be sure to develop the print first in the softer developer, and use the stronger one to complete the process. This method works well when making only a few prints, or when printing more than one negative in a single darkroom session. Whatever development method is used, it is important to realize that rich blacks require full development of the print; insufficient development causes areas that are dark gray but lacking in tonal variation or texture, usually a disturbing effect.

You should not find it too difficult in most cases to achieve a good combination for the desired overall contrast, although there may be additional refinement needed. Before you proceed, however, be sure to consider the dry-down effect; in the fixing bath the print may look quite luminous and nourish your enthusiasm, but you must expect that it will lose some brilliance when it dries. ◁

See page 82

FACTORIAL DEVELOPMENT

I have so far advised developing test prints at first for a standard time. For subtle control I have used with considerable success a method I refer to as the "factorial system" for determining development time. This system involves determining the *emergence time*

Figure 5–3. *Redwoods, Bull Creek Flat, California (c. 1960).* This wall of trees marked the edge of "clear cutting" of dense forest, a common practice of the lumber industry of this area. The subject values were quite complex: the foreground trees were in strongest light from the sky, and the shadowed depths of the forest were very dark. This is an 8 × 10 Isopan negative exposed with the 19-inch component of a Cooke Series XV lens; it received Normal-minus development in Kodak D-23.

(A) A print on Ilford Gallerie Grade 1 developed in Dektol (1:3) is obviously too soft.

(B) Gallerie Grade 2, also developed in Dektol (1:3), gives more contrast than needed.

(C) By combining Selectol-Soft and Dektol an intermediate contrast range can be achieved on the Grade 2 paper. In this case I used 500cc of Selectol-Soft stock solution and 1000cc water, with 50cc Dektol stock solution (a 1:10 ratio).

Very subtle effects are possible by combining the two developers, although the difference may be limited here by the press reproductions.

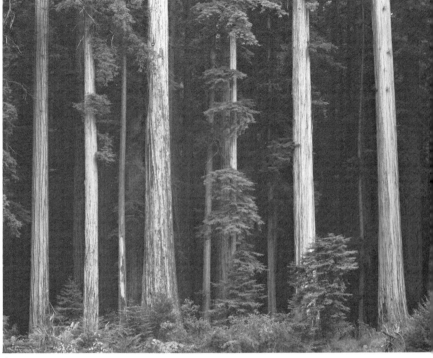

A

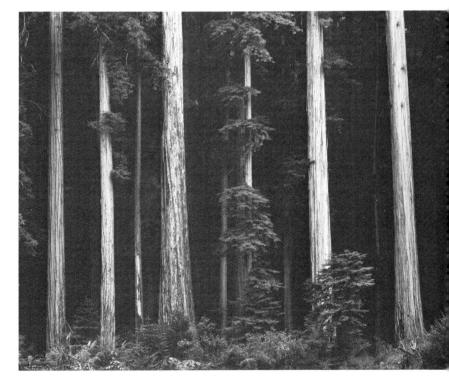

B

of a key print area, and multiplying it by a *development factor* to determine the *total developing time.*

It may seem awkward at first, but this system offers a number of advantages besides subtle control of print contrast. It helps to compensate for changes of temperature or dilution, or (to a degree) developer "fatigue"; if the developer activity changes for any of these reasons, the emergence time will change, but the factor does not. Thus if we multiply the new emergence time by the original factor to determine the new total development time, we should obtain a print that is indistinguishable from the earlier one.

See page 169

We can use the factor to determine the appropriate developing time to compensate for a change of the developer dilution. Once the factor is known, the developer can be diluted to yield a much longer total development time (this is a decided advantage when developing a number of prints at one time). ◁ The new emergence time multiplied by the original factor will yield a new development time appropriate for the change in dilution, and all the prints should be identical.

Note also that the factorial method can be helpful when the developer must be replaced. You simply mix fresh developer (of the

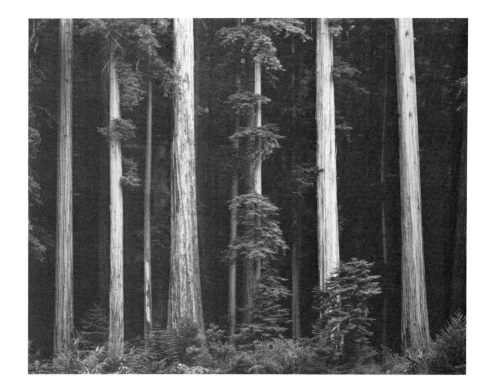

same formula) and then determine the new emergence time. Multiply it by the *original* factor to obtain the new total developing time. The resulting print should be identical to earlier prints. Without such a system, changing to fresh developer in mid-printing is far more difficult and time-consuming to control. I must remind you, however, that papers that have developing agents incorporated in the emulsion layer do not lend themselves to contrast control in development unless a developer of low alkalinity is used. ◁

See page 47

The factorial system should be applied after the first test prints have been made, when a reasonably good work print is expected. Start the timer as soon as the print is immersed in the developer, and then *watch closely* as the print develops, while agitating it constantly. You will see the image gradually appear, and you must locate one specific area you will use to determine the key emergence time for that print. This should be a middle-value area (around Value IV–V) that shows texture — foliage, or the side of a building, for example. ◁ When that area in the print "emerges" (becomes faintly visible), note the time the print has been in the developer.

See Figure 5–4

The total development time is this emergence time multiplied by the factor. For example, if you see an appropriate middle-value area emerge in 20 seconds and you are using a trial factor of 5, the total developing time would be 1 minute 40 seconds (20 seconds × 5 = 100 seconds). Inspect the print after fixing. If slightly more contrast is required, you should try a higher factor, and for less contrast, a lower one (a small exposure change may also be required to maintain the desired high values). Factors up to about 8 are usually workable; with very long development times we are likely to encounter fogging of the high values. Too low a factor (that is, too little development) causes a lack of solidity in the low values and poor print color.

Choosing the emergence area. To repeat, the "emergence area" should be about middle gray or slightly darker. In a meadow, you might look for the first trace of detail in the grass; in a building, perhaps a textured wall or door. If you look for the emergence of a dark area, like a shadowed tree trunk, you will find that it emerges rapidly in the developer and the factor needed to obtain full development will therefore be quite large; if you wait for a high value to show some texture, the factor will be small and of limited usefulness. It thus seems best to observe some value around middle gray as being accurate and efficient. I prefer, whenever possible, to select an area where there are two clearly defined values, a white and a middle gray; the gray value shows clearly against the white, and

determining the emergence time is thus more decisive. One caution: You should avoid choosing an area that has received burning or dodging, as slight variations may occur from one print to another in these operations.

Choosing the factor. The factor is usually determined while making one of the early work prints, often in the following manner: You have made a test strip, and developed it for your normal time (usually 2 minutes). You then make a full print at an exposure time chosen from the test strip. As this print begins to develop, watch for a middle-value emergence area and note the emergence time. Then give the print the remainder of the 2-minute developing time used for the test strip. For this preliminary print, the factor is the 2-minute developing time divided by the emergence time you have noted. If the emergence time is 30 seconds, for example, the initial factor is 4 (120 seconds divided by 30 seconds equals 4).

You can then adjust the factor, and thus the total developing time, to gain the desired print quality. As stated, exposure controls the high values, and the factor is altered as required to produce subtle contrast changes (other controls may be necessary, of course, if a more drastic contrast change is needed). The factor you finally choose can be used for making repeated printings of the image, provided the paper and processing are consistent. It will be helpful to record the emergence time and the factor for all proofs and prints.

Note that the factor, once chosen for the optimum print, does not subsequently change; in addition, you must keep to the *same emergence area* for the image, or the factor will have no meaning. If you find that the emergence *time* is increasing in the course of a printing session, it is a sign of developer fatigue or a drop in temperature; however, applying the known factor to the new emergence time yields a total developing time that should compensate for the developer's condition (until the developer approaches exhaustion).

If you cannot get the desired contrast by using a high factor (7 or 8 is about the limit with typical middle-value emergence areas), you must move to the next higher paper grade. On another occasion you may find that even with a factor of 3 you cannot achieve soft enough results; you would then change to Selectol-Soft or other very soft formula such as the softest Beers solution. ◁ Or you might, of course, change to a lower grade of paper with the normal developer. Remember also to consider the dry-down effect. ◁ In addition, if the finished print is to be toned, you should allow for a slight strengthening of the low values in the toning process. ◁

See Appendix 1, page 192

See page 82

See pages 130–131

A

B

Figure 5–4. *Barn and Fence, Cape Cod.*

(A) I use the appearance of the top of the fence against the grass as the emergence area for this photograph. The area emerged to the extent shown here in 20 seconds.

(B) Using the emergence area and time shown in (A), a factor of 5 yields 100 seconds total development time (in Dektol 1:3).

(C) Applying a factor of 8 to a print identically exposed causes a subtle but distinct increase in contrast. Compare the barn door, shingled walls, grass, and even the sky areas of the two prints.

See page 117

Good printing is not a simple process! As experience is gained, the trial procedures become almost intuitive, and far less time-consuming than the foregoing description may suggest. I can also attest that factorial development requires far less time and paper to arrive at high-quality results than a purely empirical approach.

To repeat, the advantage of the factorial development method is that it gives precise control of the exposure-development relationship, and counteracts the effects of developer dilution or "fatigue" and temperature change (all within reason). In most instances, the appropriate paper grade combined with factorial development will yield a print of the desired overall contrast and value rendition with Dektol. If not, you may need to change developers or try a different brand of paper. ◁

Once we arrive at the optimum printing combination, we should note the developer and dilution, development factor and emergence time, paper data, and exposure information on the negative envelope or in a notebook. However, there may very well be individual areas in the print that are not yet satisfactory, and we must next consider the dodging and burning that will be necessary.

C

DODGING AND BURNING

Dodging and burning are methods of changing the exposure of local areas within the print without affecting the overall exposure. During the main print exposure, light can be held back from certain areas by physically blocking part of the light exposing the paper. This *dodging* reduces the exposure, thus making the affected areas lighter in the final print. Then, after completing the main exposure, additional *burning-in* time can be given to specific areas that need more exposure. Although the principle is quite simple, often a rather complex sequence of burning and dodging steps is required to achieve just the right balance of values.

Both burning and dodging are done using cards or other devices (sometimes your hands will do) to control the areas affected. It is important that the device be kept in constant gentle motion throughout the operation to avoid an obvious hard edge where the burning or dodging has occurred. Carefully employed, these methods can provide local value changes that are visually "in tune" with the unmanipulated areas of the print.

See page 80

The dodging or burning time may be determined by making a separate test strip through the area requiring it. As with normal print exposures, it is useful to think of a dodging or burning-in time as a *percentage* of the total exposure. ◁ We can become quite proficient at estimating the effect of dodging or burning an area for, say, 20 percent of the total exposure time.

Dodging and Burning Procedure

In dodging, we are holding back light from selected areas of the print to raise their value. To do this we fashion pieces of cardboard which, under the enlarger light, will cast shadows of various shapes and sizes on the areas to be dodged. These cardboard shapes are attached to thin but firm wire from a clothes hanger or bicycle spoke that permits holding them in the appropriate position during the exposure. This "wand" is kept in continuous motion during the dodging; the shadow of the wire thus has no visible effect, and the edges of the dodged area are softened and made to blend into surrounding areas. It is useful to have on hand several standard dodging wands: discs of two or three sizes, and perhaps oval and rectangular shapes, will frequently be useful. These are easily made from lightweight

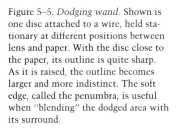

Figure 5–5. *Dodging wand.* Shown is one disc attached to a wire, held stationary at different positions between lens and paper. With the disc close to the paper, its outline is quite sharp. As it is raised, the outline becomes larger and more indistinct. The soft edge, called the penumbra, is useful when "blending" the dodged area with its surround.

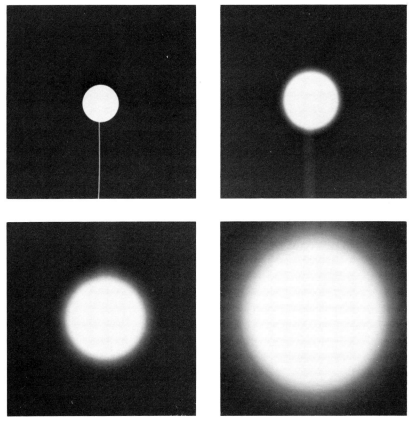

opaque cardboard, and the wire is attached thereto with strong black tape.

Burning-in requires cards large enough to more than cover the image on the easel, sometimes with a hole or edge cut to appropriate shape. The card may be white on the side facing the lens; it will then be easy to see the projected image and locate the area to be burned-in. The other side of the card, facing the paper, should be dark or black; a white surface can reflect light back to the print and cause fog. This precaution applies especially when a large area of the print is exposed through the hole in the card, or when the burning time is very long. For burning large areas the card can be used flat, or bent and held at an angle to the paper to provide a shaped edge. Small areas are usually burned using a small hole of the required shape cut in the card.

Obviously, any specific cut shapes for dodging or burning tools must be of appropriate size for the position where the device is to be held above the paper. It is often helpful to make the cutout by supporting a card at the position where it will be held, with the enlarger

Figure 5–6. *Burning-in.* A card with a hole in it is the most common device for burning. As the card is moved toward the enlarger lens and away from the paper, it affects a larger area, with a softer edge (wider penumbra).

turned on; the image projected on the card will be smaller than its final size and out of focus, but we can usually still trace the image of the area to be dodged or burned, and then make the cut shape from our tracing. This will ensure that the cutout (whether a solid shape for dodging, or a hole for burning) will be of about the right size and shape. Most camera stores sell kits that provide various dodging and burning shapes, but the photographer can easily fashion his own to meet specific requirements.

The technique for dodging or burning involves holding the device under the light source with continuous movement for the required part of the total exposure (dodging), or for an additional exposure time (burning). If the card is allowed to remain stationary, even for part of the exposure, an obvious edge is likely to be visible in the print. I suggest a continual but *gentle* movement of the device; there is no need for frantic action.

The nature of the shadow edge in dodging or burning is important. The full shadow area is called the *umbra*, and the soft, transitional area is the *penumbra*. If the dodging or burning device is held very

Figure 5–7. *Clearing Winter Storm.*
(A) The test print was exposed for
10, 15, 20, and 25 seconds.
(B) The 15-second time was chosen
to make a "straight" unmanipulated
print. Considerable burning and dodg-
ing are required, as shown in the fol-
lowing illustrations.

A

B

Figure 5–8. *Burning-in.* The upper part of *Clearing Winter Storm* receives additional exposure by burning-in. Note the slight bend I give to the card to produce the shape required. The card, of course, is in constant motion from the base of the cliffs to the top of the print, in a series of up-and-down "passages."

Figure 5–9. *Dodging.* I use a disc attached to a wire handle to dodge the two trees in the lower right portion of *Clearing Winter Storm.* Note that by rotating the disc sideways in relation to the light path, I can use it to cast an oval shadow.

close to the paper, a sharp-edged shadow results that is mostly umbra. Moving the device away from the paper produces more penumbra, giving a softer edge to the area burned or dodged. The penumbra is helpful in dodging and burning control; if a generous penumbra exists, the transition from the dodged or burned area to the open areas can be very smooth and unobtrusive.

Hence the importance of the position of the dodging/burning device. If it is held too close to the paper its shadow edge will be quite sharp, and exaggerated motion will be necessary to provide a smooth transition; if held too far from the paper, control of the area being affected will be difficult. For most applications some combination of umbra and penumbra is needed, but the proportion of each will differ depending on the character of the edges within the image. Hence for a sharper edge, hold the device closer to the paper; for more gradual transition, move the device toward the lens. I recommend that you experiment with these effects under the enlarger to see the many possible variations.

We must thus learn to slightly *overlap* the edge of the area being dodged or burned, and often a rather large penumbra is helpful. For example, when we are dodging a shadow adjacent to a bright area, the penumbra should gently overlap the edges of the bright area. To further soften the edges of the area, we can move our dodging device toward and away from the print, rather than using only a sideways circular motion, thus producing a change in the size and position of the shadow. Remember not to allow the shadow of the dodger wire

Figure 5–10. *Effect of poor dodging.*

(A) A "straight" print of the lower right portion of my *Clearing Winter Storm* shows very dark trees which obviously need dodging.

(B) Careless dodging, slightly exaggerated here for emphasis, shows a typical "halo" effect around the dodged area.

(C) More careful dodging raises the value of the trees without producing obviously illogical values in the surrounding areas.

A

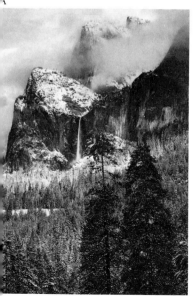

B

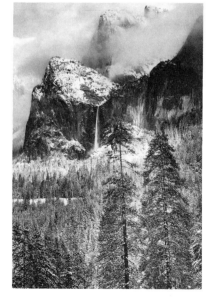

C

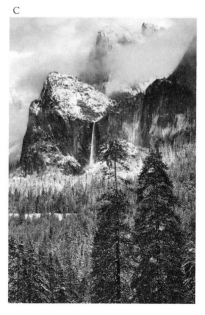

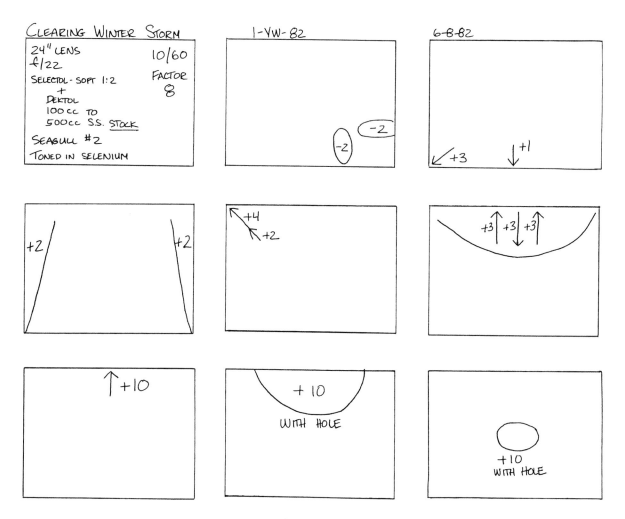

Figure 5–11. *Clearing Winter Storm, diagram of dodging and burning, and printing notes.* I almost always make a sketch of printing procedure on the back of the test prints and the final print. I then transfer the data to a separate sheet like this one, which is filed for reference. This is very helpful for future printings, although I must always make small adjustments for different batches of paper.

The basic data is in the first rectangle, and the other rectangles show the dodging and burning sequence. The areas marked with a "−" are dodged during the main exposure (light is withheld), and areas marked "+" receive burning-in after the main exposure (light is added). The time in seconds is marked next to the symbol. The final print is shown in Figure 5–12, and the printing procedure is described in that caption.

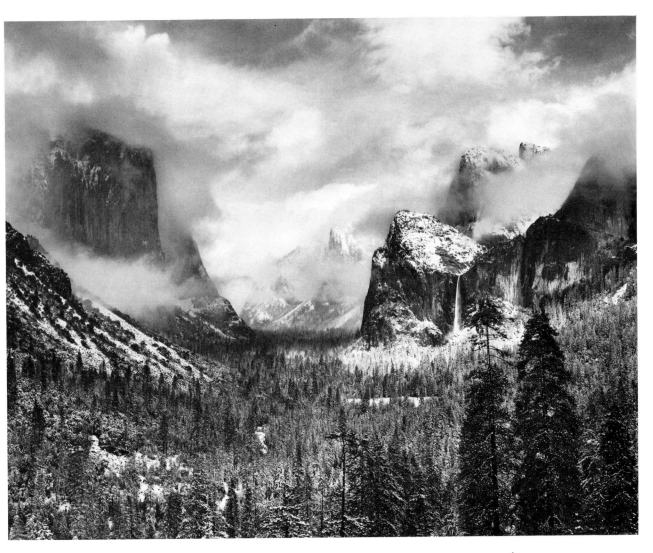

Figure 5–12. *Clearing Winter Storm, Yosemite National Park.* The subject was predominantly gray, but the emotional impact was quite strong; my visualization was rather dramatic; hence I gave reduced exposure and Normal-plus development. I used a Wratten No. 8 (K2) filter simply to reduce the slight atmospheric haze, but it did little to increase the basic contrast of the scene. I used my 8 × 10 view camera with a 12¼-inch Cooke Series XV lens, and Isopan film developed N + 1 in Kodak D-23.

During the main printing exposure of 10 seconds I hold back the shadowed cliff area near the right edge for 2 seconds, and the two trees in the right-hand corner area for 2 seconds; too much dodging will produce weak blacks (see Figure 5–10). After the basic exposure I burn the bottom edge for 1 second and the lower left corner for 3 seconds; I then burn the left edge of the print for 2 seconds and the right edge for 2 seconds, in each case tilting the card to favor the sky.

Burning is required from the base of

the sun-lit forest areas, near the waterfall, to the top of the image, with three up-and-down passages of 3 seconds each. I then burn the sky along the top for 10 seconds, continuing with 2 and 4 seconds at the upper left corner. Then, using a hole 1 inch wide, I burn the central area (between the two cliffs and the clouds above) for 10 seconds, and then bring the hole closer and burn the smaller area of cloud for an additional 10 seconds.

to remain in the same position, especially in smooth, even-valued areas. If there is a small glaring highlight, it can be softened by burning with a small hole in a card, but keep the card in motion and quite close to the print to avoid causing a dark "halo" around the high value.

We have all seen photographs where an obvious attempt has been made to burn in the sky or clouds. The card was held close to the horizon and there appears a sudden darkening of sky values, with a disturbing light area between earth and sky. To burn in a sky I usually use a pliant card, which I can bend to roughly match the horizon, held at some distance from the paper to get a broad penumbra area. I start with the penumbra well within the sub-horizon area. The motion is up from the horizon to the top of the print in, say, 4 or 5 seconds; down again at the same rate (allowing the penumbra to overlap the horizon); and back up to the top of the print. This motion is repeated as many times as necessary. If the horizon is of uneven contour, as when trees, rocks, or buildings are present, a card can be cut to an approximate match and the same plan of movement followed. The important precaution is to keep the card in *constant* motion, and to cover the burned-in areas evenly.

Finally, we must examine our results carefully. The eye is very sensitive to illogical or impossible value relationships. If we overburn a light area such as a white rock, we may not add significant detail, but only render the rock as a depressed gray. Excessive dodging can similarly cause illogical values; if detail is absent in the negative, a dodged shadow area can become an empty and murky dark gray.

Edge Burning

Mounting or overmatting a print with white board has a tendency to produce a faint "flare" effect around the borders, where the image may appear slightly weak. This is a visual effect only (uneven light distribution from the enlarger can cause a *real* loss of density at the corners and edges, but I assume the photographer has corrected any such deficiencies before printing ◁ See page 20). A slight burning of the edges of the image seems to "set" it in the mount and helps to hold the eye within the format. For an 8 × 10 print the edge burning usually begins about 2 inches in from each border. The total amount of edge burning is seldom more than about 5 to 10 percent of the basic exposure.

Note that there are two methods of edge burning, and their effects are somewhat different. ◁ See Figure 5–14 If we burn the edges separately, moving

Figure 5–13. *Thunderstorm, Near Cimarron, New Mexico.*

(A) Straight print. A lower contrast-grade paper would hold more of the values, but the all-over separation of values would be weak.

(B) With sky burned-in. I started burning with the card below the horizon, moving up to the top of the print and back again to the starting position. I then burned the upper area of the sky for additional time. The foreground was in heavy cloud shadow, and some areas of the sky were quite bright. The effect of this print is what I desired and visualized.

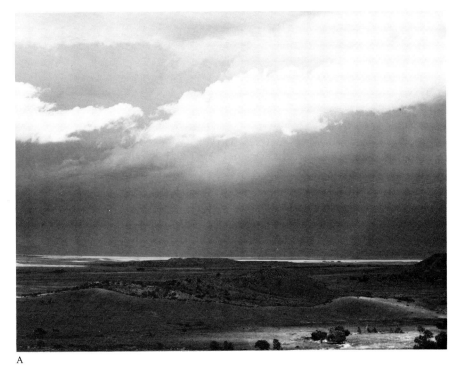

A

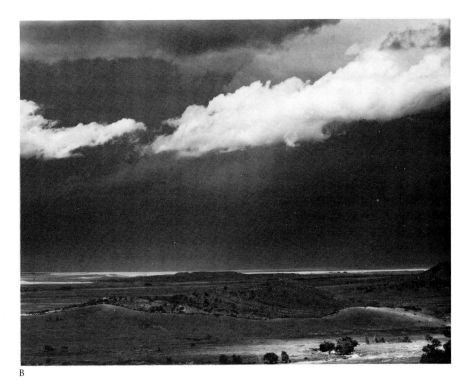

B

Figure 5–14. *Effect of two edge-burning methods.*

(A) Burning outward from the central area of the image causes an equal increase of value on all edges and corners.

(B) Burning each side separately causes an accumulation of exposure in the corners, and they become darker than the central edge areas. This can often be a useful effect.

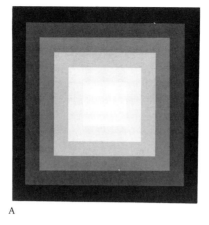

A

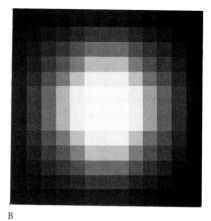

B

Figure 5–15. *Dead Foxtail Pine, Little Five Lakes, Sierra Nevada, c. 1929 (the effect of edge burning).*

(A) A straight print from the 4×5-inch negative. The flare on the left side comes largely from the sun, which was fairly close to the field of view. The lens was uncoated, and the sun-shade inadequate. The camera bellows also contributed relfections to the film.

(B) Judicious edge-burning equalized the values. The left and right sides were burned down to balance the flare. The top left corner received some burning, and the bottom corner areas were lowered in value by the edge-burning. A short burning along the bottom edge gave some solidity to the image.

A

B

Figure 5–16. *Richardson Redwood Grove, California (c. 1932).* This is an exceedingly difficult negative to print. I made the negative before the Zone System had been formulated, and the rule was simply to reduce negative development for a high-contrast subject. Taking an average meter reading (with an early Weston meter) yields typical results: underexposed shadow values.

The print was achieved by testing for optimum brilliance with a soft contrast grade of paper, while holding a trace of value in the shadows. Then, very carefully, I dodged the shadowed tree trunks with an oval wand (about ½ × 2 inches), covering each tree trunk from top to bottom for about one-third the time of the basic exposure. The dodging must begin somewhat *above* the top of the tree trunks and end *below* the bottom; otherwise these areas will appear too dark. *Slight* overlapping of adjacent areas is essential for consistent effect. The sunlit side of the left-hand tree was burned with a small hole from top to bottom for an additional half of the total exposure time, and the upper right corner was burned for about 15 percent of the time.

My lens, a 30 cm Goerz Dagor, was uncoated and produced a small amount of over-all flare (Book 1, pages 69–73). An uncoated lens can be helpful with such contrasty subjects, giving an effect somewhat similar to pre-exposure (Book 2, pages 119–123).

I was using an 8 × 10 camera and Kodak Supersensitive Pan film developed in Ansco 47. The print was made on Brovira Grade 1 developed in Dektol.

A

Figure 5–17. *Interior of Church, Men-docino, California.*

(A) In an early work print the white stair wall, illuminated by a window at the far right, does not seem logical, even though it is quite true to the subject.

(B) In the best work print, I have burned down the wall to an agreeable and logical value by using a card held fairly close to the lens so it had a wide pneumbra. I "trailed" the pneumbra within the stair railing, holding it suf-ficiently close to the lens so that the burning always included the entire wall. The print needs more refined burning in the lower left corner and near the newell post. I prefer the burned-in values of the window in Fig. 17A.

My camera was a 5 × 7 Zeiss Juwel with a 7-inch Dagor lens and no filter. The film was Isopan given Normal-minus development in D-23.

B

the card out to each edge from about one-fourth of the way into the print, the corners will "accumulate" exposure. Each corner will have been burned-in during two of the edge exposures, and thus the corners will be darker than the central portion of the edges. This is sometimes effective, depending entirely on the distribution of values within the image.

The alternative is to use a card of oval or rectangular shape that relates to the proportions of the image format and allows burning all four edges simultaneously. Move the card towards and away from the paper with a smooth steady movement that exposes the area from each edge about one-fourth of the way into the print. With this method, all edges and corners receive the same increment of light, with no accumulation of exposure at the corners.

My experience indicates that nearly all photographs require some burning of the edges. The edge-burning must not be overdone, however; the viewer should not be conscious of it.

CHANGES OF DEVELOPER

Amidol

See Appendix 1, page 192

Amidol may be found to give a slightly warmer image color than Dektol, in spite of the presence of benzotriazole in the amidol formula. ◁ This formula has slightly less contrast than Dektol, the equivalent of about one-third paper grade in our tests at 3-minute developing time. Variation of development time over a range of about 2 to 4 minutes gives some control of contrast, however; the amidol formula at 4 minutes seems about equal in contrast to Dektol (1:3) at 3 minutes. Of course the effects of amidol on the chloride contact-printing papers used by Weston and others fifty years ago are not the same as with modern papers. With current papers amidol appears to yield good separation in the middle values. Amidol seems to require about a full stop more exposure than Dektol.

The Beers Formulas

The Beers two-solution formula is an old standard in photography, but is still useful today. Two separate stock solutions are prepared, one containing metol alone as the developing agent, and the other primarily hydroquinone. These solutions are then combined in varying proportions depending on the degree of contrast desired. The total range of contrast control available is slightly greater than the range available by combining Dektol and Selectol-Soft, although the latter is a far more convenient method because the chemicals are pre-mixed. The No. 1 Beers formulation is about equal in contrast to Selectol-Soft, and the No. 7 gives somewhat more contrast than Dektol. The formulas will be found in the Appendix. ◁

See Appendix 1, page 192

Figure 5–18. *Cypress Trees in Fog, Pebble Beach, California.* The foliage of the distant tree seemed slightly light where the left-hand tree trunk crosses it (an effect of the sea fog), so I applied a little burning-in with a small hole in a card. Some burning was also given the lower left-hand and right-hand corners to simplify the composition, along with about 10 percent edge burning.

Other Developers

There are numerous other paper developers available. One of the more interesting we have tested recently is Edwal G, a prepared liquid developer that contains sodium hydroxide, and thus is quite powerful. This developer gives about one-half grade more contrast than Dektol, and is very fast acting. We found that prolonged devel-

opment with Edwal G produces noticeable fogging. Several other developers, such as Ethol LPD and Ilford Bromophen (a phenidone-hydroquinone developer), appear to me to be almost identical in effect to Dektol.

See page 47

As discussed earlier, ◁ papers with developing agents incorporated in the emulsion layer do not yield to control of contrast by changing development. This is not of great concern at the present time, since only RC papers currently include developing agents.

RESTRAINER AND ANTI-FOG SOLUTIONS

See page 55

As mentioned earlier, ◁ age, poor storage conditions, and chemical action can cause fog (unwanted reduction of the silver halides), which is visible as depressed high values. Assuming safelight fogging has been ruled out, try adding a small amount of restrainer to the developer. The restrainer can usually prevent such fog, giving crisp rendering of high values.

Potassium bromide (KBr) may be added as a restrainer. It should usually be prepared as a 10 percent solution (to mix the 10 percent solution, dissolve 100 grams of KBr in 900cc of water, and then add water to make one liter). You might begin with about 50cc of 10 percent KBr per liter of *stock* developer. If you have mixed one liter of stock developer with 3 liters of water (to make a 1:3 developer working solution), you should still measure the potassium bromide solution in relation to the amount of developer *stock* present in the working solution, in this case one liter. Check on the effect of the bromide, and add more as necessary until you have the desired effect. Examine the print in daylight if feasible, for a more accurate color evaluation. The bromide sometimes adds a slightly greenish tone to the image, which can be overcome in most cases by selenium toning. Papers and their inherent effects vary, so it is difficult to advise on the precise amount of bromide to add, or the color effect.

Benzotriazole (Kodak Anti-Fog #1) provides about the same restraining effect, but produces a noticeable shift in print color toward the blue. I usually add 1 percent benzotriazole solution in quantities of about 25cc per liter of *stock* Dektol. Do not add more than needed to clear paper fog. Adding about 50cc of benzotriazole causes a noticeable color shift toward the blue, and with 100cc the effective speed of the paper is reduced by roughly two-thirds stop. Increased amounts of benzotriazole seem to affect the image contrast some-

what, more so than potassium bromide, but this effect may depend on the paper and developer used.

The use of both these chemicals effectively reduces the speed of the papers, and thus requires an increase in exposure. They may also lengthen the emergence time of the image in the developer, and some papers may therefore require lower than normal development factors. With contemporary papers benzotriazole will cause a distinct "cooling" of the image color, and potassium bromide will increase its "warmth."

WATER-BATH AND TWO-SOLUTION DEVELOPMENT

An unusually difficult problem of excessive contrast can sometimes be managed by transferring the print from the developer to a deep tray of water and allowing it to stand without agitation for a minute or two; the print is then returned to the developer, and the cycle is repeated as many times as required. The principle is the same as for water-bath processing of negatives:◁ in the water, the dark areas of the print will soon exhaust the developer retained there, while the high values continue developing, and thus the high values receive proportionally greater development. The result is an increased revelation of the high-value qualities, and a somewhat restricted development of the low and middle tones of the print. If water-bath processing is found to yield weak low values, the print can be given a final immersion in the developer before being transferred to the stop bath. Remember that prints that are exposed to safelights for extended periods, such as when lying in a water bath, may show fog; shield the print or turn off the safelight over the tray for most of the developing and water-bath time.

See Book 2, page 229

There is no way to give a precise formula for this process; it requires testing and experimentation. In particular you must be aware of the possibility of mottle appearing in smooth, textureless areas of about Value V–VI, such as cloudless sky. Water-bath development is generally best suited to textured subjects, where slight unevenness will be less apparent. There are two procedures than can help eliminate mottle: during the water bath, a *slight* agitation can be given. Tipping the tray gently every 30 seconds, both to one side and to the back or front, reduced mottle problems in our test examples, but it also reduces the water-bath effect.

We have also found that replacing the water bath with a 10 percent sodium carbonate solution reduced the problem. This is analogous to

See Book 2, page 229

the two-solution development sometimes given with negatives. ◁
Try a 30-second immersion in Dektol, 90 seconds (without agitation) in the 10 percent carbonate, and then another 30 seconds in the developer, before transferring to the stop bath. In some cases the carbonate seems to give more uniform densities than a plain water bath.

LOCALLY APPLIED SOLUTIONS

In situations where a small recalcitrant area cannot be burned without affecting adjacent areas, we can sometimes resort to applying solutions locally. Each of the approaches described below accelerates the development of the local area, thus causing a darkening of value. We must be careful using these procedures to avoid the spreading of the accelerator effect into areas where it is not wanted. Otherwise we may have a "dark halo" around the treated areas. In general I recommend repeated applications for short periods of time, with surface rinsing and/or wiping in between.

The procedures require a flat-bottomed tray or other flat surface; a middle-sized watercolor brush; and a container of fresh water to clean the brush between operations. The procedures are as follows:

1. *Hot water.* Fill a container with very hot water; the water will cool rapidly on the brush, so apply it quickly to the print. Also I suggest using a fairly dilute developer for the print, in order to have a relatively long developing time. As development proceeds place the print on the smooth surface, and use the brush to apply hot water to the area needing more development. Give a few applications of 10 to 15 seconds each, and then return the print to the developer. The hot water accelerates the activity of the developer that has soaked into the print emulsion.

2. *Stock developer.* Applying strong developer solution also will darken the value of the affected area. I suggest using the stock solution warm (about 100°F). Wipe off the print surface with a clean sponge and brush on the stock solution. Let it rest about 10 seconds, and return the print to the developer tray. Repeat if necessary.

3. *Strong alkali.* The alkali is an "accelerator" of the development process, and using a warm, concentrated solution is sometimes more effective than other methods. Sodium carbonate in a saturated solution (i.e., a solution in which you have dissolved all the sodium carbonate possible) will be effective. Several applications may be required.

VARIABLE-CONTRAST PAPERS

See page 48

Variable-contrast papers (Kodak Polycontrast, Ilford Ilfo-Speed Multi-Grade) can, of course, be used with appropriate filters to control overall image contrast. ◁ But we can also use variable-contrast effects in individual print areas. For example, the No. 2 contrast filter may

Figure 5–19. *Los Trampas Church, New Mexico.* The reality was of rather low contrast, but I intentionally visualized the image as a full-scale photograph. Clouds behind the camera reflected considerable light on the shadowed facade. The deepest shadows retain texture, and only the distant bright clouds and small areas of the sunlit wall approach "burn-out."

In the original print some evidence of "split tone" can be seen (see page 133). The light walls and most of the sky did not tone as did the middle and low print values. In this subject the effect is not objectionable, and some think it attractive.

I used a 4 × 5 view camera with 8-inch Kodak Ektar lens and a Wratten No. 12 filter. The film was Kodak

Plus-X at ASA 64, developed for normal time in Kodak HC-110. I printed on Kodak Polycontrast developed in Dektol. A Kodak No. 3 Polycontrast filter was used for the main exposure, followed by the No. 1 Polycontrast filter for burning in some small high-value areas.

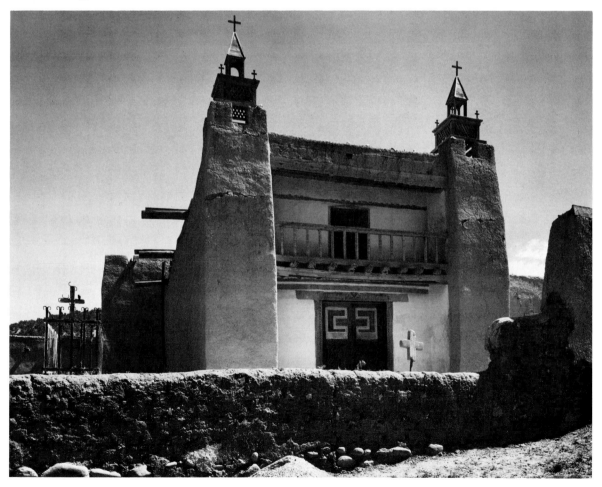

Figure 5–20. *House and Fern, Maui, Hawaii (c. 1953).* The negative was made with a Hasselblad camera and 60mm Distagon lens. The film was Plus-X, used at ASA 125 instead of its optimum ASA of 64; hence the wall in shadow (placed on Zone III) was underexposed. Conventional printing to hold the full scale of the negative results in a flat rendition of shadows; increasing paper contrast helps the shadows but "blocks" the high values of the sunlit ferns. The problem was solved by printing with both the No. 1 and the No. 4 Polycontrast filters in sequence, as follows:

(A) The number 4 filter (maximum contrast) gives maximum separation of the wall values. The ferns, of course, are fully blocked out.

(B) The No. 1 filter (lowest contrast) suggests appropriate value of the ferns.

(C) Using the two filters in sequence gives a balance of values I could obtain in no other way (except a complicated masking process).

It is important to note that there is no "formula" for this approach. For example, when the shaded rock wall is properly exposed with the No. 4 filter, it is obvious that any additional exposure with the No. 1 filter will add to the original exposure. Hence, I gave the entire image exposure with the No. 4 filter, and I then shielded the wall area while printing the fern area with the No. 1 filter. The junction of the sunlit and shaded areas was balanced by burning with a small oval hole in the card, carefully moving it from left to right across the image, following, with broad penumbra, the contours of the foreground area.

A

B

C

be appropriate for the overall values of an image, but some low values may require additional contrast, or some high values may need greater separation. We can then make the main exposure using one filter, and use a different filter for burning-in. To burn-in small areas, the filter can be placed directly over the opening in the card, provided it is of good optical quality (such as the Kodak Polycontrast filters).

FLASHING THE PRINT

See Book 2, page 119

In some circumstances "flashing" the print may serve to reduce contrast and enhance separation of high values. This process is similar to pre-exposure of negatives. ◁ But unlike negatives (where we can "print through" the filmbase-plus-fog and pre-exposure densities), prints may easily show a *visible* high-value density from pre-exposure. Thus we must take great care with the degree of flashing to avoid an obvious depreciation of the high values.

Flashing is appropriate for subjects that have slight substance in their highest print values, that is, various close tonalities that are difficult to hold in the print. Such subjects often include clouds, white water, or white painted objects. With subjects that show scintillations (specular reflection) as their highest value, flashing must not be allowed to depress these areas. Such depression of high values may be visually acceptable where texture is present, but is not appropriate for pure white values.

I suggest using a piece of diffusing plastic over the enlarger lens for the flashing exposure. The negative can remain in place, with the lens set at the aperture used for the main exposure. The diffuser will cause a "haze" of light to be projected, but no image. It may be necessary to experiment with various combinations of main exposure and flashing exposure. Above all, you should avoid any appearance of graying of the high values. In general, flashing is not a method of contrast control I would use for fine prints except as a last resort. It may be useful, however, when making prints for reproduction, where high-value texture and substance should be fairly strong.

TILTING THE EASEL

See Book 1, Chapter 10

This is not a value control, but an extension of image management. ◁ All photographers have at times suffered "geometric anomalies" — convergence of lines that should be parallel, caused by

Figure 5–21. *Convergence control in printing.* Parallel lines that converge in the negative can sometimes be corrected in printing, provided the convergence is not too severe. The easel is tilted, using a support underneath that can be moved side-to-side to adjust the slope. If the enlarger design permits, the lens is also tilted, in the same direction but to a lesser degree. The lines representing the three principal planes (negative, lensboard, easel) should meet at a single point for optimum focus (see Book 1, pages 149–154). If the enlarger lens cannot be tilted, adequate focus may be achieved for a moderate tilt of the easel by stopping the lens well down. Some professional enlargers are equipped with tilting devices on camera and easel.

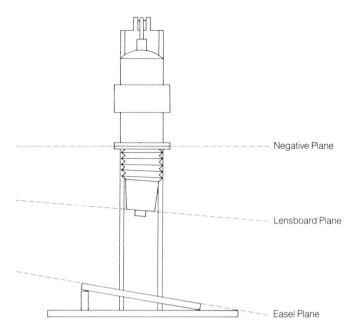

Negative Plane

Lensboard Plane

Easel Plane

See Book 1, Chapter 10

improperly adjusting a view camera, or using a camera without adjustments. ◁ Strong convergence is frequently less unsettling than a slight convergence that suggests carelessness. With natural objects a slight convergence is not usually noticeable, but with buildings it is often difficult to accept.

Convergence of parallel lines can be overcome to some extent in enlarging. Ideally we would tilt the enlarger negative plane, lensboard, and easel, although most enlargers are not designed to permit adjustments. In most cases, therefore, the amount of correction is limited. The Beseler 4 × 5 enlarger, however, does permit lateral tilting of the lens.

The first step is to tilt the easel, while the negative is projected on it, until the converging lines become parallel. The principle is to *raise* the edge of the image where the lines must be brought closer together. Doing this naturally throws the image out of focus. If no lens tilt is possible, we must then refocus and stop the lens well down to see if the entire image can be brought into focus.

Tilting the lens will help greatly in correcting focus. The lens is tilted in the same direction, but not as severely, as the easel. We then refocus and stop down the lens until all parts of the image are sharp. Tilting the lens raises other potential problems, however. The coverage of the lens may not be sufficient to allow the required degree of tilt for full correction of focus. In that case, tilt the lens as

far as its coverage permits, and see if the image is sharp all over at the smallest aperture. It will help to focus on a point on the easel about one-third the distance from the raised edge to the far border, on the same principle as when focusing a camera. ◁

See Book 1, pages 48–52

These controls may introduce some unevenness of illumination that must be corrected by careful dodging and burning.

Figure 5–22. *Alfred Stieglitz, and O'Keeffe Painting, New York.* This photograph was made in Stieglitz's important New York gallery, An American Place. Working with limited time, I set the camera in true vertical and horizontal level, but I failed to have the camera back (film plane) parallel with the wall.

(A) The camera was pointed slightly to the left, and the horizontal lines show convergence (they are closer together at the left). I could have turned the camera more to the right and used the sliding back or front to bring the image into the desired position on the ground glass (see Book 1, pages 141–146). This would require adequate lens coverage capability. Lacking that, I would have moved the entire camera and tripod to the left, which would have required re-check-ing of the levels and the composition. A grid focusing screen is helpful in situations where convergence must be avoided.

(B) I corrected the geometry of the image by tilting the easel while enlarging. Note that the top of the painting is now parallel with the border of the photograph.

A

B

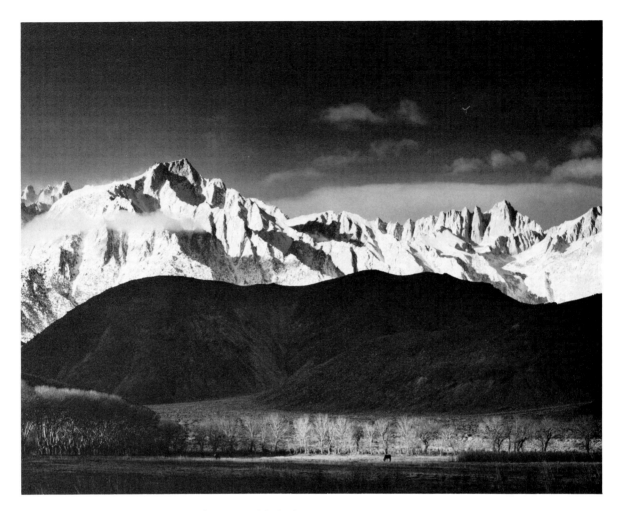

Figure 5–23. *Winter Sunrise, Sierra Nevada, California (1944).* This is a well-known image which I have printed in various ways over the years. The original visualization remains intact, but the problem is to achieve adequate "performance of the score"; the optimum print I have still to make! A description of the complete printing sequence I presently use may be informative:

During the basic exposure (usually about 30 seconds) the central area of the sunlit trees is dodged for about 5 seconds, as are the far left dark areas of the hills and the grove of trees (the entire left area is later burned in for about 5 seconds). The foreground is burned in for about 8 seconds, the left edge for 10 seconds, and the right edge for 5 seconds. By edge I refer to an area from several inches into the image to the border; this effect should never be obvious.

I then burn from the sunlit trees to the top of the dark hills, giving two up-and-down passages of 6 seconds each, bending the card to approximate the contour of the hills. Then I burn from the top of the dark hills to the top of the sky in four passages of 5 seconds each. If I burn too long just above the clouds I depress the brilliance of the snow peaks. Then, with a 2-inch hole in a card, I support the left-hand upper quadrant with 6 seconds of burning, and the right-hand upper quadrant with about 10 seconds of burning, necessary because of light haze in the sky. The snowy area at the extreme right requires about 15 seconds' burning; it is at a glare angle to the sun and needs some value reduction.

My camera was an 8×10 view camera with the 23-inch element of a Cooke Series XV lens. I used a Wratten No. 15 (G) yellow filter and Isopan film, which I developed N + 1 in D-23. The print was made on Oriental Seagull Grade 3 developed in Dektol.

THE FINE PRINT (SUMMARY)

I have described a number of procedures for subtle print control (and will discuss several more in the next chapter), without attempting to describe verbally what a fine print looks like. The qualities that make one print "just right" and another only "almost right" are intangible, and impossible to express in words. Each stage of printing must involve careful scrutiny of effect and refinement of procedure. Once you know what truly fine prints look like, trust your intuitive reactions to your own prints!

In evaluating the print some of the qualities to look for include:

— Are the high values distinct and "open," so they convey a sense of substance and texture without appearing drab or flat?
— Are the shadow values luminous and not overly heavy?
— Is there texture and substance in the *dry* print in all areas where you sought to reveal it?
— Does the print overall convey an "impression of light"?

My former assistant John Sexton, an accomplished photographer and teacher, has made the following observation about the refinements of printing: "Students often print with a lot of contrast to get 'good blacks and whites,' but somehow overlook the subtle shades of gray. Many are taught that, when you have a good black and a good white in a print, then you have a good print. Actually, when you achieve a good black and a good white in a print, you are then ready to *begin* to print the negative. You have just reached the point of having a good test strip!"

I cannot possibly describe all the opportunities for enhancing an image, or the attendant creative satisfaction. It should be understood that the subjective process need not terminate after one printing; I have reexamined prints after a period of years and become aware of refinements which I might put into effect. I can only urge you to approach the process with patience and an open mind. Perhaps you will now appreciate why I consider the making of a print a subtle, and sometimes difficult, "performance" of the negative!

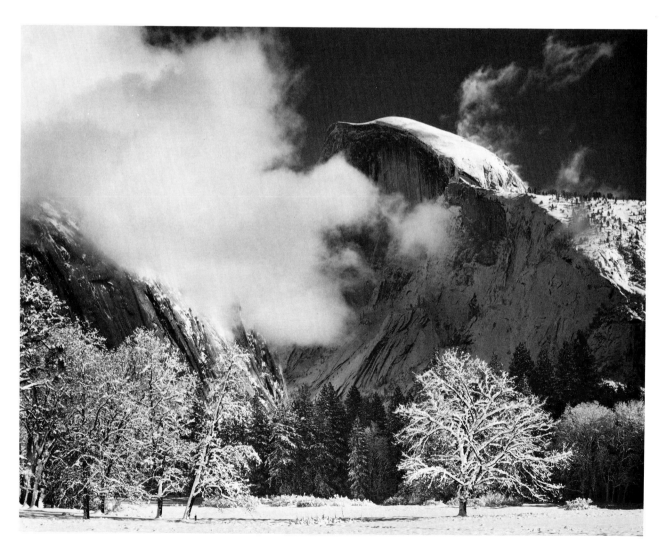

Chapter 6 **Final Processing; Sensitometry**

Figure 6–1. *Half Dome, Clouds, Winter, Yosemite Valley, California.* The problem here is to differentiate between the whites of the sunlit snow and the cloud. The sky area was burned about 15 percent, and both edges received about 10 percent burning. The level snow on the valley floor was of about the same values as the snow in the trees. I burned the level snow area by moving a card with a small hole constantly across the image for about 20 percent of the total exposure. I used the hole rather than the edge of a card because I wanted to "explore" this area, avoiding over-burning of the tree trunks. Without this burning the snow value was quite unpleasant. The trees on the left were in the beginnings of an encroaching cloud shadow, and were in full shadow a short time after exposure.

I was using a 4 × 5 Arca Swiss camera with 121mm Schneider Super Angulon lens and a Wratten No. 12 filter. The film was Kodak Tri-X and I gave Normal-minus development in HC-110. The print was made on Ilford Ilfobrom Grade 2 developed in Dektol.

Careful fixing and final processing are extremely important if prints are expected to last more than a few years or decades. For test prints and work prints that are to be saved only for short-term reference, a somewhat abbreviated fixing and washing procedure is adequate. However, fine prints should be processed fully and toned, and all file proofs and work prints will require full two-bath fixing and washing. Many documentary and news photographs are also worthy of archival preservation; such photography is visual history, and should be respected. Thus the specifics of the final processing may vary somewhat depending on the intended use of the prints.

The use of two separate fixing baths is very important, and should be considered standard practice for all prints. The two-bath process is necessary because some of the by-products of fixing are contaminants that form in the hypo solution as it is used. These substances are extremely difficult to wash out of the paper fibers; the fresh second fixer helps prevent their formation and removes any that are present. The prints must be agitated and separated constantly throughout the fixing process. However, you must avoid over-fixing, since the fixer itself will begin to bleach out the image silver, especially if a rapid fixer is used. In addition, prolonged fixing allows the hypo and residual contaminants to permeate the paper fibers thoroughly, and they become even more difficult to remove. Use fresh fixing solutions and observe the time closely.

FIXING AND WASHING UNTONED PRINTS

For prints that are *not* to be toned, I recommend an acid-hardening fixer for both solutions — a 3-minute treatment in the first fixer followed by 3 minutes in the second. A plain hypo bath is sometimes used for the second fixer, but in that case the wash water must be relatively cool — about 65°F — to avoid possible detachment of the emulsion along the print edges. During the work session, prints can be stored in cold water after the first fixing and a thorough rinse. They are then given the second treatment in fixer at the end of the session. Since the second fixer does relatively little "work" and contains few contaminants, it is possible to save it and use it as the *first* fixer in the next printing session; however, I now use fresh fixer for both baths.

When taken out of the second fixer, the prints should be rinsed on both sides under running water to remove surface chemicals, and then placed in a deep tray or sink for further rinsing. An initial 5- to 10-minute rinsing through several changes of water is very important to remove the bulk of the fixer and residual contaminants. A strong stream of water is not required for adequate rinsing, but it is important that all prints be separated and that fresh water be supplied at an adequate rate. The prints should then be treated for 3 minutes in Kodak Hypo Clearing Agent or the equivalent, mixed as directed on the package, followed by a rinse and final washing. ◁

See page 134

FIXING, WASHING, SELENIUM TONING

Prints that are to be toned should receive only the first 3-minute treatment in acid-hardening fixer. They can then be rinsed and stored in cold water until you are ready for the second fixer treatment just prior to toning, as discussed below.

A number of toning formulas are available, and many provide both a change of image color and a measure of protection of the finished print from harmful gases in the air. Sulfide toning has archival benefit, for example, but I do not favor the print colors it yields. The only toner I use or recommend is selenium, which produces a slight cooling of the image color and neutralizes the unpleasant greenish cast of many papers. As toning continues, the low values become deeper and richer and assume a degree of color, usually a cool purple-

brown, depending on the paper type. The resulting slight contrast increase should be anticipated when making a print you expect to tone. Selenium toning is an important part of archival processing of prints, ◁ and it is also an excellent intensifier for negatives. ◁

See page 139

See Book 2, page 235

I strongly advise using the pre-mixed toner; the mixing of selenium toner from basic ingredients can be dangerous in that inhaling the selenium powder is very harmful. With the prepared solutions (such as Kodak Rapid Selenium Toner), I am not aware of any danger (although ingesting the solution is certainly not advised!). I have used selenium toner for over forty years with no apparent ill effects. However, for those who have an allergic reaction to selenium, the use of rubber gloves or tongs will be necessary.

I must also caution about the image color effect of selenium toning. The color changes are often subtle, and the final visual effect depends partly on such details as the nature of the light used to evaluate the prints during toning, and the viewing light used for display. The subtle color changes of toning are more apparent under tungsten lighting than in daylight. In addition, the degree of development of the print will affect the toning action: prints that received shorter development time tend to take on a warmer and more obvious tone, and prolonged development of the print minimizes the color change. Sometimes prints will lose tone in the final washing and drying. All these effects may vary from one paper to another, and experimentation is required.

Figure 6–2. *Rocks, Baker Beach.*

(A) This is a slightly soft print on Ilford Gallerie Grade 1.

(B) An identical print was treated in selenium toner. Ilford Gallerie is unique in having a strong tendency to intensify in selenium toner with almost no color change.

In previous years, when papers could be neatly classified as chloride, chloro-bromide, bromo-chloride, and bromide, the selenium toning effects could be predicted largely by paper type. It was generally agreed that the more silver chloride a paper contained, the more pronounced the effect of selenium toning; bromide papers

A

B

toned only slightly, if at all. My more recent personal experience indicates that papers such as Azo (presumably still a chloride paper) tone very well. Many other contemporary papers tone beautifully, ◁ but the effect must be determined by trial since we do not know the composition of their emulsions.

See pages 49–51

Toning Procedure

The instructions for Kodak Rapid Selenium Toner recommend (after two fixing baths and a wash) a pre-toning bath of Kodalk or Kodak Hypo Clearing Agent. This step achieves two important chemical results — it removes residual silver-sulfur compounds and counter-acts any acidity in the emulsion. Selenium toning requires an alkaline environment or stains may result, especially in the whites and high values of the image.

I have modified this procedure by using the following sequence:

The first fixing of the prints should be in an acid-hardener fixer (Kodak F-5 or F-6, or the pre-mixed Kodak Fixer), for about 3 minutes with continuous agitation. This is followed by a *thorough* rinse. When ready to tone, treat the prints with a *plain* hypo bath (2 pounds of hypo per gallon, to which about 4 ounces of sodium sulfite is added) for 3 minutes. You must include a thorough rinse or water storage between the first fixer and the second, or the acid fixer carried into the plain hypo may cause the latter to form a precipitate, turning it a milky white and rendering it useless. If the prints are insufficiently fixed, or fixed in an over-used bath without the fresh plain hypo bath, the toning may be uneven and show stains. The sulfite added to the plain hypo solution prevents stains.

The prints are then transferred *directly* from the plain hypo bath to the toning bath. Instead of using plain water, I dilute the Rapid Selenium Toner 1:10 to 1:20 with Hypo Clearing Agent working solution, which is made up from 1 part stock to 4 parts water.

Some papers show differences in print color at the different dilutions of toner. With papers that tone rather rapidly, the more dilute solutions will give greater control. If you desire a marked color change, you may wish to use the stronger dilutions; if your intention is primarily to provide archival protection and neutralize the greenish print color, a weaker dilution allows more consistent results.*

*There has been some recent evidence that maximum archival benefit occurs with selenium toner if it is used at dilutions of 1:5 to 1:9. At this strength, the toning time

The toning requires 1 to 10 minutes or more, depending on the toner strength and paper, with continuous agitation. I have sometimes achieved beautiful results with only 1 minute's toning; a different paper might demand as much as 10 minutes with the same toner concentration. Occasionally, prolonged toning *reduces* tone, or stops toning and then intensifies the image. You should monitor the progress of the toning by having a bright light over the toner tray. It is very helpful to have an untoned reject print nearby in a tray of water for comparison purposes. It is important to agitate constantly in all solutions to assure thorough chemical action and to avoid unequal areas of toning.

Just before the prints reach the degree of toning you desire, immerse them in plain hypo-clearing solution for 3 minutes. The toning activity continues for a short time after the print is removed from the toner, and the print must be agitated in the hypo-clearing bath to fully arrest the process; never allow the print to stand in the hypo-clearing bath without agitation, or uneven toning may result. Then rinse and wash the prints as described below.

Temperature is not critical, but all solutions should be about normal (68°F, 20°C), *except* the toning bath, which I have found should be somewhat higher — about 75°–80°F. If the wash water were of higher temperature than the toning solution, some of the tone might be reduced or lost. The reason the tone can be lost is, I understand, that the selenium reacts with the emulsion in two ways, by forming a silver-selenium compound or by attaching to the surface of the silver grain. In the latter case the selenium can dissipate in solution or can actually be wiped off the wet print. Both situations assure archival protection; when dry, the selenium is firmly associated with the silver grain in either case.

Occasionally "split toning" occurs. The middle to low values may respond to the toner with added density and color, while the higher values do not respond at all. As noted, this is especially likely to occur with papers that contain a mixture of emulsions, such as variable-contrast papers. ◁ The result is seldom agreeable: a greenish color prevails in the high values while a cool brown color appears in the low values. (However, there are photographers who make use of

See page 121

will be quite short with some papers if you are to avoid excessive change in color, and I prefer the higher dilutions because of the greater control possible. In addition, I have recently been advised by scientists at Eastman Kodak that there may be no advantage to mixing Hypo Clearing Agent, instead of plain water, with the selenium toner. However, since this was previously considered the preferred method, I am continuing with the use of Hypo Clearing Agent; I have used this system for many years with apparent success.

split-toning or similar effect for aesthetic purposes — Olivia Parker has made magnificent prints in this way.)

It is sometimes a practical advantage to accumulate prints from several days' darkroom work and tone them all together. In such cases it is best to give prints the first fixer and a *complete* washing, and then dry them. When ready to tone, soak the dry prints in plain water for several minutes before immersing them in the plain hypo solution.

FINAL WASHING

Careful washing of prints is an essential factor in preserving them. Both the residual hypo and the silver compounds produced during fixing will eventually cause discoloration and damage to the image if not removed. Since fine prints are on a fibrous paper support that absorbs contaminants, they require more washing than negatives or RC prints, on their impermeable bases.

Figure 6–3. *Print washing.* The advantage of archival print washers, such as these from Zone VI Studios, is that they keep the prints separated throughout washing. If prints are allowed to stick together, no washing effect occurs, and residual contaminants are likely to remain in the print. The washer should provide good water circulation to all areas, although not all washers are equally effective in this regard.

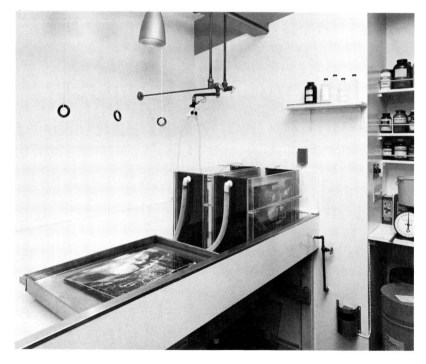

After the hypo-clearing treatment, the prints should be thoroughly rinsed. This rinsing is an important step, as it removes the bulk of the solution, thus improving the efficiency of the final washing.

The prints then receive a final wash of at least one hour, preferably in a vertical archival washer. Be certain not to buckle the prints as you insert them; hold each print firmly and allow it to sink into the washer by its own weight. Residual hypo may fall on the top surfaces of the washer as the prints are inserted, so you should hose off the top of the washer carefully after loading the prints. The washer also must be kept clean of dirt and "slime" inside, which may collect residual hypo and become a source of contamination.

A certain amount of agitation by hand in the washer is often worthwhile. Lift and drop the prints frequently to avoid air bubbles on the surface; if not removed, such bubbles will prevent contact of the water flow with the print and reduce the effectiveness of the washing.

All prints must be in the washer before you start timing the wash; any that are added during the washing will carry over fresh contaminants into the water. Be careful to maintain the proper water temperature during washing — 65° to 70°F (18° to 22°C). If it is too cold, the wash process becomes inefficient, and considerable extra time will be required; if too warm, the emulsion may be softened and damaged.

I also want to caution you regarding contamination by hand. Fixer is surprisingly difficult to remove fully from the hands; if you have handled fixer during the time prints are washing, be sure to wash your hands *thoroughly* with soap and warm water before touching the washed prints, or you will almost certainly contaminate them.

If you do not have an archival washer, I suggest using a system of soaking prints in two trays, although it is a time-consuming process. After a *throrough* rinse, immerse the prints in a tray filled with water and agitate constantly for 5 minutes. Then drain them and move them to a tray of clean water, and again agitate for 5 minutes while replacing the water in the first tray. This process is repeated through 12 changes, for a total of one hour. But be sure not to crowd the tray with too many prints.

Archival washers provide optimum washing because they have dividers that keep the prints separated, and they provide full water circulation around each print. Those who are good with tools may find they can build a washer that meets these requirements at a considerable savings. The efficiency of the washer should be tested using the procedure given in the Appendix. ◁

See Appendix 3, page 202

DRYING

Each print should be removed from the washer, drained, and squeegeed or wiped with a clean sponge on both sides to remove excess surface water. A clean and flat surface that drains into the sink

Figure 6–4. *Squeegeeing print.* Surface water on both sides of the print is removed using a rubber squeegee — an automobile windshield wiper is good. The print should be rested on a flat surface, tilted to permit the water to drain into the sink. Apply the squeegee *gently*, and lift the print carefully to avoid "breaking."

Figure 6–5. *Drying prints.* The prints should be laid face-down on clean screens to dry. The bottom screens are reserved for proofs and work prints that may not have received full archival washing treatment.

should be provided for this purpose. Be very careful handling the prints to avoid breaks in the emulsion, and be *certain* your hands are clean. The squeegee is drawn lightly across the print surface (both sides), using care not to buckle the print. Then lift each print carefully and lay it face-down on the drying screen. Do not move it until it has fully dried.

See pages 15–16

I prefer the use of drying racks over all other methods. ◁ Drying racks made with plastic screen material can easily be cleaned by hosing them off periodically. They are efficient and avoid the contamination that can occur with drying blotters or cloth screens. I do not favor heat drying for prints (except for examining proofs or work prints, as noted earlier ◁), since the dryer becomes a potential source of contamination.

See page 84

BLEACHING

I do not enjoy this process as it is uncertain and can produce rather strange tonal relationships. In addition, some scientists have questions about the archival effects of bleaching, although I have not personally been aware of any problem. At times, bleaching may be a helpful means of modifying the image values. For example, we may have specular high values that fall just short of being pure white, or other important light areas that are not "crisp" enough when we examine the dry print. Bleaching can be employed when we would like such areas to be *slightly* lighter.

See Appendix 1, page 196

I shall limit my description to the use of the ferricyanide Farmer's Reducer. ◁ For a minimum high-value reduction, 1 part of Solution A and 1 part of B, diluted with 10 to 15 parts of water, will be satisfactory. However, some photographers use a much stronger solution: 1 part of A, 1 part of B, and 2 or 3 parts of water. This is a faster-working bleach and can easily get out of control.

See Book 2, page 237

We must be sure the print is well fixed and washed, and it should be *dry* and *not toned*. The advantage of working with a dry print is that it restricts the reducer action at first to the print surface and slows its penetration into the emulsion, where it may affect lower values. The effect is similar to "cutting" reduction of negatives. ◁ As soon as the reducing solution is ready, quickly immerse the print face-up for about 5 to 10 seconds, with vigorous agitation. Then quickly put the print under a flow of water, washing off all traces of the bleach.

Examine the print closely, comparing the high print values with the white border areas, or with an unbleached (but wet) reference print. If more bleaching is needed, return the print to the bleach solution, but proceed with great caution; since the emulsion has now been wetted, the reducer action can be expected to occur somewhat proportionally throughout the entire print, affecting both high and low values.

When the reduction is completed to your satisfaction, rinse the print well to remove the reducer solution, and then immerse it for a few minutes in a fixing bath (this can be plain hypo if all the solutions and wash water are cool). Then rinse, treat the print in Hypo Clearing Agent, rinse, and wash it thoroughly. The fixer should minimize the possibility of yellowish stain which ferricyanide may produce, especially when the print is toned.

We must use care to avoid over-bleaching of the high values; if we allow texture and substance to be lost, there is no way to retrieve them. I suggest making preliminary trials using a reject print; it can be trimmed into several strips for comparison purposes. Then mix a fresh reducer bath before treating the fine print.

Figure 6–6. *Detail of Bird Carving, Juneau, Alaska (1948).* Except for a few flecks of weak sunlight, the lichen-covered stone was in shade and had low contrast and rather somber mood.

(A) A rather heavy print; the final print should be lighter and suggest the rough marble quality.

(B) I tried reducing a duplicate print in an attempt to lighten the higher stone values. This was successful overall, but where I attempted further reduction, by applying the solution with a brush on areas of the head, it "got away" from me and bleached out the higher values. I show this to suggest what great care is needed in print reduction.

A

B

"Local" reduction can be very useful for "clearing" the high values in a single area, but you must be careful to control the spreading of the reducer solution. I place the *wet* print on a smooth, inclined surface and wipe off excess water with a sponge. I then apply the reducing solution with a small brush (frequently adding 2 or 3 drops of wetting agent — Photo-Flo — to the solution). After a few seconds I quickly hose off the print, and then reapply if necessary, each time allowing it to stand on the print for only a few seconds. For local reduction, the use of a dry print may cause an obvious "edge" around the reduced area which will require spotting. ◁ After you finish the local bleaching, rinse and re-fix the print. Then rinse again and treat with hypo clearing solution, followed by a thorough washing. For both overall and local reduction, the final evaluation of the print must occur after it has dried.

See page 157

ARCHIVAL PROCESSING

In recent years the issue of long-term preservation of photographs has been given much attention. Properly treated and stored, a black-and-white photograph should last for centuries. Archival processing is not an exact science, however, and some issues relating to image permanence have not been resolved. I will give a few guidelines on the subject here; for more detailed information, I suggest consulting publications such as Kodak's *Preservation of Photographs*, No. F-30.

The most usual cause of long-term deterioration of prints has to do with the fixer. Incomplete fixing leaves silver halides in the emulsion that discolor. In addition, silver thiosulfate complexes that form as the fixer becomes "fatigued" may remain in the emulsion and eventually cause deterioration. Hence the importance of careful two-bath fixing, using fresh solutions and agitating regularly. It should not be assumed that prolonging the fixing time increases permanence; rather, extended fixing causes hypo and residual chemicals to penetrate throughout the paper fibers, and removing them becomes increasingly difficult or impossible. Complete archival processing of prints must therefore include careful fixing, hypo clearing, and full washing.

For optimum permanence, the prints should be toned, usually in selenium toner although conventional sulfide toners also improve stability. The advantage of toning, from a preservation standpoint, is that it converts the image silver to silver selenide and/or silver sulfide, both of which are resistant to attack by oxidizing gases in the atmosphere and other potential contaminants.

Figure 6–7. *Archival print washers.* The washers shown are all designed to keep the prints separated throughout washing, with fresh water reaching all areas of each print continuously. Shown are the washers from Zone VI Studios (Newfane, Vermont); Kostiner (Haydenville, Massachusetts); Cascade (Light Source Inc., Salt Lake City); and Arkay (Milwaukee). Both the stainless-steel washer tank and the print basket of the Cascade washer are shown.

An alternative to selenium toning is the use of Gold Protective Solution (GP-1), which also protects the image from attack by atmospheric gases. It does, however, produce a cold bluish tone in most papers, and it thus "cools" the tone of warm-toned papers. The gold solution (the formula is given in the Appendix ◁) is quite expensive, and offers no significant advantage over selenium toning. The Gold Protective Solution should not be used together with selenium toning.

See Appendix 1, page 194

For a carefully processed print, the conditions of storage are the next important issue in determining its longevity; these will be discussed in Chapter 7. ◁

See pages 165–167

SENSITOMETRY

It is my opinion that the photographer need not devote much time to the theoretical study of print sensitometry. Such matters as the

Figure 6–8. *Jose Clemente Orozco.* Light from overcast sky was not favorable to his face values, and it is difficult to strike the balance of value and contrast in the print. The intensity of the glasses and eyes is paramount. The cropping is rather critical to retain concentration on the face and remove confusing edge details.

The eyes, shadowed by the brows, were dodged slightly; the dodging had to be very carefully done, and required six or seven test prints to determine. The lower left area of the cheek was burned-in slightly.

This was made with a 7-inch lens on film of moderate speed. The negative was developed in a pyro-metol formula, and the print was made on Ilford Gallerie Grade 3.

exposure range can be established in practical terms by testing of the materials and processing, a more useful form of knowledge for the photographer than abstract sensitometric measures. As I have stated, producing expressive prints depends entirely upon visual appraisal of the tonal values. It is a different matter with negatives; since each negative is unique and usually cannot be redone, a somewhat greater reliance on technical and mechanical control is necessary than for prints. However, a short discussion of the sensitometric principles of papers may help establish understanding of the exposure and density scales. For those interested, standard technical works can provide more detailed information on the theory of tone reproduction.

As with negatives, we can plot for any paper a characteristic curve which indicates its response to light and processing. The density

Figure 6–9. *Characteristic curve for a typical paper.* The low-density areas near the "toe" of the curve represent *high* values, which appear "white" because there is little silver present. High-density areas at the "shoulder" represent very *low* values, where much more silver has been deposited. The slope of the straight line section is a measure of the contrast of the paper.

read from a print is referred to as *reflection density* (R.D.), which is measured with a reflection densitometer. This instrument directs a beam of light on a very small print area, and measures the fraction of the incident light reflected from that area, called its *reflectance* (this is analogous to transmission with a negative). *Reflection density is the log_{10} of the reciprocal of the reflectance*, or $D = log_{10}$ (1/R). Thus if half the incident light is reflected from a given print area, it has a reflectance of 0.5 (50 percent), and 1 divided by 0.5 equals 2. The reflection density for this area is the log of 2, or 0.30.

The print characteristic curve consists of a horizontal *exposure* scale in log units and a vertical scale of *density* (which is already a logarithmic unit). We can look at a paper curve and find the points where it approaches pure "white" and full "black." By drawing lines from these points down to the log exposure scale, we can then determine the *range of exposures* required with this paper to achieve a print-value range from textured white to black.

For example, we can determine the effective contrast scale of a paper by the following test: we find the exposure required to produce a value just perceptibly lower than the white paper base, and then find the exposure required to produce a black (D_{max}). Assume these

exposures are 1 second and 25 seconds; we then have a paper exposure range of 1:25. By converting to logarithms, we arrive at a *log exposure range* of 1.40 required with this paper to achieve a full scale from black to white.

In practice, the range of exposures a paper receives is determined by the density scale of a negative. A negative with opacity range (arithmetic) of 1:25 has a density range (logarithmic) of 1.40. In principle, such a negative should be an ideal match for this paper, yielding the appropriate range of exposures to achieve a full range of print values. Note, however, that we may require a "softer" or "harder" paper for expressive reasons; if so we are not violating sensitometric principles, but merely adapting them to informational or aesthetic objectives.

The usefulness of graded papers lies in their ability to produce full-range prints from negatives of differing density ranges. If we have a "flat" negative, we will want a paper with a fairly "steep" curve so the short exposure range provided by this negative will still translate into a full scale of densities. This is the situation when we choose a higher-than-normal paper grade for printing a low-contrast negative. Similarly, when printing a contrasty negative, we will need a paper with a much flatter curve, so that the extremes of the print density scale will be reached over the longer exposure range provided by this negative.

In determining their paper grades from print curves, most manufacturers exclude the extreme ends of the scale — the *toe* and *shoulder* of the paper curve — as these extremes are not considered within the "useful" response of the emulsion. Actually, the subtleties of the lightest and darkest tones involve the entire range of the paper's sensitivity, and often the qualities characterizing a truly fine print may be found in the delicate variations of the extremely light and dark values.

Thus the designations of paper grades are often confusing if we attempt to understand them in sensitometric terms. There is little standardization among manufacturers as to the sensitometric response of each grade. Even among the products of one manufacturer the contrast-grade indications for different types of paper may not be alike. Furthermore, the characteristic curves of various papers are often dissimilar, some having a longer toe or shoulder than others, and such qualities are not conveyed in the paper-grade designation. It is for these reasons that I do not consider paper sensitometry as important as practical tests and the visual evaluation of print materials and image qualities. Remember, the print is a "performance," not a literal translation, of the negative "score."

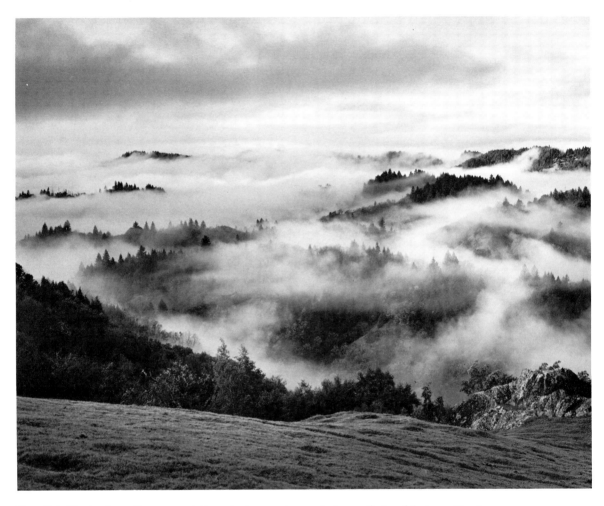

Figure 7–1. *Clearing Storm, Sonoma County Hills, California.* This was a very soft subject photographed in rain. The negative received N + 1 development, and the print was made on Oriental Seagull Grade 3. Both the foreground and clouds were "soft" in themselves, yet the clouds were very much brighter than the forest and meadow areas. Hence the need for a fairly contrasty paper, to separate the values of the foreground and dark forested hills. Burning-in the sky required about half the basic exposure.

After the basic exposure, I burned the near foreground for about 20 percent of the basic exposure. Then the burning-in of the sky was done using a card in three up-and-down passages from within the mountain crests to the top of the image. The sky, especially the left-hand areas, were further burned with the card curved, moving to the left. The card could have been held at an angle, but bending it to a curved shape related better to the well-defined sky area of higher negative density.

The camera was 8 × 10, with Cooke 12¼-inch Series XV lens.

Chapter 7	# Finishing, Mounting, Storage, Display

The aesthetic decisions on how best to finish and present a photograph usually must take into account the use of materials that is consistent with long-term preservation. We must be aware that the "archival" permanence of a photograph is affected as much by its handling and storage conditions as by the processing methods described in the last chapter. It is fortunate that high-quality materials are available for print finishing that provide good archival stability.

MOUNTING AND OVERMATTING

Mounting the print serves to protect it and facilitate handling, as well as allowing us to present the print to the viewer under optimum conditions, isolated visually from its surroundings. There are various opinions on the most efficient and "safe" means of mounting. One method is to attach the untrimmed print to a backing board by corner tabs, and then prepare an overmat cut to the desired proportions. Some museums and archives prefer this system as it leaves the print free for later re-processing and washing, should they become necessary. However, I find this method gives me a sense of uncertainty, as the edges of the image are not precisely defined, but are imposed by the enlarger easel or by the window of the overmat. In addition, the print is loose, with both surfaces exposed to the atmosphere, and a signature on the overmat is not permanently affixed to the image or its immediate support.

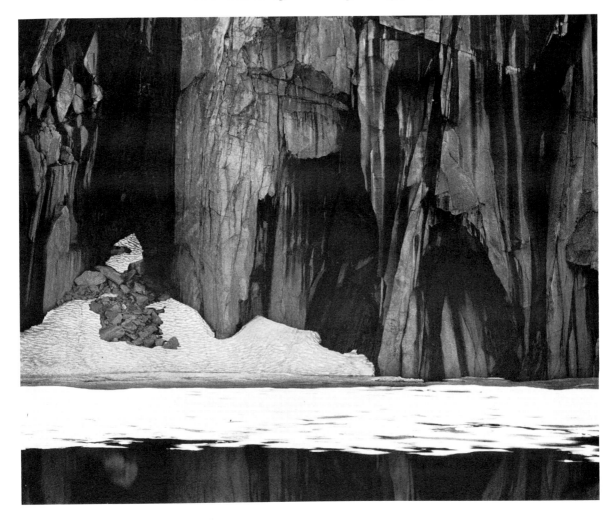

I prefer to dry mount the print on a smooth archival mat board of appropriate color and surface quality. This should be 100 percent rag museum board, which is non-acidic and free of impurities that can attack the print. The so-called illustration boards should be avoided, as they usually have a pulp-board interior beneath the surface layer. It is especially important not to use such board for overmatting; the inner material is exposed along the cut edges surrounding the print, and impurities may be released that will attack the print over time.

The relationship between the print color and the color of the mount or mat is also important. Museum board is not usually dyed in definite colors, as most dyes detract from archival stability. (Recently some colored museum boards have been developed, but I have not used these materials.) Black board is sometimes used for mounts or overmats; however, black papers (including the black pages in most photographic albums) are often heavily contaminated. In ad-

Figure 7–2. *Frozen Lake and Cliffs, Sierra Nevada, California.* On returning from a Sierra Club outing in the southern Sierra I had several hundred negatives to develop. I was using small tanks at the time, and I was careless in allowing the developer to be over-used. A semi-exhausted developer can give strange qualities to a negative, and this one is very difficult to print. The shadowed cliffs and the reflection have "degraded" values, while the sunlit ice is of very high relative contrast. A high-contrast paper is necessary for the cliff area, and this creates problems for printing the glaring ice. In addition, the negative density of the ice is blocked and "prints down" as a rather flat gray.

Thus a high-contrast paper is required, with extensive dodging of the ice area. I now use Oriental Seagull No. 4, developed in Dektol; I had used Agfa Brovira Grade 5, but I find that the Seagull paper gives the best rendition of the shadowed cliffs (as well as a beautiful tone with selenium). With such high-contrast paper, very careful and subtle control must be used. The total exposure time was 60 seconds for this print, using a small aperture to manage a longer-than-usual exposure required for the rather complicated burning plan. I burned the reflection area from the upper edge of the ice down to the bottom of the print for 30 seconds (holding the card fairly close to the lens to assure a broad penumbra). I then burned for 30 seconds from the lower edge of the ice to the top of the print in the same manner. Hence the cliffs and the reflections received 30 seconds' exposure, and the ice received 60 seconds. The card has to be in constant motion to assure that no obvious line appears.

I further burned the reflections for about 10 seconds along the bottom edge, with an additional 5 seconds toward the corners. I also burned the top area of the cliffs and the corners for about 5 seconds.

I made the photograph with a 4 × 5 Korona View camera and 10-inch Dagor, using the rear component of about 19-inch focal length. The film was Kodak Super-Sensitive Pan developed in Kodak D-76.

dition, placing a black cutout opening over the photograph may raise a distressing conflict between the low values in the print and the black of the mat. Hence we generally select only from various shades of warm or cool "white" one that we consider complementary to the image coloring. Occasionally a gray board is agreeable.

In most cases a smooth-surfaced print looks best on a smooth, matte-surfaced mount board of a neutral shade of white. By "neutral" I mean free of color cast (either bluish or yellowish), although a suggestion of "ivory" white can relate very well to a print that has been toned in selenium. The ivory tone can be an excellent complement to the faint cool purple tone of the print. A conflict may occur if the print is mounted on a glaring white board; the whites of the print can be visually degraded by close proximity to the brilliant white of the board. The problem is not necessarily to *match* the color and value of the print, but to select a mount of harmonizing or complementary tonality.

At this writing, I am using Lenox 100 percent rag Museum Mounting Board, 4-ply, described as "bright white." This board is buffered to a pH of 8 to 8.5. I have found that the 4-ply mount with a 4-ply overmat produces an ensemble that is quite stiff and not too bulky for handling and display.

Before we can proceed with mounting, we must determine the size of the mount and placement of the print on it, both of which are subjective considerations. The mounts are sometimes adjusted to the proportions and general "feeling" of each print, but it is difficult to store and exhibit prints if they are on mounts of varying sizes. I use 22 × 28–inch mounts for 16 × 20 prints; 16 × 20 mounts for 11 × 14 prints; and 14 × 18 mounts for 8 × 10 prints (I am referring to the size of the enlarging paper; the actual image size will be somewhat smaller depending on the final trimming). I have also used 11 × 14 mounts for 4 × 5 and 5 × 7 prints, and I have used other sizes (e.g., 23 × 29) on a few occasions.

I prefer to position the print so that equal space exists on both sides, whether it is a horizontal or vertical print. The top and bottom margins of the mount board/overmat can be determined according to the composition and tonal "weight" of the image. I usually leave slightly more space at the bottom than at the top, although I find that mounting a print far above center can be disturbing.

I advise against mounting a vertical print on a horizontal board, or horizontal print on vertical board. Both are almost always highly illogical in a visual sense, and can destroy the impression of movement and vitality of the image. In general the intention is to have the mount feel "right" to the viewer, and thus not call attention to itself as a separate, and distracting, element. The print and the

mount should become a single expressive unit to the spectator; careless or inappropriate mounting can seriously reduce the effectiveness of a fine photograph.

When the print has been trimmed to its final proportions (for a print that will be dry-mounted, this is done *after* attaching the dry-mount tissue), it can be laid on the mount and moved about until its position appears most pleasing.

Mounting the Print

I consider dry mounting by all odds the best method. It is clean, dependable, and most unlikely to cause damage to the print. For optimum results it is necessary to have, or have access to, a dry-mount press, although an ordinary clothes iron can be used for small prints. Advanced photographers usually find the press a worthwhile investment, as it makes the procedure more efficient and certain.

See page 180

The alternatives to dry mounting are wet mounting with paste or the use of another form of adhesive. Wet mounting is sometimes recommended for mural-size prints. ◁ Most adhesives, however, cannot be considered archival. Rubber cement, for example, should *never* be used for mounting photographs, as it is certain to cause eventual staining. The same holds true for other typical household cements. A few adhesives that are not likely to cause damage to the print themselves (rice paste or flour paste), have an unfortunate tendency to attract insects or support the growth of mold or fungus, any of which can destroy the print. Some of Edward Weston's beautiful early platinum prints were "tipped-on" their mounts using mucilage. Chemicals in the mucilage have since come through some of the prints, discoloring them. Baryta-coated papers may minimize such penetration, but cannot be relied on to prevent it. If an adhesive other than dry-mount tissue is required, library paste is usually considered adequate. Kodak makes a mounting cement they say is of archival quality, but it may prove difficult to use except for small prints.

Dry-mount tissue is a thermoplastic material, meaning that it softens when heat is applied. Under heat from a dry-mount press, the tissue coating softens and impregnates the fibrous materials of both the print back and the mount, forming a permanent and waterproof bond between them. Tissues are made for various requirements, usually differing primarily in the heat level required for bonding. Note that the dry mounting of RC papers, Polaroid Land prints and color prints usually requires a special low-heat tissue and short pressing time to avoid damaging the print. A few tissues are available that

Figure 7–3. *Tacking tissue to print.* The dry-mount tissue, in a size slightly larger the final print size, is tacked to the back of the print using a heated tacking iron. The iron should be drawn gently outward using steady pressure; be careful not to press too hard or the print surface may be damaged.

purportedly allow the print to be removed from the mount if necessary for restoration work; however, most valuable dry-mounted prints should be removed only by an expert in the conservation of photographs (of which there are very few!).

To mount the print, first dust off both sides and lay it face-down on a clean sheet of paper or mount board on the work surface (cotton gloves should be worn whenever handling fine prints). Place over it a clean, dust-free sheet of dry-mount tissue that overlaps the image area of the print. Then "tack" the tissue to the print using a tacking iron, a small device not unlike a soldering iron that heats a small area of the tissue and bonds it to the print. Be sure the flat part of the tacking iron rests evenly on the tissue, and do not press the iron too hard lest you cause ridges in the surface of the print. You should begin at the center of the print and move the iron outward, to ensure that the tissue lies flat where it is tacked. Never push the iron toward the center of the print, as this is certain to cause wrinkles in the tissue which will show on the print surface. Be sure not to tack all the way to all edges of the print, or it will later be difficult to tack the tissue-print combination to the board.

Once the tissue has been tacked, the print and tissue are trimmed together to final size, using a high-quality paper cutter. You are thus assured that the size of the tissue exactly matches the print, with no uncovered tissue and no overlapping print edges. If you prefer,

Figure 7–4. *Trimming the tissue and print.* The print and tissue are next trimmed to final size. The cutter shown has a "hold-down bar" which ensures that the print and tissue are aligned precisely. With a cutter not equipped with such a bar, a firm straightedge should be held down on the print as close as possible to the cutter edge. Keep fingers away from the blade!

See pages 153–154

you can trim the print to approximate size before tacking the tissue, and then make the final trim with tissue in place. After tacking and trimming, do not allow the print to stand more than an hour or so before mounting; humidity may cause the print to change in dimension while leaving the tissue unaffected. The result will be a problem with the print edge after mounting. ◁

During the trimming, you must prevent "creeping" of the tissue to ensure that its edge and the print edge align exactly; place a sheet of cardboard near the edge of the tacked print to hold it flat in the paper cutter. Some trimmers have a pressure bar, the best means of holding a print flat during trimming. The pressure bar must be clean and free of grit, paper particles, etc. I once damaged nearly a hundred prints before I realized the trimmer pressure bar needed cleaning! Dents in a print surface are impossible to remove.

After trimming the print-tissue ensemble, tack it to the mount board. Under humid conditions, however, you must first dry out both the mount board and the cover board in the press. Dust off both boards carefully, and place them in the dry-mount press (separately) for several minutes; then expose them to air for a short time prior to mounting. Moisture in the mount board can prevent good adhesion of the tissue, and it can cause the cover board to stick disastrously to the print.

Figure 7–5. *Tacking the trimmed print to the board.* The print and attached tissue are carefully positioned on the mount, and then held in place with a "shot bag." The print corners are then lifted gently and the tacking iron inserted beneath to tack the tissue to the board. Apply the tacking iron with a gentle *outward* motion; pressing inward can fold the tissue, leaving visible marks on the mounted print. Be careful not to trail the tacking iron beyond the print edge and over the mount surface, as such marks are impossible to remove.

Then place the print in the desired position on the mount and hold it there with any weight that will not mar the surface, such as a draftsman's "shot bag." Lift one corner or edge of the print gently and insert the tacking iron between print and tissue, pressing the tissue against the mount with a downward and slightly *outward* movement. With the weight at the center, you should draw the iron slightly outward, away from it, to ensure that the tissue lies flat; it must not be "bunched-up" by the iron, or a smooth dry mounting will be impossible. The print can be carefully tacked to the board at opposite edges to ensure that it does not shift position while being placed in the dry-mount press. Be careful not to allow the tacking iron to trail over the exposed areas of the mount, or a glistening mark will result.

Once the print is tacked to the board, carefully dust off the print surface and assemble it in a "sandwich" to go in the mounting press. The print should be between two smooth mount boards, which must be clean and dry; use an additional thick and dry cover board on top, as this will hold and distribute the heat more evenly to the print surface. These boards should be larger than the press platen.

The temperature of the dry-mount press should be carefully regulated. Check the tissue package for instructions; most tissues for fiber-based papers require a heat level of about 195°–225°F. If the

Figure 7–6. *Dry mounting.* The tacked print is inserted between two clean sheets of museum board and then pressed. The time and temperature of pressing depend on the tissue and thickness of cover board, and should be regulated carefully. The mounting press should be equipped with a trustworthy thermostat, and the process monitored closely.

heat level is too low the tissue will stick to the print and not to the mount, and if too high, the tissue will adhere to the mount and not to the print. Excessive heat or too much time in the press will reduce the adhesive capability of the tissue, and may damage the print. With the low-temperature tissue (Seal Color Mount) we are now using at my studio, pressing for 3 minutes at about 210°–225°F is about right. This is a fairly long pressing time, but we use two heavy boards above the print which absorb a lot of heat, while the temperature at the print surface is relatively low.

After pressing, remove the mounted print and allow it to cool for about a minute. Then bend the board rather severely (away from the print) at each corner. If the adhesion is insufficient, the print corners will snap away from the mount. The remedy is to return the print to the press for more time, perhaps raising the temperature setting slightly. Then allow the print to cool for several minutes on a flat table, preferably under a moderate weight to prevent curling and warping; use a clean sheet of mount board between the weight and the print. The cool print should again be checked for adhesion at the edges and corners.

A frequent problem in dry mounting is caused by particles that are pressed into the print from the top, or are lodged between the print and the mount. These cause dents or bumps in the surface which are not repairable. I cannot overstate the importance of carefully dusting

Figure 7–7. *Testing the dry-mount adhesion.* After the print has cooled somewhat, bend the board rather severely at each corner to be sure the tissue is adhering properly to both print and board. If the print detaches, replace it in the press for about two-thirds the original time. Too-long mounting time may weaken the adhesive power of the tissue.

each print and the mounting and cover boards at every stage. Precise trimming and positioning are also essential, and the application of heat must be uniform and adequate for complete bonding.

Occasionally the print will form a "bubble" in mounting when a central area becomes detached from the mount board. Such can usually be corrected by the following procedure, although naturally I cannot guarantee success: with the mounting press at moderate temperature, insert the print–cover board sandwich and apply *light* pressure for about 6 to 8 seconds. Then remove the print and examine it. Repeat this light application of pressure if necessary. If the bubble is successfully flattened, return the print to the press for the normal mounting time. I must advise that there is danger of ruining the print during the re-heating, as the bubble area may develop wrinkles when it is pressed — an irrevocable disaster!

Another common defect is a thin glistening line of dry-mount tissue found along the edge of the mounted print, where the tissue was not trimmed precisely in line with the print edge. This problem is usually caused by "creeping" during the print trimming. If found to be a persistent problem, it will help to pre-heat the print for about 15 to 30 seconds under *light* pressure before tacking. Once the tissue has been tacked, the dry mounting should be completed within an hour. To remove this thin tissue edge from a print already mounted, lay the mounted print flat and clamp a smooth straightedge precisely

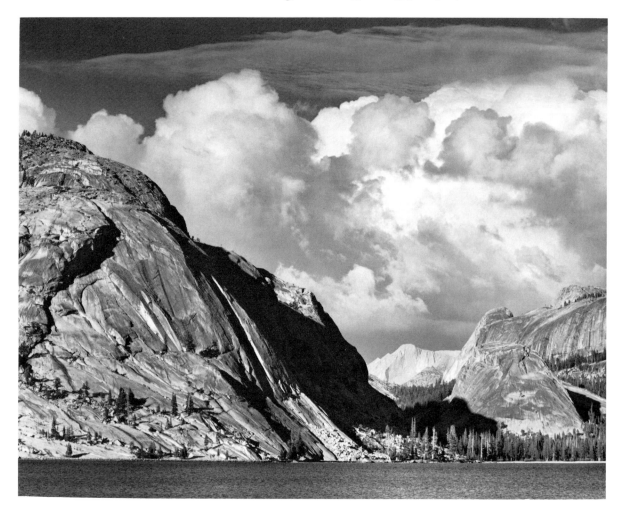

along the edge of the print. Using a very sharp razor blade or mat knife, make a clean cut with only enough pressure to trim the tissue *without* cutting into the board. Be very careful not to allow the razor to slice into the print edge, as such cuts cannot be repaired. When the trim is complete, gently lift one end of the trimmed strip from the mount and pull it away from the board. If there is a trace of roughness on the mount where the tissue adhered, polish it with a smooth soft piece of wood, such as an "orange stick" used for polishing fingernails, or a framer's burnishing bone.

To mount prints that are larger than the platen of the press, use a very thick cover board the size of the mount. Insert the ensemble in the press so the platen covers one corner of the print and mount at a time, and move it in rotation to press all four corners for 15 to 20 seconds each. Repeat until the print has received the required total time. The platen should always generously overlap the area of

Figure 7–8. *Tenaya Lake, Mount Conness, Yosemite National Park (c. 1946).* The dark shadow area in the rock slopes received less exposure than expected because of the effect of the Wratten No. 15 (G) filter on the blue-sky illumination. It needs a slight amount of dodging to reveal what detail is in the thin negative area. The foreground requires slight burning, as does the left-hand lower area, where the angle of the rock to the sun produces some glare which should be reduced in printing.

The area from the mountains to the top of the image was given four up-and-down burning passages using a curved card. The penumbra must be rather wide and the card kept in constant motion so that there is no obvious burning effect seen. In addition, I gave about 20 percent extra burning in the distant mountain area, needed because the mountain was at a glare angle to the sun. The negative will print on a Grade 2 Oriental Seagull, but the Grade 3 Ilford Gallerie used with Dektol brought more life to the clouds. Seagull Grade 3 with Selectol-Soft is also rewarding, and allows for good toning effects.

I used an 8 × 10 camera and the 23-inch component of my Cooke Series XV lens. The film was Kodak Supersensitive Pan, which I developed in Kodak D-23.

See page 33

the previous and the following applications. Any part of the print that is not sufficiently pressed will probably show as a raised area. If the cover board is smaller than the mount, its edges may emboss the surface.

The procedure for mounting prints with a flatiron is similar throughout except for the pressing itself. You should use one or more thick cover boards, usually 8 or 12 plies in total thickness, to assure even heat distribution. The iron should be heated to quite high temperature and then moved slowly over the cover board, working generally from the center outward. Constant movement of the iron over the cover board is important to accumulate and evenly distribute the heat to the print and mount; *never* allow the iron to stand in one area. A little experience will show the appropriate temperature. If the heat is too great, a visible change in the surface brilliance of the print may take place, and poor adhesion may also result.

Prints and mounts have different expansion coefficients, and the concentration of heat in one area can warp the mounted print. Thus a thick cover board should be used to distribute the heat evenly. Be sure the cover board is held firmly in place and never allowed to slide across the print surface during mounting.

For casual display purposes there are other mounting arrangements that are sometimes effective. The print can, for example, be mounted "flush" with the edge of the mount surface, without borders. This method will at least serve to keep the print flat, and may be the only practical method with very large prints. A backing of archival material and a simple corner molding can then be attached to protect the edges of the print. In some cases the print edges are wrapped around the edge of a thick mounting surface and left exposed. This method may be effective for a short-term display, but it leaves the edges very vulnerable to damage, and the bending of the print around the edges may eventually produce cracks in the emulsion.

When it is desired to show prints without mounting on board — in a portfolio, for example — they can be given more weight and body by dry-mounting them back-to-back with a separate sheet of the same type of enlarging paper (of course, the paper used for backing must be fully fixed and washed). Such prints will still be susceptible to damage, but will have added body and usually will lie flat, since the tendency of the print to curl will be offset by that of the backing. It may be effective in such cases to make the print with a border an inch or more wide, resembling an overmat, to provide a measure of visual isolation of the image. This can be accomplished by masking off the enlarging paper in the easel when printing; professional-quality easels should give accurate wide borders. ◁

Print identification. I strongly urge full identification and labeling of all prints. I recommend having a large rubber stamp made up to be impressed on the back of every print mount. The stamp should give full name and address, and also provide spaces for the title of the photograph, the negative date, the printing date, and a statement of reproduction limitation or copyright, if any. Additional stamps can provide copyright notice, return shipment request, intended use (e.g., for reproduction only), etc.

Overmats

A conventionally mounted print is, of course, raised above the surface of the mount by the combined thickness of the print paper and mounting tissue. Obviously this means that the print surface or edges may be damaged by contact with other prints, and if framed, the print itself will be pressed against the glass or Plexiglass. Either occurrence can cause irreparable damage, and the latter is especially dangerous: the print should *never* be in contact with the glass or acrylic in a frame.

Hence the need for overmatting. The standard "window" mat is cut from appropriate board with a beveled edge, slanting outward, which lends a sense of depth to the mat and minimizes shadowing of its edges. It is quite possible to learn to do your own overmatting, although some practice is required; excellent mat-cutting devices are available that can greatly assist the process. Often, however, it is best to have the work done professionally.

My system of presentation uses identical board for the mount and the overmat. I mount the prints trimmed to exact final image proportions, and then sign them lightly in pencil on the mount below the lower right corner of the print. The overmat is then cut to expose about ¼ inch around the top and sides of the print and ⅜ inch at the bottom, thus revealing the signature and a narrow area of the mount. For large prints (16 × 20 or larger) I advise about ⅜ inch at the top and sides, and ½ inch at the bottom.

SPOTTING AND ETCHING

It is usually necessary to use spotting, and occasionally etching, to conceal tiny blemishes and dust specks in the print. These procedures are perfective in nature, and stop short of actual retouching to alter the image.

Spotting

Spotting is the use of dyes or pigments to correct white specks and lines produced in the print by opaque defects or dust on the negative. Spotting is usually done using dyes such as Spot-Tone, which have the advantage of darkening an area without appreciably altering the surface reflectance. The dyes are available in several colors, and frequently two of them must be mixed to arrive at a coloring that matches the print exactly, particularly a toned print. There is some question about the permanence of spotting dyes; some may have a tendency to darken and turn blue in time. If a dye spot must be removed, be sure to use a dye remover recommended for the particular type of dye used.

A pigment or permanent ink may be preferable to spotting dyes for spots in very heavy black areas. Permanent spotting can be

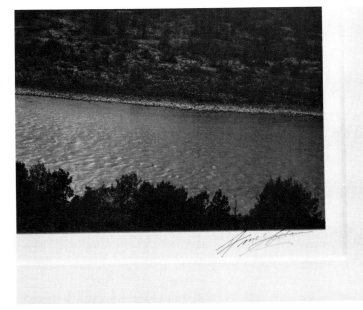

Figure 7–9. *The overmat.* The beveled edge of the overmat can be seen. The print has been dry-mounted, and the overmat is cut slightly larger to leave a border on all sides. A wider border on the bottom edge leaves room for a signature just below the print. In practice, I do not sign a fine print until it is completely finished, including mounting, spotting, etc.

Figure 7–10. *Print spotting.* Small spots and defects are removed using dyes and a fine brush. Good light is essential, both to judge the dye density required and to match the color.

Figure 7–11. *Print spotting.* Use a stippling motion to apply the dye, rather than "painting" it on. A good-quality brush is very important.

See Appendix 1, page 196

achieved using India ink mixed with gum arabic (available at art supply stores). The formula given in the Appendix ◁ was Edward Weston's spotting solution. This method gives rich blacks (and other values if diluted), with a good gloss that closely matches the surface of an unferrotyped glossy print.

The print should be placed under strong illumination, and should be carefully wiped free of dust specks that may appear to be defects in the image. Protect the surface of the print with paper, especially in the area where you will rest your hand. A black paper with a hole cut in it will minimize eyestrain and provide good protection against the possibility of dropping the brush on the print or mount. I also strongly advise wearing white cotton gloves (available at camera or art supply stores) during this and all other handling of negatives and finished prints.

The application of the spotting color to the print should be done with a good-quality brush like the Windsor and Newton Series 7 finest red sable brush — usually a No. 0 or No. 00. A high-quality brush will have enough bristles to hold the spotting fluid while still coming to a fine taper point that affords good control. The brushes sold in camera stores for spotting are often of inferior quality, and it is well worth a trip to a good art supply store for this important acquisition.

Mix the spotting colors to match the general color of the print, and test by applying to a discarded photograph on the same paper as the actual print. You can dip the brush in the spotting color and then lightly in water, or you may prefer to dilute the basic spotting color with one or more parts of water for middle to light values. Usually a fairly dry brush works best; after dipping the brush in the spotting color, remove most of the solution by wiping it lightly on a piece of plain paper before touching it to the print. It is best to build up the required "density" by repeated applications of the dye. However, if you apply too much dye you can usually reduce it by pressing immediately with a damp cloth. Since the dye may darken over time, you should leave the spotted area *slightly* lighter than its surround.

The surface coating on the paper can affect the way the spotting material "takes." The color may penetrate better if a drop or two of wetting agent (Photo-Flo) is added to the water used with the spotting material. If oil is present from contact with fingers, it may interfere with application of the spotting material. Wipe the area carefully with a tissue or clean cloth; if necessary, try applying denatured alcohol (ethanol). In addition, the hardening of the emulsion in the fixer can affect spotting. If you find all your prints difficult to spot, be sure that you are not over-fixing the prints. You may be able to reduce the amount of hardener or change to a non-hardening for-

See Appendix 1, page 194

mula (F-24), at least for the second fixer. ◁ RC papers can be very hard to spot, as the dye does not readily penetrate the print surface.

Where a very faint speck or line must be removed, I have often found it satisfactory to apply lightly a soft or medium pencil, rubbing the print gently with a soft cloth after application. Never press hard with a pencil, or you will have a permanent depression on the print. A pencil can also be used on middle- or high-value areas that have been spotted almost, but not quite, to the final value required.

Real skill is required to spot larger areas. It is usually best to stipple the areas to equalize the values and approximate the effect of image grain. You may also wish to repair such defects on the negative, to avoid or reduce the spotting of prints. In dire cases a defect in a reproduction print may be most effectively repaired by an airbrush expert, but I would never allow airbrushing of a fine print.

Etching

This is a potentially dangerous process and requires considerable practice. Scratches and "pinholes" in the negative will print black, and if possible, they should be repaired by careful spotting directly on the back of the negative. Etching is the physical removal of such dark specks on the print using a very sharp knife.

The technique of etching requires patience and practice. The tendency is to "dig out" the dark defects, but the result will be an obvious crater in the emulsion. The preferred technique is to use a very sharp blade with a gently rounded point, and to scrape the surface of the defect *very lightly*, holding the blade perpendicular to the print surface. A surgeon's scalpel blade #15 has been found to be good for the purpose, as it has one slightly rounded side which reduces the tendency to dig into the print.

The treatment should be so light that many strokes are required to wear down the dark spot; progress can be checked by examining the area through a magnifying glass. For a dark line, use light, discontinuous scrapings in the direction of the line. It is best not to work in any one area too long, but return again and again to previously worked spots to avoid eye fatigue and to aid in judging the extent of etching required. The etched area will usually require some spotting and "smoothing" to match the surrounding values.

Etching is certain to leave a mark on the print surface, and such can be especially distracting on a glossy print. One remedy for the surface is to coat the entire print with a plastic, lacquer, or varnish

Figure 7–12. *Etching.* A very sharp knife can be used to remove dark spots. The spot must be gently scraped, however, not gouged out. It is often better to remove the defect by spotting on the negative, and then make a new print; if the negative spotting shows as a small white area it can then be spotted out in the print, a much better process than print etching.

after etching, although such procedures are of quite questionable archival effect. A dab of lacquer over only the etched spot may help conceal it, but the difference in reflectance between the varnished area and the rest of the print surface is likely to be visible. If the scraping has been kept light, resoaking and drying the unmounted print may help reduce the roughening. Sometimes brisk rubbing with a silk handkerchief will partially restore the surface. With a framed print, the cover glass will help reduce the visibility of the etched area.

As with spotting, etching should be done cautiously, to give acceptable effect at normal viewing distance. In smooth, continuous surrounding tonalities, it is extremely difficult to do an invisible job. The best approach is to clear up as many defects as possible on the negative. Small areas of light density in the negative can sometimes be neutralized by delicately "roughening" the back (base) of the negative (*never* try this on the emulsion side!). The roughening scatters the light and produces the effect of increased negative density.

Chemical reduction of dark spots or streaks may be satisfactory as it leaves no marks on the print surface, but it is a laborious and exacting process. The process is carried out on a wet print before toning. For a very small defect, reduction usually leaves a light ring around the reduced area, and this must then be spotted as well as possible to match the surrounding value.

FRAMING, LIGHTING, AND DISPLAY

The manner of displaying the finished print deserves careful attention. Be sure to study the display situation with the print in its final condition; if it is to be framed behind glass or acrylic, this will affect its appearance, and decisions regarding lighting, etc., should be made with the framed print at hand. Often subtle low values clearly visible in the unframed print are obscured by the presence of even slight reflections in the glass.

I now use acrylic (such as Plexiglass) for all framing; glass is fragile, and if a framed print is dropped, there will inevitably be damage to the surface from sharp glass fragments. On the other hand, the acrylic must be handled extremely carefully, as it is quite soft and susceptible to scratching. It also has an unfortunate tendency to hold a static electrical charge which attracts dust; assembling a print in a frame with acrylic can be an exercise in frustration unless the environment is *very* clean and free from dust. It will help to vacuum clean the work area frequently.

Care must be used to avoid allowing humidity or the residuals of glass-cleaning materials to be trapped in the frame, or they will damage the print. Cleaning compounds should be thoroughly rinsed off, and the glass or acrylic *gently* wiped with a clean soft cloth or tissue. Use an anti-static brush to dust off the print, overmat, and Plexiglass before assembling the frame; using compressed air to blow away dust merely scatters it from one place to another.

My preference is to hang prints in simple brushed aluminum frames, since these are relatively inconspicuous and do not compete with the image. The frame plus acrylic provide good protection for handling and shipping the print.

The intensity and color of the light under which prints are seen can reveal or obscure their delicate values. Subtle dark values in the print that are apparent under normal lighting may appear solid black if the intensity of viewing light is too low; conversely, the same area may appear rather insubstantial and weak if the viewing light is too intense.

If you are making prints specifically for an exhibition or for display in a known location, it is worthwhile to determine the nature and intensity of the lighting (measured with a meter) and reproduce these conditions as closely as possible in your own studio for determining optimum printing. Framing material for permanent installations

Figure 7–13. *Print display in the studio-gallery.* I have suspended panels with a metal strip near the bottom to hold unframed prints, which are held in place with white plastic pushpins. The panels are plywood covered in a gray fabric of about 12 percent reflectance, and can also be used to hang framed photographs, as at the right. The walls in this area are 18 to 20 percent gray; they could also be of any color of the same reflective value. Very large framed prints are suspended from the molding at the ten-foot level of the wall. A combination of daylight from a skylight and flood lights suspended from the ceiling provides good illumination.

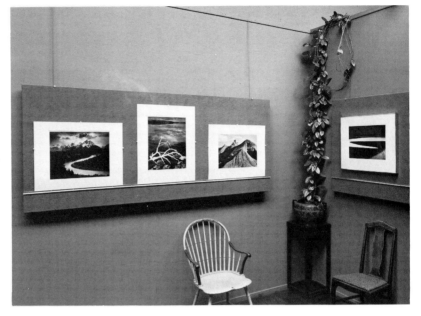

should also be carefully considered for compatibility with both the print values and the environment.

I consider the best gallery illumination a mixture of daylight and tungsten lighting. Prints that are displayed under tungsten light will appear warmer in tone than under daylight illumination from, say, a north skylight. Daylight alone is often too "cold" for optimum display effect. Hanging prints opposite windows, light walls, or bright objects is certain to cause distracting reflections that make viewing difficult.

Direct sunlight on color prints should be avoided at all costs. Well-processed black-and-white prints are more tolerant of sunlight, except that the low values (dark areas) absorb more radiant energy than the high values. This effect can place expansion strains on the emulsion, which may eventually cause cracks or detachment of the print from the mount.

The lighting should usually be from ceiling-mounted reflector floodlamps, which give quite uniform illumination over a broad field. They should be mounted far enough away from the print-display wall to provide relatively even lighting from top to bottom of the print. This placement will also help avoid exaggerating the texture of the print mount and will prevent strong shadows at the edge of the print from the overmat. If the angle of the lighting is too

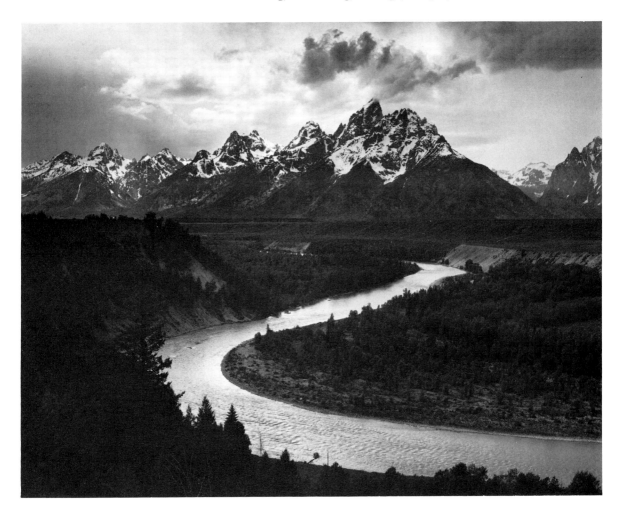

low, however, glare will appear on the cover glass, and the viewer's own shadow may fall on the print.

I do not consider ordinary fluorescent lighting favorable for viewing prints. In addition, its high ultraviolet content can be damaging, particularly to color prints, for long-term display. Probably the best arrangement is to install "track" lighting in the ceiling; this allows adjustment of individual tungsten lamps for optimum light distribution, and units can be added or removed as required. Although personal preference is a factor, I have found illumination levels of 80 to 100 ft-c at the print position to be agreeable if the walls and general environment are of a middle value.

I consider a background value of about middle gray to be optimum. In my studio/gallery area I have used a gray of about 20 percent reflectance. Note that this value can be achieved using a color other

Figure 7–14. *The Tetons and the Snake River, Grand Teton National Park, Wyoming.* This was visually a rather gray subject, although emotionally it was dramatic and powerful and I visualized a very strong image. The central forest was placed on Zone III, and the left-hand areas fell on Zone II. The brightest clouds fell on Zone VII, and the brightest water about on Zone VIII. I gave N + 2 development in D-23, and the negative contains adequate information, although considerable printing control is required for the desired effect.

I dodge a small amount in the dark areas in the lower half of the image and in the sky at the extreme left. I then burn-in using up-and-down passages of a card from just below the base of the peaks to the top, for about 1½ times the basic exposure. Then I give more burning of the sky, curving the card, for about half the basic exposure, and the same amount for the upper left corner. Finally I give about half the basic exposure to the bright area left of the high peaks. It is difficult to keep all values "logical." It is important to repeat that exposure and development of the negative control the total density scale, but areas *within* different parts of the photograph may not have the optimum density range (local contrast) for the desired effects. Hence the need for burning and dodging controls.

The photograph was made with an 8 × 10 view camera with 12¼-inch Cooke Series XV lens and No. 8 (K2) filter. I used Isopan film, rated at ASA 64, and gave N + 2 development.

than gray. I have seen very effective gallery displays where a cool brown, green, or even blue of about 20 to 25 percent reflectance provided an excellent complement to the prints.

The reason for choosing a middle value can be seen from a simple exercise. Place a group of photographs on a white wall of about 75 to 85 percent reflectance. The reflectance of photographic prints usually averages about 20 to 25 percent. When hung on a white wall the prints will appear much darker than normal. You can check this by looking at them through a length of black mailing tube, standing at a distance where a single print will occupy the entire field of vision through the tube. Look first at the prints on the walls for a minute or two, then quickly put the tube to the eye and observe a print through it. It will surprise you how quickly the print will "lift" in value. When you remove the tube, the print will quickly return to its previous, darker visual appearance. If the prints are hung on a very dark wall, the opposite effect occurs; they will appear lighter than normal.

The cause of this phenomenon is complex. Suffice it to say that the mechanism of vision involves the interaction of the eye (retina) and the cerebral cortex (that part of the brain that receives and interprets the messages from the retina). The average level of reflectance of the environment determines the *relative* reflective luminosity of the prints displayed. With paintings, color prints, etc., the reactions to environmental reflectance are somewhat different. It is unfortunate that so many museums and galleries install photographic exhibitions on white walls and in fairly high-reflectance environments. The most agreeable presentation of my work that I have seen was at the Victoria and Albert Museum in London; the walls were a rich cool chocolate hue of about 20 percent reflectance, and all the prints were "alive" on these walls.

STORAGE AND SHIPPING

It is probably best to discuss the optimum in storage conditions, although you may have to make some compromises depending on available storage facilities, etc. Mounted prints will ideally be stored with an overmat to separate each from adjacent prints, and with a "slip-sheet" of archival-quality paper (such as 1-ply Strathmore) between the print and the mat. Prints are then placed in museum storage boxes. Beware of wooden containers because the wood can emit harmful vapors, as can wood finishes (for example, varnish) and

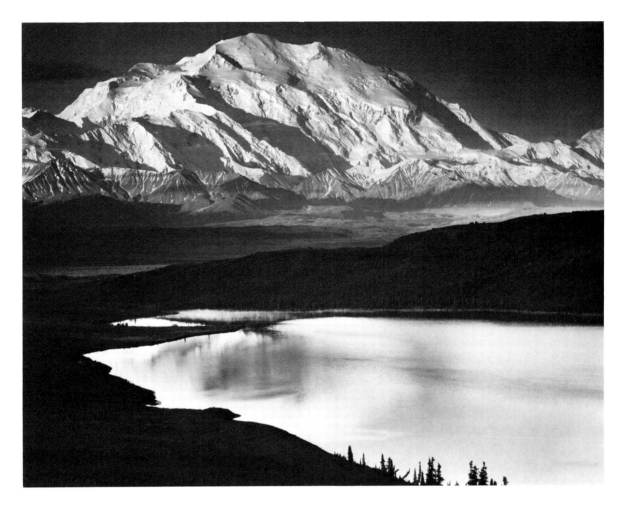

Figure 7–15. *Mount McKinley and Wonder Lake, Alaska (1948).* Taken at sunrise, here 1:30 A.M. The foreground was in deep shadow, and the mountain and faintly misty sky were suffused with golden light. A light breeze on the lake gave very diffuse reflections. I used a Wratten No. 15 filter to clear the foreground shadows; the sky was of such low-saturation blue that no filter would have had much effect. The first prints I made were quite soft and do not adequately express the impressive qualities of the subject.

Considerable burning and dodging are required. I hold back the shadowed lake and foreground for about three-fourths of the total exposure time, using a constantly moving card held relatively close to the lens for a wide penumbra. (The lake surface is burned in later to balance the amount of dodging of the surrounding hills and foreground.) Then the mountain and sky are burned from near the base of the mountain to the top, with three up-and-down passages. The sky is then further burned-in with the card bent to approximate the mountain shape. The upper left corner area and the upper right corner and edge areas receive additional burning.

The degree of dodging and burning required is explained by the fact that the contrast of the mountain and sky is quite low, while the all-over contrast of shadowed lake and mountain is high. I used a rather high contrast paper (Oriental Seagull Grade 3). Had the sky and shadows on the mountain been free of mist, the filter would have assured ample separation of values for Grade 2 Seagull.

I used the 23-inch component of the Cooke Series XV lens and a Wratten No. 15 (G) filter. The film was 8 × 10 Isopan rated at ASA 64 and developed in Kodak D-23.

the cement used in plywood. Fumes from some oil-base paints are especially harmful, as are automobile exhaust fumes and the vapors given off by some cleaning agents.

High humidity may be the most frequent cause of damage in long-term storage. The relative humidity should be kept at around 30 to 50 percent (no higher), and cool temperatures (below 65°F, if possible) are advised. Furthermore, *cycling* of temperature over a range of more than 7°F, or humidity over a range exceeding about 10 percentage points, should be avoided.

When a small number of unframed prints is to be shipped, they should be slip-sheeted and then wrapped securely in paper. This package can be taped to the center of a larger piece of heavy cardboard, and then sandwiched with one or more additional sheets before final wrapping. Keeping the corners and edges of the prints several inches from the edges of the packaging will usually prevent damage to the mounts. I use a very heavy corrugated board, some sheets cut with the grain horizontal and some with the grain vertical. By using opposing grain in the sheets of one package, considerable stiffness is gained. For very valuable prints, masonite or even plywood may be used, provided the prints are not to remain in the container for very long. For a group of framed prints, a wooden crate should be constructed. *Never* ship prints framed with glass; only acrylic can withstand the rigors of shipping.

You must also, of course, be sure all prints are fully identified with title, your name and address, etc. The package should be insured for adequate value and marked "Fragile" in large letters. For foreign shipments be sure to investigate current Customs regulations, and coordinate shipping plans with the recipient.

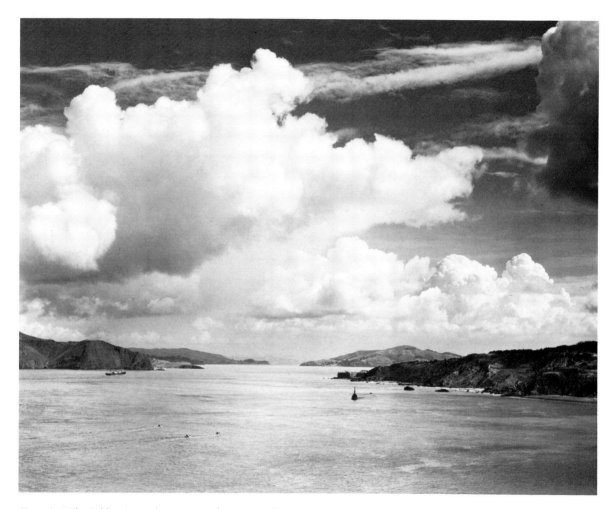

Figure 8–1. *The Golden Gate Before the Bridge, San Francisco (1932).* I was using the 8 × 10 camera with 30cm Goerz Dagor lens and Wratten No. 9 (K3) filter. The film was Kodak Super-Sensitive Panchromatic, developed in pyro. It is rather grainy and does not enlarge well with condenser light, although it is quite smooth with diffuse enlarger illumination. It was one of

my "fortunate" early exposures and is not too difficult to print. The printing has gone through various interpretations; my first contact prints were very soft.

I can print it now on Ilford Gallerie Grade 3 or Oriental Seagull Grade 3 (for the latter I use Selectol-Soft with a little Dektol added). The foreground water needs a little burning from hori-

zon to base. I give the sky several up-and-down burning passages from the horizon line, with extra burning along the top. A slight mist effect in the right-hand cloud area requires some broad burning with a circular hole. This is a case where I first try to get the best possible effects without any burning or dodging.

Chapter 8 · **Special Printing Applications**

Several specialized printing applications require modifying the standard processing, and we shall consider some of these situations in this chapter. Bear in mind that the specific recommendations I make may well need to be adjusted to fit your existing circumstances and working conditions.

HIGH-VOLUME PRINTING

I consider high volume to refer to the making of an "edition" of about 25 to 100 prints or more of the highest quality, not the mass production of prints by machine. It is my conviction that, with clear visualization and adequate equipment and procedure, any number of perfectly consistent prints can be made to match a first "pilot" print. I have frequently spent much more time getting the pilot print just right than making a hundred subsequent prints. Consistency is the primary requirement.

You must consider several factors to ensure the uniformity of the prints:

1. Use the same brand, type, and emulsion number of paper.

2. Use a printing or enlarging lamp of consistent intensity, with provision for voltage stabilization or, better yet, output stabilization such as is provided by the Horowitz unit.◁

See page 23

3. Use the same developer formula throughout, with the same dilution, temperature, and additives (such as restrainer), if any. For

developing a batch of 5 to 8 prints simultaneously, I find it best to use a developer of higher than normal dilution or a slow-working formula. One formula I have used in the past was the Ansco #130, which required about a 6-minute developing time; it was a variant of this formula I used to make 100 prints each of twelve subjects for *Portfolio I* (1948). ◁ With Dektol I suggest a 1:6 or 1:8 dilution. Be sure the developer solution contains an ample amount of *stock* developer for the number of prints to be developed; one quart of Dektol stock solution has a capacity (after dilution) of about 64 8 × 10 prints or the equivalent. Use the factorial method to control development precisely. ◁

See page 54

See page 95

4. Give the prints uniform, and *careful*, processing: developing, fixing, washing, toning, hypo clearing, and final washing. I do not start timing any process until I have leafed through the stack of prints once in the solution to be sure the chemicals have come into contact with each print.

Two frequent bottlenecks exist in the typical darkroom when large volumes are handled. The first is adequate washing facilities. The prints must not be washed in an overcrowded tray or washer; do not attempt to handle a high volume unless you can ensure as thorough washing for the batch of prints as for smaller quantities. The second bottleneck is likely to be drying space. Sufficient drying racks are required to allow about one inch between prints. On occasion I have produced as many as 200 good prints a day in a relatively small darkroom. I had adequate drying space but could wash only 30 prints at one time.

Procedure

1. Make the ideal pilot print first. This may require a day or more of work with a difficult negative. Be sure you judge the print after drying, and ideally after toning as well. Once you have the optimum print, record all data: enlarger position, lens stop, exposure time, all burning and dodging times, development (developer, dilution, temperature, emergence time and factor, total development time).

2. Then prepare for batch printing by checking all equipment and preparing the developer, stop bath, and first (acid-hardening) fixer. Ample quantities of each working solution will be required, in trays that are large enough to provide room for easy handling. Development of several prints will be most uniform with relatively long development times (5 to 6 minutes), which minimize the effect of the inevitable slight variations in handling each print. If the devel-

opment time for the pilot print was short (less than 3 minutes), increase the developer dilution and determine the new time by using the original factor multiplied by the new emergence time. With long development, you must always beware of safelight fogging.

3. Expose the first batch of 4 to 8 prints, storing them in a light-tight box or paper safe until all have been exposed. Before you begin the processing, mark one print that will be the first or last to go into the developer, so you can transfer the batch to the stop bath in the same order; I usually tear off a corner of the last print to go into the developer. Immerse the prints quickly but carefully in the developer, one by one. When the last print is in the solution, immediately start the timer. Keep rotating the prints, raising the bottom print to the top continuously, as rapidly as possible without damage. Note the emergence time for the *last* print immersed. Multiply the time required for emergence by the development factor to determine the total developing time.

4. After development is complete, drain the prints for a few seconds and move them to the stop bath, starting with the print that went into the developer first. Leaf through the stack at least twice to ensure complete neutralization of the developer.

5. Drain and move the prints to the first fixing bath, and agitate constantly for 3 minutes.

6. After fixing, remove the prints to a tray of fresh water and rinse them well. Then place them in a water storage tray. Be sure there is an adequate supply of fresh running water in this tray, and that the prints are given frequent agitation. If they are merely placed in standing water without rinsing, or are not agitated and separated, the fixing activity will continue.

7. Proceed with additional batches of prints, using fresh developer when an obvious increase in the emergence time is observed. The stop bath and fixer also must be replaced regularly. It is advisable to check each batch as a whole against the *pilot* print for quality and depth of tone; keep the pilot print nearby in a tray of water for continual reference. In addition, carefully check the last print of each batch for any obvious physical defect (such as a dust speck on the negative) that will persist in subsequent batches.

See page 132

8. When all prints are made, discard all solutions. If the prints are to be selenium toned, make up a fresh plain hypo fixer, ◁ selenium toning solution, and hypo-clearing bath. You can conveniently process up to 12 prints at a time through these solutions. After thorough rinsing, give the prints 3 minutes in the second fixer, followed by *direct* immersion in the toning bath; the toner dilution should be

adjusted to permit a 4- to 10-minute toning process if possible, so the prints can be carefully watched and removed without over-toning. Then move the prints directly to the hypo-clearing bath for 3 minutes with constant agitation. Rinse the prints carefully

Figure 8–2. *Print positioning guide.* The gray cardboard is a "self-centering" device. When both print edges align at the same number on the scale, the print is centered. The width of this scale positions the print a specific distance from the top edge, and the scale is then used to center it. Such a scale can greatly facilitate mounting a large number of prints.

Figure 8–3. *Tacking using positioning guide.* Once the print is in position, the weight is used to hold it while the corners are tacked.

and store them in fresh running water, frequently separating them, until all prints have been treated.

9. Then place the prints in the washer. Give at least one hour total washing time. Drain and refill the washer every 5 to 10 minutes, unless you are using an archival washer and you are confident that it provides full circulation of fresh water around each print.

10. After washing, rinse, drain, and swab the prints, and set them out to dry. I usually carry out this step by placing a batch of prints face-up on the drainboard. I swab the top print with a squeegee and then place it face-down on another part of the drainboard to swab the back. The next print can be stacked on top of it until all have been so treated. (You can use the bottom of a flat tray for a drainboard, provided it is *clean*.) I then carefully lift each print from the stack and lay it face-down on the drying screen, gently wiping off any water on the backs using a clean cloth or a sponge.

11. When fully dry, the prints should be carefully stacked (be sure there is no dust or grit between them) and submitted to light pressure to flatten them.

The trimming, mounting, and spotting of a quantity of prints will also require some "production line" planning. First mount the pilot print, and record the dimensions of the board and positioning of the print. If necessary, cut the required quantity of mount board to size. Tack the dry-mount tissue to the prints, and then, just before mounting, trim each one to correspond to the pilot print.

You can save considerable time in dry-mounting if you first prepare a cardboard guide for positioning, as shown. In this manner it should be possible to position and tack one print during the time another is in the dry-mount press.

VERY LARGE PRINTS

The making of big enlargements can be cumbersome, and therefore requires a certain amount of specialized equipment and planning. Before undertaking the mechanical aspects, however, the aesthetics must be considered. Since large print installations are usually permanent, I urge you, before printing, to examine the site where the print will be shown. If the lighting is subdued, you can then avoid making a too-rich print; if glare from windows or skylights appears likely to be a problem, you will be able to choose a low-gloss or matte enlarging paper. In addition, the print "color" can be chosen in relation to the surrounding environment: it is usually sufficient

to make the print slightly "warm" or "cold" in tone if the general tone of the room suggests either quality. The color relationship can sometimes be further enhanced by the choice of framing. You may also be able to apply a special background color as a suitable transition from print to general environment; usually, however, the print must be matched to the environment, rather than the other way around.

In general the paper used should have a semi-gloss surface without obvious texture (assuming the print is not to be framed behind glass or acrylic). However, for very large images that will be seen from relatively large distances, the illusion of definition can sometimes be enhanced by using a fine-textured surface. Glossy surfaces are difficult to process in large sizes because they are subject to breaks and abrasions. Avoiding glossy papers will also help you achieve a somewhat softer image for the mural-sized print than for a smaller print of the same negative; a brilliant full-tone image may be far too dominating, especially in a location where it is seen frequently. Kodabromide is currently available in 40-inch by 100-foot rolls (Kodak also makes a paper called Mural, but it is single-weight and I do not care for its qualities).

The choice of subject matter should be made with due consideration for the viewing location and circumstances. In cases where the print will be a permanent installation, its long-term effect on viewers should be considered. I have found that a "semi-abstract" subject — a pattern of leaves, natural or mechanical forms, etc. — wears much better, with less likelihood of visual fatigue, than the usual representative subject matter. Of course, personal taste should dominate the final selection. In a home it may be appropriate to use a fairly quiet subject, whereas a work space or public building, where the viewers circulate past the image, may require a more vigorous design in bold tonalities.

For very large spaces, consider printing an image in multiple panels. We can attempt to match the separate sheets precisely so they will bend together with an invisible border, but this is extremely difficult and uncertain. The alternative is to mount each panel separately with its own borders, defined by very narrow "T"-shaped framing material of appropriate tonal value. Strangely enough, dividing the entire image into sections does not destroy the illusion of continuity; rather, it seems to augment the impression of depth. The narrow dividing strips are accepted by the viewer as a "window" that exists in space before the image. I have also made such panels free-standing, in the form of a screen, with the panels connected by hinges. The width of such panels will be limited by the width of the enlarging-paper rolls available or by processing facilities.

For all such large projects, a scale-model dummy (perhaps 16×20 inches) should be prepared to study the overall effect, and to determine final cropping and disposition of the image. It often takes a lot of time and experimentation to decide how to trim the photograph in sections so the image will maintain its compositional effectiveness. With multiple panels, the dividing lines must be carefully located in relation to the forms and lines in the subject to avoid, for example, a conflict between the edges and vertical lines in the subject. The separation of the panels by the frame strips should not expand the composition of the image; rather, the separations should be merely "interruptions" of the image. Panel edges will require a slight trim to keep the all-over design intact when the framed panels are assembled.

Procedures

The required darkroom facilities include adequate projection space and a large easel, and a lens of appropriate focal length and high quality. The enlarger must be very sturdy, and capable of horizontal projection. The effects of misalignment of the enlarger or easel will be particularly obvious; the larger the image, the more exacting the mechanical requirements.

For the smoothest effects I prefer diffused-light enlargement; this implies a fairly long exposure — several minutes or more — but avoids the exaggeration of grain and negative defects inherent with condenser illumination. ◁ Remember that at prolonged exposure times the speed of the paper is reduced by the reciprocity effect. ◁

See page 21
See page 48

Be very careful of all sources of darkroom fog, especially safelights; considerable handling time is involved, and any potential source of fog can become a problem. You will need adequate processing trays, washing sinks, and drying frames. It is usually best to process the paper in a trough rather than attempting to process it in a very large tray. For very large prints I have used three fiberglass troughs, each about 50 inches long, 12 inches wide, and 9 inches deep. I can thus handle the standard 40-inch-wide rolls of double-weight paper, cut to lengths of up to 80 inches (the practical limit with my easel). Each tray requires at least 10 liters of solution. The trays are thus set up with developer solution, stop bath (standard formula), and conventional hardening fixer for the first fixing bath.

A long development time is advantageous to accommodate the time required for the paper to be rolled and unrolled in the developer. Thus a fairly dilute or slow-working developer is called for, such as Dektol at 1:6 to 1:8 dilution. The development time can be deter-

mined by making test strips; it must then be standardized, since it will be difficult to see the emergence time of any specific print area while the print is being rolled through the developer. For this reason it is very important that the developer always be fresh for each large sheet, and at a constant temperature.

Focusing is a real problem, since the image is quite faint. A focusing magnifier is essential, and you will need an assistant to adjust the focus while you inspect the sharpness of the grain at the easel. When working alone I have often made separate focus tests on fast paper to examine the sharpness of the grain. Remember that, at long projection distances, the lens-to-film distance is more critical than the lens-to-paper distance. ◁ Thus any bulge in the negative is likely to destroy the image sharpness, and a glass negative carrier may be required (watch for dust or Newton's rings ◁). Be sure the darkroom has consistent fairly low humidity; paper absorbs moisture, and may buckle during exposure if the humidity is high.

See Book 1, page 48

See page 24

Exposing and Processing

To determine exposure, make careful test prints using pieces cut from the paper roll and attached to the easel with pins, magnets or tape. When you are ready to make the first full-size image, cut off the appropriate length of paper and attach it to the easel. I find it most convenient to hang the entire roll of paper at the top of the easel from a sturdy iron bar, and unroll the required length by pulling it down like a windowshade; I then attach the paper to the easel, working from the top down to ensure flatness. Once the paper is secure, I cut it off at the top and replace the roll in the box to protect it from light.

Make the exposure, including whatever dodging and burning are required. Be certain the enlarger and easel are completely stationary and free from vibration during exposure time. Remove the paper by detaching it first at the bottom and rolling it loosely as you work toward the top. You must use care to avoid pinching the roll. To process, immerse the roll in the developer, and immediately begin unrolling it and forming a new roll at the opposite side of the tray. ◁ When the entire sheet has passed through the developer, start the timer and reverse the direction of rolling.

See Figure 8–6

This rolling back and forth continues throughout development, and in the subsequent baths. Some practice is required to perform

Figure 8–4. *Support for roll paper.* The hinged support shown allows the paper roll to be slipped onto the pipe easily. The far end of the pipe is threaded into a bracket. Once the required amount of paper has been cut off, the roll must be removed to its light-tight box, so ease of handling the large and heavy rolls becomes important.

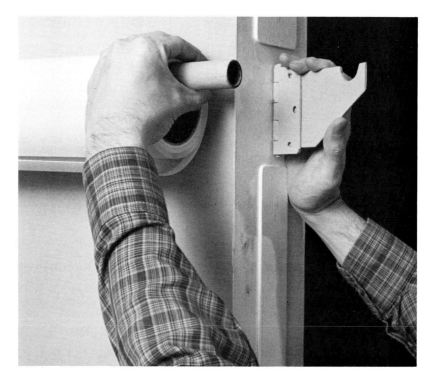

Figure 8–5. *Cutting paper for oversized print.* I have had magnets mounted in two large T-squares, and these hold the top and bottom edges of the paper. Additional magnets have been placed along the sides. My assistant, John Sexton, is cutting the paper along the top. I leave at least 2 inches of paper beyond the top and bottom edges of the image, and I center the horizontal image in the 40-inch width of the paper. With ample edge space the large prints are somewhat protected in processing. If a tear appears in the borders, it should be closed with tape on both sides to prevent the tear from spreading into the image during processing.

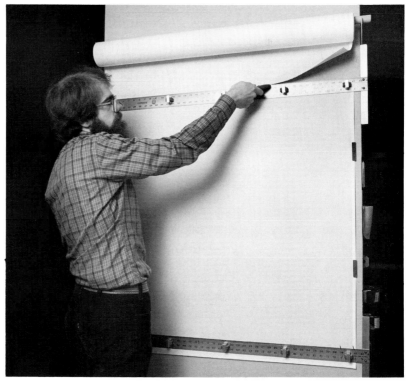

this motion smoothly and consistently. Do not be alarmed by apparent unevenness and streaking as the image starts to develop. If the rolling is consistent and the developing time relatively long, the print values will be entirely smooth by the time development is finished. When making several matched panels, the development time must be carefully controlled, and you must use the same amount of *fresh* developer at the same temperature with uniform agitation for every print.

As the end of the development time approaches, make the last rolling of the paper somewhat tighter than the others. Place both hands under the roll and *slowly* and *gently* lift it, giving it a tilt so the solution within will drain out. A sudden movement may cause serious damage; the weight of the solution is almost certain to "break" the roll.

Once free of the solution, the roll can be tipped at a steep angle and drained for about 15 seconds before placing it in the stop bath (the time required to drain the print must be included as part of the total developing time). You should then roll and unroll the print in the stop bath without delay. Use similar caution when moving the print to the fixer, where the rolling procedure continues for 3 minutes, and then into the washing sink. The processing of the rolls can be done by one person, although an assistant can take over the rolls in the stop bath and fixer while a new roll is developed.

Roll the print back and forth several times in water to remove the fixing solution from the surface; if your sink is large enough to hold the print flat, you can gently hose it off several times, draining the sink after each rinse. It is important to remove as much of the surface hypo as possible, since, if rolled prints that retain fixer are allowed to stand, bleach marks can result. Store all prints flat or loosely rolled in running water until you have completed the printing. For important assignments, I have found it economical to make two or more identical prints of each image or section of an image; the possibility of loss by accident in processing and mounting must not be overlooked.

When all the panels are made and *thoroughly* rinsed, they can be rolled up separately and stood on end to drain for a short time. Then, one by one, they are put through a non-hardening fixer followed by toning and hypo-clearing. If the prints are not to be toned they should receive the second fixer treatment and several minutes of careful rinsing followed by hypo-clearing. After the hypo-clearing bath move the prints into a separate wash sink (do *not* return the treated prints to the wash sink that contains hypo-laden prints). The prints should be washed for at least one hour. Roll the prints continuously 4 or 5

Figure 8–6. *Agitating roll paper in developer.* Using the trough-type trays, the paper can be rolled back and forth from one side to the other. Provided developing time is not too short, this method will ensure adequate agitation. Care must be used not to allow the paper to buckle during handling. It also must not be allowed to "stand" for any length of time, as streaking may appear.

Figure 8–7. *Rinsing large print.* Prints should be carefully rinsed one at a time in a large sink, if available. The alternative is to use the rolling procedure in a trough of fresh water, changing the water several times.

times in water, and drain and refill the sink 8 to 10 times during the wash. This is undoubtedly a long and wearying procedure, but we must remember that prints of this kind are usually exposed to light on continous display and *must* be as permanent as possible. I strongly advise selenium toning for archival security.

When the wash has been completed, roll the prints separately and stand them on end to drain. Gently unroll each one face-up on a taut, flat drying screen of ample size, and carefully wipe the surface with a clean cloth or viscose sponge. Water drops should not be allowed to remain on the surface as they may warp the paper, and this might show when they are mounted. When thoroughly dry the print may be gently turned over and rolled, face outward, for storage. If care is used, several prints can be rolled together and stored in the original paper-roll box. Rolling them face-outward tends to impart less curl to the paper than if they are rolled face-in, and they flatten out more easily for mounting.

Mounting and Presentation

Mounting technique is very important, and requires great delicacy! The larger the print, the greater the potential difficulty. My advice would be to have an expert do it. A good picture-framer can usually manage the entire job of mounting and presentation; take no chances with poor workmanship. The print must be mounted with no breaks or blisters, maintaining exactly the cropping and alignment determined in the small dummy.

However, you must first make the decisions regarding final presentation. Simply mounting the image flat on the wall is often not acceptable, physically or aesthetically. A photograph usually implies space and depth, and this effect needs some physical enhancement in the presentation. I have always preferred to have large prints mounted on a firm panel (I have used ½-inch plywood — carefully sanded to a smooth finish — as a base under an archival material). The edges are covered with a thin aluminum molding that overlaps the image area by about ¼ inch. The whole panel is then held about 2 to 4 inches away from the wall using hidden supports, thus achieving a great feeling of depth and "presence." The print should be spotted after mounting (but before any lacquer or other overcoating is applied) as it is then flat and less vulnerable to damage than the large sheet alone.

A thin coat of colorless lacquer will protect the print surface and make cleaning simpler. The archival quality of lacquers and var-

Figure 8–8. *Fresh Snow*, screen. Three separate large prints were made of slightly overlapping segments of the single 8 × 10 negative, carefully balancing and matching the tonal values; a fresh developer solution was prepared for each segment. These prints were mounted on sealed plywood and framed with aluminum molding to which piano hinges were attached. (Courtesy Minneapolis Institute of Arts, from the exhibition "Ansel Adams and the West," 1980. Installation photograph by Gary Mortensen.)

See pages 162–164

nishes is disputed, and it is difficult to make a recommendation at this time. However, for a print not protected by glass or acrylic, you may decide that the protection afforded by a lacquer coat is more important than the possibility that the lacquer might detract from long-term archival permanence. With lacquer surfacing, the print can be cleaned with a slightly damp cloth.

If possible provide uniform lighting from tungsten floodlamps above the image. The lamps should be directed downward on the print from sufficient distance to illuminate the surface evenly. ◁ Check to be sure that glare will not be a problem for viewers; because of the large size of the print, glare may be difficult to control. Be certain the print is not exposed to direct sunlight or heat; the expansion and contraction produced by the heat may cause the print to become detached from the mounting material in irregular patches.

In a large display area, powerful spotlights can be directed at the print at the appropriate angle to provide even illumination without glare. Geometrically cut masks over the lights can provide an accurate rectangle of light on the print, isolating it from the surround.

PRINTING FOR REPRODUCTION

The present state of reproduction processes makes it possible to interpret fine original photographs with astonishing accuracy. We must remember, however, that a reproduction in printer's ink is only a simulation of the silver image of the photographic print. The factors leading to a fine photomechanical reproduction are numerous, and quite different from those of photography itself. Considerable expertise is required of the engraving and printing technicians to simulate the visual and emotional effect of a photograph. When submitting prints for reproduction, you should first know as much as possible about the intended means of reproduction.

The halftone process is almost universally used for reproduction of photographs. In this process, the image is formed by solid ink dots of varying size; from normal viewing distance the dots are not resolved separately by the eye, but tend to merge and simulate values of gray. Note that no gray is actually present, but only solid dots and white spaces between them; the dots themselves are all of the same density of "black." The proportion of solid dots and white spaces in a given area determines the value of gray it simulates.

With halftones, the dots are arrayed in a regular pattern, referred to as the "screen." A coarse screen of fewer than 100 lines per inch is common in newspaper reproduction, where the paper stock is of inferior texture and surface. For high-quality reproduction better paper and finer screens are used; screens may have 200 or even 300 lines per inch (a 200-line screen has 40,000 dots per square inch!). The finer screens give higher resolution and simulate the effect of the photograph more realistically, but a limit is usually set by the press methods and paper stock; attempting to use too fine a screen tends to obliterate texture in the low values and causes unevenness in the high values.

My first experience with fine engraving was with the Walter Mann Co. of San Francisco, where Raymond Peterson was the chief engraver; a more excellent technician I have yet to find. The printing process then used was letterpress, where the printing plates are metal and the image dots are *raised* above the surface of the plate. With

letterpress we considered a 133-line screen to be optimum for clarity; finer screens produced a smudged effect in the low values of the reproduction. This result occurred because of the impact of the metal plate directly on the paper, which tended to spread the dots slightly. For this very reason, however, letterpress could produce a remarkably smooth reproduction, even with only a 133-line screen.

To "clear the whites" and enhance the separation of subtle high values, the plates were etched in acid. This process was complicated and somewhat intuitive; slightly too much etching meant the plate had to be remade. Hence the presence of a superior craftsman to make the engravings was of utmost importance. (Good examples can be seen in *My Camera in Yosemite Valley*, and *My Camera in the National Parks*, both by the author,* and in other photographic books of the period.)

The gravure process was in favor for many years. The magnificent gravure reproductions in Alfred Stieglitz's periodical *Camera Work* (issued from 1902 to 1917) attest to its quality. A certain style of image was favored by this process, but I found it sometimes difficult and uncertain, quite hard to control with continuous-tone images. For example, there was frequently a definite "jump" in the value scale around Values IV–VI. The modern rotogravure process is related, but is generally used for very large press runs at extremely high speeds rather than for fine reproduction.

The reproduction of photographs is usually done today by offset photolithography. With this process the halftone dots are not physically raised, but are separated instead by the "hydrophilic-hydrophobic" principle: the dots accept ink and not water, while the spaces between the dots reject ink and accept water. Hence only the dots carry ink. The term offset means that the image is transferred from the plate to a "blanket" in the press, and the blanket then transfers the ink to the paper (in letterpress work, the plate comes into direct contact with the paper). Ordinary lithography reproduces images with a single plate, but high-quality printing of full value scale usually requires at least two plates printed in register referred to as duotone or "extended range" lithography. ◁

See page 185

The general factors influencing the quality of reproduction are (1) the manner of exposing the films used to make the plates; (2) the type of lithography (single-plate or duotone); and (3) related factors such as the choice of ink and paper stock, and whether or not a varnish is applied. A crucial issue in all aspects of printing is cost; the preferred methods for fine reproduction invariably add to the cost of the project.

*Published by Virginia Adams and Houghton Mifflin Co., Boston, 1949 and 1950.

Figure 8–9. *Trailer Camp Children, Richmond, California (1944).* This photograph was made for a wartime project at the shipyards at Richmond in which Dorothea Lange and I were engaged. The boy was caring for his sisters while both father and mother worked in the shipyards. He was being interviewed and was obviously concerned. At the time I was using only my view camera; for this I borrowed Dorothea's twin-lens Rolleiflex and made this negative (only one, as she needed the camera). It is a difficult negative to print. The camera lens was uncoated (and probably dusty) and the negative shows considerable all-over flare. The lighting was very uneven and both cropping and dodging were critical.

The negative contrast varies extensively. The faces require careful dodging with a small wand. Other areas — parts of clothing, hands, arms, near door-jam — were in patches of sunlight against areas of deep shadow, and thus demand precise burning. This is a good example of correcting an uncontrolled negative. In fact, I was fortunate to get any negative (or acceptable print) at all! The subject was vital to the story, and fleeting; the visualization was only "general."

Photoengraving

The original photograph to be reproduced must be recorded on film, usually in halftone dots. The photoengraver's negative is exposed in a process camera through a contact screen that introduces the dots. This negative is then used to expose the press plate, which ultimately transmits the positive image in ink to the paper.

In the past engraving materials had too short an exposure range to handle the full scale of a fine print. There has always been discussion on what the reflection-density range of the print should be to match the scale of the negative/printing-plate system. In newspaper photography, the values of the optimum print were described as "black and white, plus two or three grays at most in between." Engravers were trained to expose their negatives to hold all possible shadow detail in the print to be reproduced. This usually resulted in the high values being overexposed and "burned out" in the reproduction.

The current state of the art in photoengraving makes use of the laser scanner, originally designed for reproducing color images but superbly suited for black-and-white reproduction with duotone printing. To use this device, the unmounted print is attached to a drum, which rotates in front of a fine beam of light. The light beam scans the image, and the light reflected is translated through a computer into exposure information for the negatives (one for each plate), which are then automatically exposed by laser beams.

The result is exceptional image resolution and greater control of the tonalities. The dot pattern created by the laser beam is distinctly sharper than that of a contact screen in a process camera. The scanner also permits selective enhancement of values; it is possible to reveal subtle separation of values at either end of the scale which may even exceed those attained by the photographer in the original print! Of course, the result is subject to the skill and taste of the operator, and, if possible, the photographer should be available to suggest appropriate value controls during the engraving and printing.

Duotone

It is impossible with a single lithographic plate to have full control of the ink deposited on the paper. With a single plate the image typically will have weak low values and/or harsh high values. Thus a second plate may be used in reproducing full-scale photographs, primarily to reinforce the dark areas. The ink used on the second printing plate may also differ from the ink on the primary plate, to provide subtle control of the image "color." The techniques used in

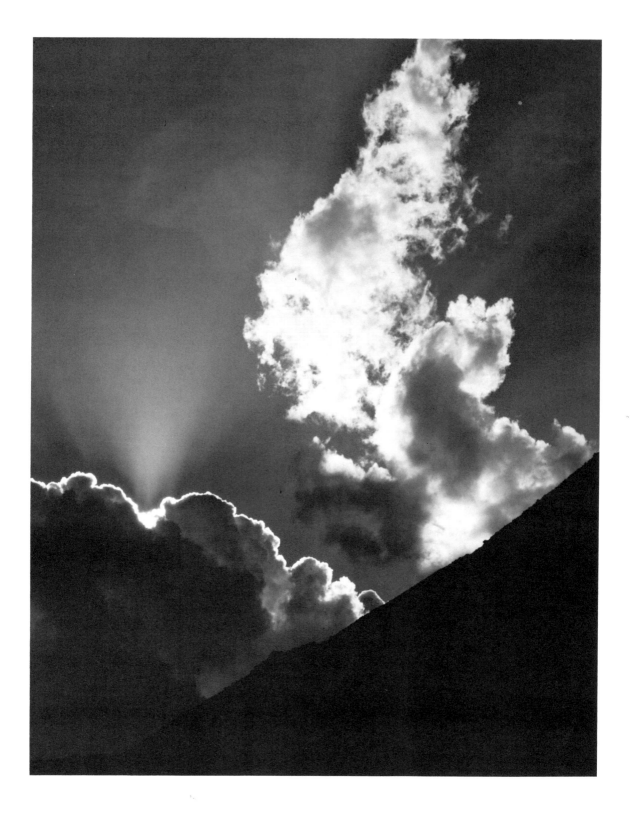

Figure 8–10. *Evening Cloud, Sierra Nevada, California, c. 1936.* This is an example of an extreme luminance range. I used a deep yellow filter (Wratten G, No. 15) to lower the sky values, which enhanced the shaft of light from the lower cloud. The filter also reduced the values of the dark mountain slope in shadow (it was illuminated by blue-sky light). The sun-lit clouds are "blocked." I developed the negative normally in Kodak D-76; obviously, a two-solution or water-bath development would have better preserved the textures of the extreme values. The print was made on a Grade 1 paper. Since there is little or no subtle value showing in the high values of the clouds, merely making a softer print would have reduced the feeling of light which is, to a certain extent, preserved in this image.

duotone reproduction are related to those of color printing, where at least four plates are used, although a printer skilled in four-color work will not necessarily be experienced in fine black-and-white reproduction.

Duotone printing is sometimes called "two-pass" litho, since it can be done using a single-plate press by feeding the paper through twice, using different plates that are printed in register. It is now far more common to use a two-color or four-color press, where the paper passes directly from one impression to the next; this assures optimum registration of the impressions, and minimizes printing time and paper handling.

Paper and Ink

The selection of paper stock involves determining the *weight* of the stock (too light a paper will "show-through" the image on the reverse side), the *color*, and the *coating*. Coated papers are best for fine reproduction, and the paper color should be chosen together with the ink color to achieve a good balance that will represent the images well.

In addition, the "gloss" of both paper and ink should be matched. If a high-gloss ink is used on a matte paper, the high values will be relatively dull and the dark values quite brilliant, a disturbing effect. In the reverse situation — when the paper is of higher gloss than the ink — the dark values will be dull compared with the high values and paper base.

I have found that using a semi-gloss paper with an ink of maximum gloss produces reasonably uniform reflectance and eliminates the need to "spot-varnish." It has been common practice to apply a varnish over the printed image (using a separate printing plate) to provide uniform "gloss." However, it seems that *all* varnishes tend to turn yellow in time; the discoloration can be minimized by using a very light varnish coat, but ink and paper of matching gloss can often eliminate the need for varnishing.

My recent monographs and books have been laser-scanned and printed in duotone by Pacific Litho Co. of San Francisco, under the direction of George Waters, and by Gardner/Fulmer Lithograph of Los Angeles, under the direction of Dave Gardner; the results have been extraordinary.

Prints for Reproduction

For conventional process-camera photoengraving, I have always found it best to make a slightly "soft" print, being sure to maintain slightly *more* detail in the subtle high and low values than I expect to be retained in the final reproduction. In my work with George Waters in San Francisco (printing, for example, *Images 1923–1974**) we agreed on a 1.50 reflection-density range for the textural range of the reproduction print (excluding the deepest blacks or true whites). Hence these reproduction prints were somewhat shorter in scale than fine display prints. The plate-making and printing were then done with fine prints at hand for comparison.

With the laser-scanning method I have found that the reflection-density range of the reproduction print can be higher, about 1.80. It is therefore frequently possible to use unmounted fine prints for scanner reproduction. However, the scanner technician may have different ideas on this subject, and it is best to consult with him and the pressman if possible prior to making the prints. The maximum print size for scanning is usually 16×20 inches, although a few machines exist that can take a larger print. The actual image area may need to be slightly smaller, as margin space is required for taping the print to the cylinder.

Once you are satisfied that your prints are suited to the process, be certain they are well spotted with neutral black/gray material. Large defects should be left to a professional retoucher, often available at the printing shop. The prints must also be free of surface defects such as breaks or scratches. Be sure to leave some margin around the full image; if you trim the print to exactly the final image you want, you may be sure you will loose some image area on each edge because of the "window" used in making the plates. Mark crop lines precisely in the border area using a ruler and square. If possible, provide a trimmed proof print of *exactly* the cropping you want to appear in the reproduction. I have found it most discouraging to define the edges of an image most carefully, only to find that the photoengraver has overlooked the instructions. By submitting a carefully trimmed proof there can be little excuse for error.

*Published by New York Graphic Society Books, Boston.

Appendixes

Chemical Formulas

Countless formulas for developers and other solutions have been advanced over the years. The ones given here are those I consider of potential usefulness with contemporary materials, for those willing to experiment. In all cases I urge you to try out each formula before using it for important work.

We have supplied both avoirdupois and metric system values for the formulas whenever practical. I believe the metric system will be universally accepted in the near future; most technical formulas are in metric values already, and it is highly efficient.

For those not familiar with the preparation of percent solutions, a 10 percent solution contains 10 grams of dry chemical in 100 ml of *mixed solution*. Note that this is not the same as adding 10 grams of the chemical to 100 ml of water. Usually the dry chemical is added to about three-fourths of the water, and after mixing, more water is added to make up the required total volume.

The advantage of using percent solutions is that a specific *weight* of a substance may be measured out using the *volume* of solution, providing an accurate means of measuring small quantities. Thus if we need 5 grams of potassium bromide and the bromide is in a 10 percent solution, we would use 50 ml of the solution, since 10 percent of 50 ml gives the required 5 grams of bromide. Approximately the same proportions can be obtained in avoirdupois units by dissolving 1 ounce of dry chemical in sufficient water to make 10 fluid ounces of *mixed solution*.

Print Developers

Kodak D-72

Water (125°F, 52°C)	750 ml	64 oz.
Metol	3 grams	175 grains
Sodium sulfite (desiccated)	45 g	6 oz.
Hydroquinone	12 g	1 oz., 260 gr.
Sodium carbonate (monohydrated)	80 g	10 oz., 290 gr.
Potassium bromide	2 g	115 gr.
Cold water to make	1 liter	1 gallon

This formula is very similar to Dektol. It is a stock solution, usually diluted 1:2 to 1:4 for use, with developing times usually of 1½ to 3 minutes. Note that the potassium bromide may be mixed in a 10 percent solution for convenience, in which case 20 ml would be added per liter, or 2.7 fluid ounces per gallon.

Ansco 120

Water (125°F, 52°C)	750 ml	100 oz.
Metol	12.3 g	1 oz., 280 gr.
Sodium sulfite (desic.)	36 g	4 oz., 350 gr.
Sodium carbonate (desic.)	30 g	4 oz
(OR monohydrated, 36g; 4 oz., 350 gr.)		
Potassium bromide (10% solution)	18 ml	2.3 fl. oz.
Cold water to make	1 liter	1 gallon

This is a very soft working developer, using metol only, and it gives good print color. In effect it is quite similar to Kodak Selectol-Soft developer. It is usually diluted 1:2 or more for use, with 1½ to 3-minute developing times, although it can be used full-strength.

Ansco 130

Water (125°F, 52°C)	750 ml	100 oz.
Metol (Elon)	2.2 g	130 gr.
Sodium sulfite (desic.)	50 g	6 oz., 300 gr.
Hydroquinone	11 g	1½ oz.
Sodium carbonate (desic.)	67 g	9 oz.
(OR monohydrated, 78 g; 10½ oz.)		
Potassium bromide (10% solution)	55 ml	7 fl. oz.
Glycin	11 g	1 oz., 205 gr.
Cold water to make	1 liter	1 gallon

My personal variation on this formula was as follows: omit the hydroquinone and the bromide, and reduce the sulfite to 35 grams per liter (4 oz., 305 gr. per gallon). Then add bromide only as needed to prevent fog. This was strictly a personal adjustment, but it gave a beautiful print color. If its contrast was found to be too low, I added as required the following hydroquinone solution (which does, however, cause a cooling of the image color):

Hydroquinone Solution

Water (125°F, 52°C)	750 ml	100 oz.
Sodium sulfite (desic.).	25 g	3 oz., 150 gr.
Hydroquinone	10 g	1 oz., 145 gr.
Water to make	1 liter	1 gallon

Beers Two-Solution Formula

(I include this as a long-time standard in photography, although combining Dektol and Selectol-Soft in various proportions will give almost as much contrast control; see page 93.)

Solution A

Water (125°F, 52°C)	750 ml	100 oz.
Metol (Elon)	8 g	1 oz.
Sodium sulfite (desic.)	23 g	3 oz., 30 gr.
Sodium carbonate (desic.)	20 g	2 oz., 295 gr.
(OR monohydrated, 23.4 g; 3 oz., 55 gr.)		
Potassium bromide (10% solution)	11 ml	1½ fl. oz.
Cold water to make	1 liter	1 gallon

Solution B

Water (125°F, 52°C)	750 ml	100 oz.
Hydroquinone	8 g	1 oz., 30 gr.
Sodium sulfite (desic.)	23 g	3 oz., 30 gr.
Sodium carbonate (desic.)	27 g	3 oz., 265 gr.
(OR monohydrated, 31.5 g; 4 oz., 96 gr.)		
Potassium bromide (10% solution)	22 ml	2 3/4 fl. oz.
Cold water to make	1 liter	1 gallon

These are the stock solutions, which are mixed in the following proportions to give a progressive range of contrasts. The low-numbered solutions can be further diluted with water for very soft effects at normal developing times, with longer intervals of agitation; however the resulting print color may not be good with some papers. The original Beers formulas called for potassium carbonate instead of sodium carbonate. Potassium carbonate is less readily available and more expensive, and I have found it to offer no practical advantage.

Contrast	Low		Normal				High
Solution Number	1	2	3	4	5	6	7
Parts of A	8	7	6	5	4	3	2
Parts of B	0	1	2	3	4	5	14
Parts water	8	8	8	8	8	8	0

Amidol Developer

Water (125°F, 52°C)	800 ml	20 fl. oz.
Amidol	10 g	120 gr.
Sodium sulfite	30 g	365 gr.
Citric acid (crystal)	5 g	60 gr.
Potassium bromide (10% solution)	30 ml	3/4 fl. oz.
Benzotriazole (1% solution)	20 ml	1/2 fl. oz.
Cold water to make	1200 ml	1 quart

This formula was kindly furnished by Henry Gilpin. It replaces the Edward Weston formula of my previous texts, which contained "B-B compound," no longer marketed but apparently consisting largely of benzotriazole. I would expect this formula to give quite similar results.

Stop Bath

Water (room temperature)	750 ml	100 oz.
Acetic acid (28% solution)	48 ml	6 oz.
Water to make	1 liter	1 gallon

To make 28 percent acetic acid, add 3 parts glacial acetic acid to 8 parts water. Glacial acetic acid is harmful to skin and respiratory tract. Do not breathe the fumes or allow it to spatter on skin.

Fixers

The packaged Kodak Fixer in powder form is an acid hardening fixer that is adequate for most applications. The following formulas have become standards in photography; note that F-6 is comparable to F-5, but without the strong acidic odor. The fixing formulas given are to be used full strength. Thiosulfate quantities are given for the pentahydrated (crystal) form.

Kodak F-5

Water (125°F or 52°C)	600 ml	80 oz.
Sodium thiosulfate (hypo)	240 g	32 oz.
Sodium sulfite (desic.)	15 g	2 oz.
Acetic acid (28% solution)	48 ml	6 oz.
Boric acid (crystals)	7.5 g	1 oz.
Potassium alum	15 g	2 oz.
Cold water to make	1 liter	1 gallon

The F-5 formula can be easily memorized: the proportion of hypo is 2 pounds per gallon, with 2 ounces each of sodium sulfite and potassium alum, 1 ounce of boric acid, and 6 ounces of acetic acid (28 percent solution). *Always mix the ingredients in the order listed in the table.* If the acid is added before the sodium sulfite is *completely* dissolved, the solution will form a precipitate and become useless.

Kodak F-6

Water (125°F, 52°C)	600 ml	80 oz.
Sodium thiosulfate (hypo)	240 g	32 oz.
Sodium sulfite (desic.)	15 g	2 oz.
Acetic acid (28% solution)	48 ml	6 oz.
Kodak Kodalk Balanced Alkali	15 g	2 oz.
Potassium alum	15 g	2 oz.
Cold water to make	1 liter	1 gallon

I use F-6 for all work. F-6 is an odorless fixer that eliminates the boric acid of the F-5 formula, and uses Kodalk instead. I further modify the formula by

using one-half the hardener (potassium alum) given in the formula. This facilitates toning and washing of the prints, as well as spotting, and causes no adverse effects provided the solution and drying temperatures are not excessively warm. As with F-5, the ingredients must be mixed *in the order given.*

F-24

Water (125°F, 52°C)	500 ml	64 oz.
Sodium thiosulfate (hypo)	240 g	32 oz.
Sodium sulfite (anhydrous)	10 g	1 oz., 145 gr.
Sodium bisulfite (anhydrous)	25 g	3 oz., 150 gr.
Cold water to make	1 liter	1 gallon

This is a non-hardening fixer. Some photographers think that it improves image color. The absence of hardener may reduce the time needed for complete washing. Keep all solutions at or below 70°F when using this fixer.

Plain Hypo Fixer

Water (125°F, 52°C)	800 ml	80 oz.
Sodium thiosulfate (hypo)	240 g	32 oz.
Sodium sulfite	30 g	4 oz.
Water to make	1 liter	1 gallon

The sodium sulfite minimizes the possibility of staining and avoids build-up of thiocyanates in the fixer. Use at 68°F (20°C).

Other formulas

Gold Protective Solution (Kodak GP-1)

Water (room temperature)	750 ml	24 fl. oz.
Gold chloride (1% stock solution)	10 ml	1/3 fl. oz.
Sodium thiocyanate		
or potassium thiocyanate	10 g	145 gr.
Water to make	1 liter	1 quart

Add the gold chloride solution to the water. Dissolve the thiocyanate *separately* in 125 ml (or 4 fl. oz.) water. Then add this solution to the gold-chloride solution while stirring rapidly. There may be a slight precipitate; if so decant the solution.

To use, immerse the fully washed print for about 10 minutes or more. Watch for a perceptible change of image tone; it will gradually become slightly bluish-black. After treating, wash the print thoroughly for at least 15 minutes, swab, rinse, and dry as usual. This solution should be sufficient for treating about thirty 8 × 10 prints per gallon. For best results the solution should be mixed immediately before use.

This formula provides archival protection for prints that have *not* been selenium toned, as well as cooling the tone of print that is too warm. I include the formula mainly for reference; I consider selenium toning (see

page 130) far more practical and economical both for archival protection and for image tone.

Toning and Fixing Bath for Printing-Out Paper

Solution A

Boiling water	500 ml	20 oz.
Sodium thiosulfate (hypo)	125 g	7 oz.
Potassium alum	7.5 g	185 gr.
Lead acetate	1 g	25 gr.
Water to make	600 ml	1 quart

Dissolve the hypo and the alum, let the solution cool, filter it, and add the lead acetate dissolved in a little distilled water. Handle lead acetate carefully; it is highly toxic.

Solution B

Distilled water (room temp.)	100 ml	4 oz.
Gold chloride	1 g	18 gr.

To use, add 6 ml of B to 100 ml of A and let the mixture stand for 24 hours. Print for degraded highlights, and then, in a very subdued light, wash the prints until the wash water ceases to look milky. Then immerse the print in the toner. Toning must be continued for not less than 10 minutes. Use a *very* clean tray — porcelain or glass — and keep temperature at about 65°F. POP prints have a distinctive quality that some photographers find rewarding. The paper is marketed by Kodak as *Studio Proof*, and will fade rapidly if not toned.

Reducer

With some prints a very slight overall bleaching will serve to clear the whites and brighten the image. I recommend the following formula for this purpose, as it has very little tendency to cause stains.

Solution A

Water (room temperature)	300 ml	12 fl. oz.
Potassium ferricyanide	62.5 g	2 oz. 40 gr.
Potassium metabisulfite		
(or sodium bisulfite)	4.2 g	60 gr.
Water to make	500 ml	1 pint

Solution B

Water (room temperature)	600 ml	24 fl. oz.
Ammonium thiocyanate	330 g	11 oz.
Potassium bromide	30 g	1 oz.
Water to make	1 liter	1 quart

Mix 1 part of A, 2 parts of B, and 10 to 15 parts of water. Immerse the *dry* print face up with vigorous agitation for 5 to 10 seconds. Place immediately

in water and agitate until the bleaching solution has been removed from the surface of the print. Examine the print, and return it if necessary to the bleaching bath (advised only for a few seconds). If the print is wet initially, or if the solution is too dilute, the middle and lower tones may respond to the action of the bleach, thereby weakening the print values in general.

Farmer's Reducer (R-4a)

Solution A

Potassium ferricyanide	37.5 g	1¼ oz.
Water to make	500 ml	1 pint

Solution B

Sodium thiosulfate	480 g	16 oz.
Water (125°F, 52°C) to make	2 liters	2 quarts

This is the same reducer listed in Book 2 for use with negatives. For prints, however, a very weak dilution is advised:

Solution A	3 ml	0.1 fl. oz.
Solution B	12 ml	0.4 fl. oz.
Water to make	1 liter	1 quart

For overall proportional reduction Kodak advises a 10-minute soaking of the dry print before use. The print is then immersed in the reducer for 5 to 10 seconds with constant agitation, followed by rinsing under running water. Repeat as necessary until the desired reduction has occurred. The print should then be washed for one minute, fixed for 5 minutes, and given the complete washing, hypo-clearing, washing cycle (see pages 137–139). If you wish to use this formula only to clear the high values, I recommend that you not pre-soak the print.

For local reduction, the solution may be applied with a brush or cotton swab. Allow it to stand on the print for 5 to 10 seconds, and then flush with running water. Repeat if necessary, and then give full fixing and washing.

The pre-packaged Kodak Farmer's Reducer may be used in dilute form for print reduction.

Spotting Solutions

Dye materials such as Spot-Tone are almost universally used and are generally quite satisfactory. Edward Weston used an ink-based spotting formula consisting of equal parts (by weight) of Chinese (stick) ink and gum arabic. Dissolve in enough water to cover them, and mix. Let dry out and mold to suit. To use, moisten a brush in water (to which a wetting agent like Kodak Photo-Flo may be added), touch the brush to the ink compound and wipe on a piece of paper until the proper gray shows, and then apply to the print. A "dry" brush works much better than one that is too wet. The amount of gum arabic may be increased 2 or 3 times to increase the glossiness of the spotted area on the print.

Most of my prints are spotted using the standard Spot-Tone dyes. The appropriate color is achieved using primarily the #3 dye (neutral), mixed together with a small amount of #2 (selenium) dye in a pallette.

Test Data

The interpretation of sensitometric curves may at first be perplexing. To the practiced eye the curves give an immediate appreciation of the characteristics of the film or paper. Density range, contrast, and response within the low-value and high-value regions can be noted at a glance. As with curves for negatives, paper curves are perhaps most useful when compared to other paper curves, rather than seen alone.

Remember that the paper curves are *positive* curves. *High* densities in the print are dark areas (low values) represented by *low*-density areas of the negative. Much confusion arises around this point: the relationship is not hard to remember if you think in terms of density. High density always means a heavy deposit of silver, and relates to the shoulder of the curve; with a negative the high densities represent *high* subject luminances, and in a print high densities represent *low* subject luminances.

The curves for papers are presented here with the shoulder of the paper curve to the right. Sometimes the positive curves are reversed, showing the high densities to the left; we followed that form, for example in my *Polaroid Land Photography* (pages 288 and 290), since it enabled us to show print and negative values as they relate to each other for the positive/negative Polaroid films.

Note also that the exposure values used on the horizontal axis are *relative* values. A change of 0.30 units on this axis represents a doubling or halving of exposure, but no actual exposure values in specific units are given. Papers being tested were exposed to a step tablet containing 31 steps, contact printing with normal cold-light enlarger illumination. Processing was in Dektol diluted 1:3 for 3 minutes at 70°F (21°C), unless otherwise noted.

These curves are the result of careful testing by my colleague, John Sexton. The original sensitometric curves were plotted from Sexton's data by Rod Dresser on a computer, with a program developed by Dresser. We have carefully confirmed the results in practical terms, and are confident of them. It must be remembered, however, that the characteristics of all photographic materials are subject to change, and these results may not be specifically applicable to later materials. They are, however, very informative about the *relative* qualities of different materials, and suggest important relationships. For more current specific data, I suggest contacting the manufacturers.

Paper Grades

The curves show the increase in slope (contrast) as we go from Grade 1 to Grade 4, in this case with Ilford Gallerie.

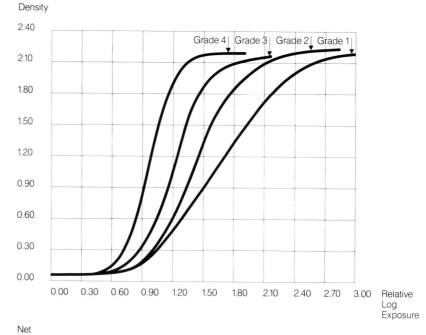

Dektol and Selectol-Soft Developers

These tests were printed on Oriental Seagull Grade 2, all processed 3 minutes at 70°F. Curve A represents development in Dektol 1:3 solution. Curve B represents development in Selectol-Soft combined with Dektol (1000 ml each of Selectol-Soft stock and water, and 100 ml of Dektol stock). Curve C shows the effect of Selectol-Soft alone, diluted 1:1.

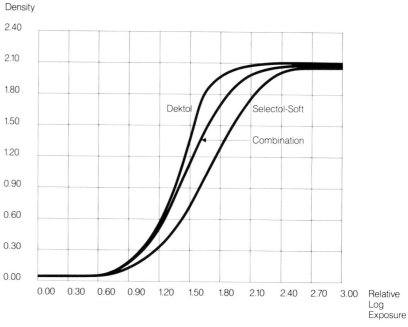

Effect of Changing Development Factor

As discussed in the text (page 95), increasing the factor causes an increase in contrast with most papers. With this paper — Oriental Seagull Grade 2 — the difference is comparable to one whole paper grade.

Using Factorial Development To Counteract Changes in Developer Dilution

These four curves represent test prints (on Ilford Gallerie Grade 2) exposed identically and developed in Dektol at dilutions of 1:2 to 1:8. If the prints had all received the same development time, their curves would differ markedly. However, by applying factorial development (see page 95) the difference in dilution can be counteracted, and virtually identical prints are obtained. The emergence time of each print was noted as it developed, and this emergence time was multiplied by the factor to determine the total developing time for each print. The developing times thus ranged from about 2 minutes to 5½ minutes, as shown below:

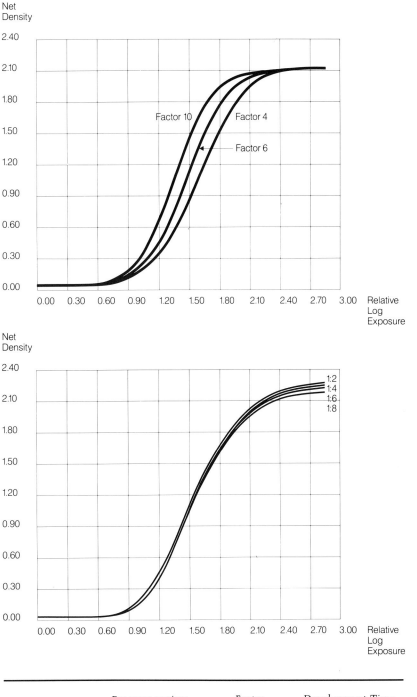

		Emergence time	Factor	Development Time
Dektol	1:2	21 seconds	6	126 seconds
	1:4	32 seconds	6	192 seconds
	1:6	42 seconds	6	252 seconds
	1:8	55 seconds	6	330 seconds

Reciprocity Effect

In testing for the effect of very long exposures, our data showed a significant loss of emulsion speed. However, no measurable change of contrast occurred. The exposures used for this test were 18 seconds, 144 seconds with ND 0.90 neutral-density filtration, and 288 seconds with ND 1.20. Calibrated neutral density filters were used instead of simply changing aperture to ensure the greatest possible accuracy. The paper was Ilford Gallerie Grade 2.

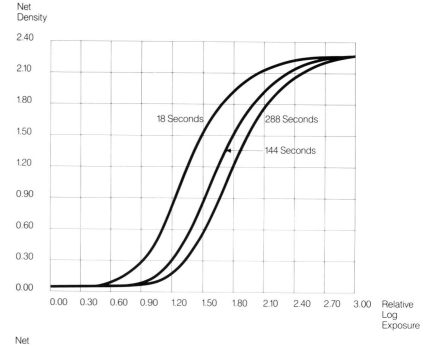

Effect of Selenium Toning

Identical test prints were toned in Kodak Rapid Selenium Toner diluted 1:10 with Kodak Hypo Clearing Agent (working strength). Note that the scale has been extended — the low values are darker — as a result of the toning. The paper was Ilford Gallerie Grade 2.

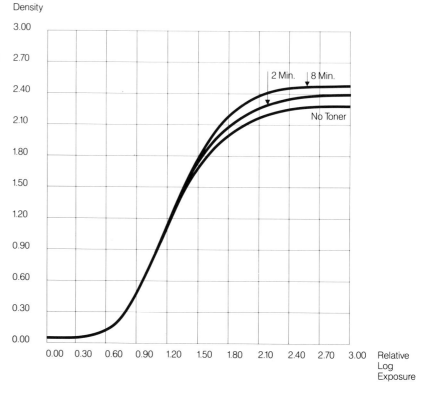

Comparison of Enlarger Light Sources

The three curves represent point source, condenser, and diffusion enlarger lighting systems. Note the increase in contrast and more abrupt toe with condenser enlarger compared to the diffusion system. Point source, the most contrasty of all, is seldom used today. The test samples were projected onto Ilfobrom Grade 2 paper.

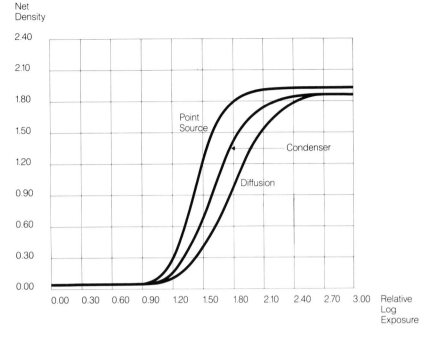

Appendix 3 **Print Washing Test**

It is important that tests be made periodically to determine if the prints are receiving thorough washing, as indicated by the absence of residual thiosulfate from the fixer. The usual test is the Kodak HT-2 spot test, but since this procedure tests only a small spot, it can give misleading results, and disastrous effects may appear years later. With some washers a portion of the print may be washed quite well while another area is hardly washed at all! If you do choose to use the spot test, check at least the four corners of the print as well as the center.

The test described here* involves immersing the entire print in the test solution, thus eliminating the potential inaccuracy of the spot test procedure. I suggest conducting this test thoroughly and carefully once, to establish your optimum wash procedure. You then may test single sheets periodically to monitor the washing.

First give your complete normal processing (developer, stop bath, two fixers, hypo clearing, toning, etc.) to several *unexposed* sheets. Before loading them into the washer, label each sheet on the back in soft pencil with the time at which it is to be removed and tested. Try using 10-minute intervals beginning with 30 minutes, if hypo-clearing has been used. Keep one sheet marked as a reference, which is washed but not tested, to compare with the stains generated by the test. Record the wash temperature; if it is allowed to drop below 65°F, the washing process will be significantly slowed down.

Throughout the procedure you should wear *clean* rubber gloves to avoid stains on your hands. Be careful not to let the silver nitrate splash on clothing, etc., since it stains these as well. Store the solution in a brown glass bottle away from strong light. Discard if the solution darkens noticeably in color.

Silver Nitrate/Acetic Acid Solution

Distilled or deionized water (room temperature)	750 ml	20 fl. oz.
Glacial acetic acid	30 ml	1 fl. oz.
Silver nitrate (CAUTION: POISON)	10 g	145 gr.
Distilled or deionized water to make	1 liter	1 quart

*This procedure is based on the American National Standards Institute (ANSI) Standard PH4.8–1978.

When ready to test a print, remove it from the washer and immerse it in the silver nitrate test solution for four minutes, in *subdued* tungsten light with agitation. Compare this print (both emulsion and base side) with the reference sample to see if there is any stain (be careful not to let the silver nitrate solution come in contact with the reference sample, or it too will be stained).

Continue testing samples from the washer every 10 minutes until there is absolutely *no visible stain* anywhere on the test prints. It may be easier to compare the tests with the reference sample if you use the optional clearing and re-fixing procedure to make the stains permanent, and compare the samples after they have dried.

I would advise washing 20 to 30 minutes longer than the first test that shows no visible stain. This seems to be a good margin of safety. Note also that, with some archival washers, not all compartments wash at the same rate. To be certain that all prints are properly washed, it would be worthwhile to test an entire load of samples that have been given your normal wash time.

I also want to emphasize that it is of the utmost importance to wash your hands *thoroughly* with soap and warm water before handling test prints, if your hands have been in the fixer. It is surprisingly difficult to remove the last traces of hypo from the fingers, and fingerprints will appear on the test prints if you are not careful. You should also hose off the top of the washer after loading the prints to remove hypo that may have dripped on the washer surface, since this can be transferred to the prints as they are removed.

If you wish to make the stain sample permanent as a record of the test, it may be treated in the following solutions:

Sodium Chloride Solution

Distilled or deionized water (room temperature)	750 ml	20 fl. oz.
Sodium chloride*	50 g	1 oz., 300 gr.
Distilled or deionized water to make	1 liter	1 quart

*plain table salt is suitable for this solution

The sample should be transferred from the silver nitrate solution to this solution, and treated for 4 minutes with agitation. Do not allow the sodium chloride solution to spill or splash into the silver nitrate solution, or a precipitate will form and ruin the silver nitrate test solution.

Fixing bath

Hot water (125°F, 52°C)	750 ml	20 fl. oz.
Sodium sulfite	19 g	280 gr.
Sodium thiosulfate	50 g	1 oz., 295 gr.
Water to make	1 liter	1 quart

Treat the sample for 4 minutes with agitation, then rinse, wash, and dry as usual.

Index